DESIGNERS AT HOME

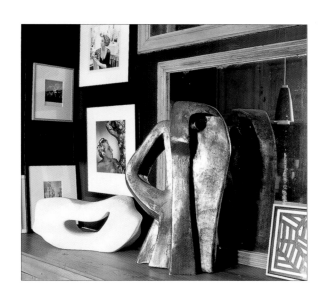

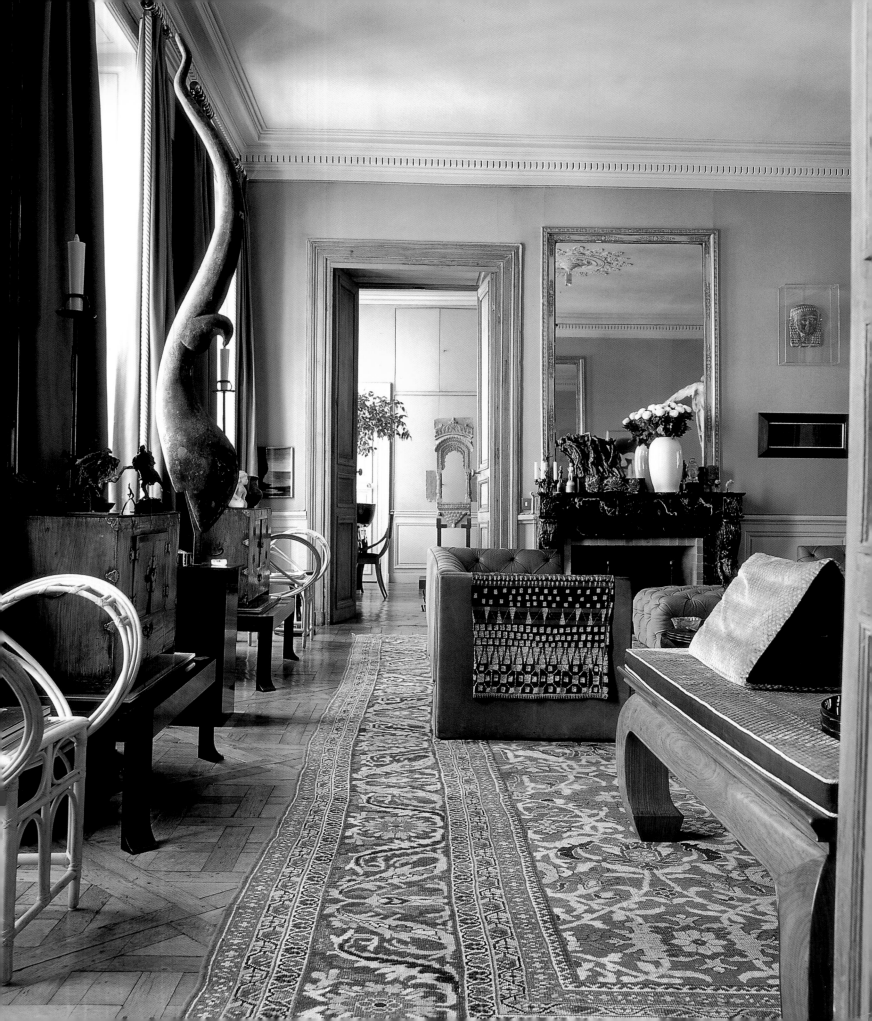

DESIGNERS AT HOME

DOMINIC BRADBURY

Photography
MARK LUSCOMBE–WHYTE

PAVILION

TO MY FATHER

First published in Great Britain in 2001 by
PAVILION BOOKS LIMITED
London House, Great Eastern Wharf
Parkgate Road, London SW11 4NQ
www.pavilionbooks.co.uk

A CIP catalogue record for this book is
available from the British Library.

ISBN 1 86205 454 1

Colour reproduction in England by
 Anglia Graphics
Printed and bound in Italy by Conti
 Tipocolor, Florence

10 9 8 7 6 5 4 3 2 1

This book can be ordered direct from the
publisher. Please contact the Marketing
Department. But try your bookshop first.

Additional picture captions:
p1 Frédéric Méchiche; p2 Ed Tuttle;
p4–5 Kelly Hoppen; p13 Anthony
Collett; p79 Kelly Hoppen; p139 Anne
Maria Jagdfeld.

CONTENTS

INTRODUCTION 6

NEW CLASSIC 12

ALIDAD 14
ANTHONY COLLETT 22
CHRISTIAN DE FALBE 30
ASHLEY AND ALLEGRA HICKS 40
JACQUES GARCIA 48
JACQUES GRANGE 60
JOHN MINSHAW 68

FUSION 78

KELLY HOPPEN 80
FRÉDÉRIC MÉCHICHE 90
MIMMI O'CONNELL 100
PETER PRELLER 108
MICHAEL REEVES 114
STEPHEN RYAN 122
ED TUTTLE 130

MODERN 138

CHARLES BATESON 140
THOMAS SANDELL 148
JONATHAN REED 154
NICO RENSCH 162
ANDRÉE PUTMAN 170
ANNE MARIA JAGDFELD 182

INDEX AND
SELECTED BIBLIOGRAPHY 190

ADDRESSES AND
ACKNOWLEDGEMENTS 192

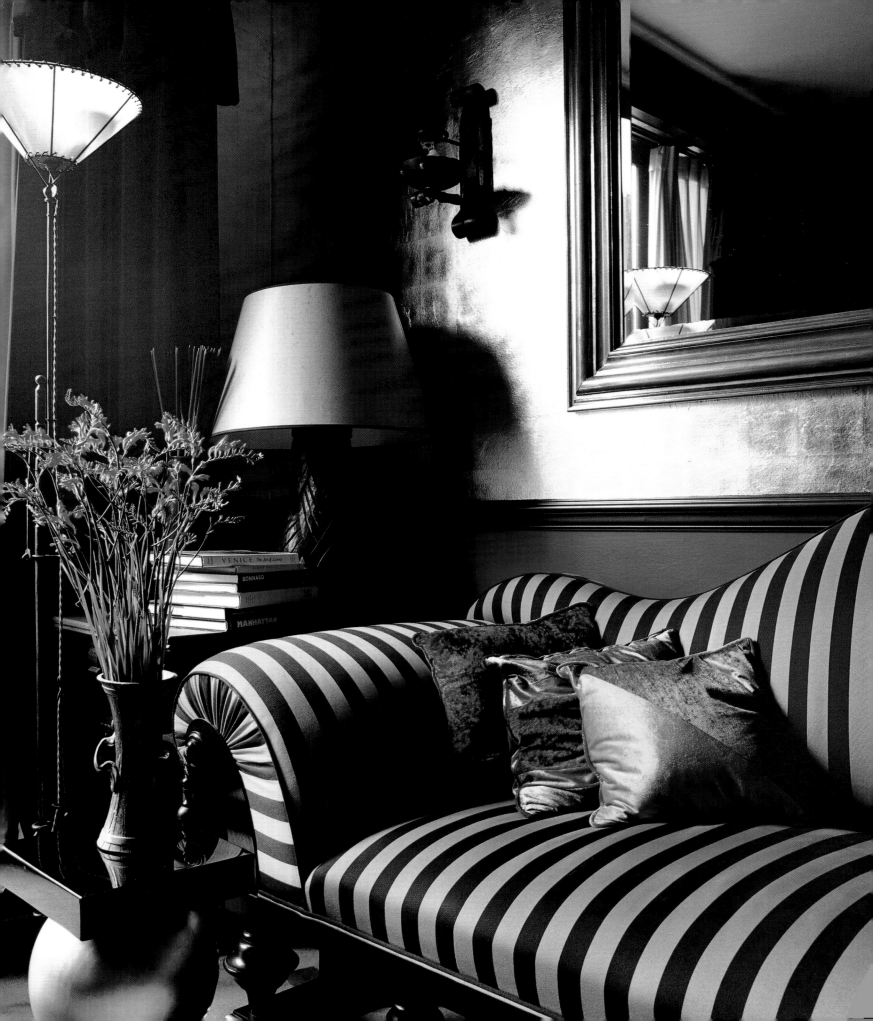

Introduction

We are witnessing a new golden age of interior design. It is now a time of innovation, originality and the gradual creation of a new way of living – one that places a renewed emphasis on comfort and indulgence, pleasure and relaxation, as well as style and aesthetics. Interior designers are, of course, at the forefront of this renewed emphasis on home pleasure, drawing inspiration from past and present, from art and architecture, from Europe and America, from East and West, to forge a fresh spirit of invention.

Nowhere is this sense of making it new more apparent than on the canvas of a designer's own home. Which is why this book sets out to offer a glimpse of the most personal and uncompromising of spaces, the most carefully considered expressions of individual style created by twenty of some of the best interior designers working internationally at the start of the new century.

LEFT The sitting room of Anthony Collett's home works around neoclassical ideals of proportion and scale, but adds the seductive glamour of golden walls, velvet curtains and silk cushions.

RIGHT Mimmi O'Connell's Italian villa places an eclectic mix of Asian and European furniture against a neutral backdrop.

In Paris there is the eclectic vision of Frédéric Méchiche – tying modern art and different ages of design together with original thinking – and the reinvention by Jacques Grange of Colette's famous flat overlooking the gardens of the Palais-Royal, now rich in an extraordinary mix of 1930s influences, classical notes and contemporary style. In London there is the elegant fusion look of Kelly Hoppen, reinterpreting ideas from Thailand and China, and the positive reinvention of more classical methods and motifs by designers such as Ashley

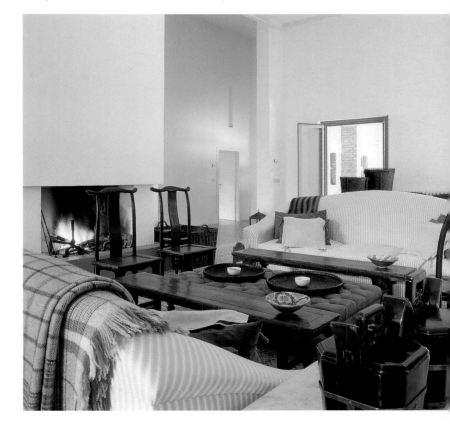

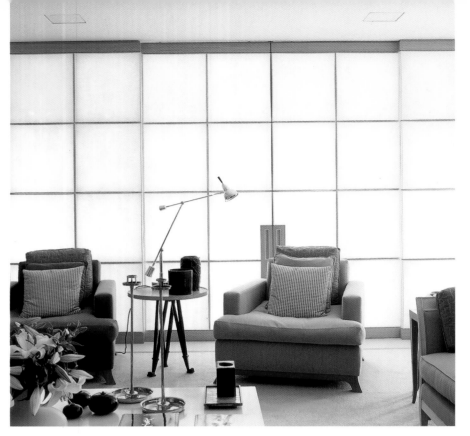

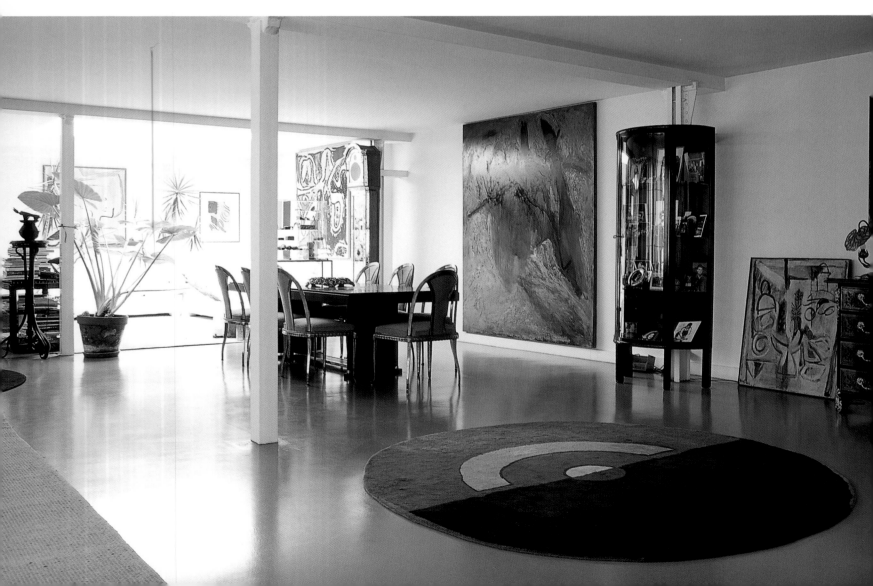

Hicks and John Minshaw. In Tuscany Mimmi O'Connell blends English and Eastern references on a startling white canvas, while in Berlin Anne Maria Jagdfeld maximizes technology and interior architecture in conjunction with designs inspired by Japanese interiors and the work of Jean-Michel Frank.

Along with Andrée Putman, Jonathan Reed, Ed Tuttle and others, these are pioneers of today, designers who – in their very different ways – have moved well beyond traditionalism and the confines of the country-house look, with its many period equivalents. These are designers who have an awareness of the past without being restricted by their knowledge, who are grounded in the present but also have an eye on the future. They are willing to experiment, to invigorate, as well as being familiar with the changing demands of contemporary life and of new technology, both of which are significantly influencing the form and function of the home.

LEFT Three different designers (clockwise from top left, Anne Maria Jagdfeld, Jonathan Reed and Andrée Putman) adopt solutions for loft-style living by lightly creating separate zones for dining and relaxing, while still preserving the luxury of a large, light, open-plan space.

This book categorizes the designers into three sections, although all of them are in a sense contemporary. New Classic is monopolized by those who make particular use of classical and neoclassical thinking, especially in their approach to proportion and scale. They use antiques, period fabrics and period touches, yet at the same time they also have a modern approach to the needs of the twenty-first-century home. Fusion applies to those inspired by travel (especially by India, China and the Far East) and those who have a particularly international outlook, more so than a usual inevitable global influence. And Modern can speak for itself – it suggests a more architectural approach, a pared-down vision, a taste for more futuristic materials and building methods, while still making allowances for indulgence.

As this book has gradually come together, many of the designers that have been interviewed have prompted thoughts of that last great and powerfully influential era of interior design. This was the 1920s and 1930s, the period of masters such as Jean-Michel Frank, Jacques-Emile Ruhlmann and Pierre Chareau. Like many of those featured in these pages, Frank and his contemporaries were international figures and were multi-talented. They reacted to the staid conservatism of the Victorian age with an enthused originality, combining a new outlook on design and the home with a far-reaching frame

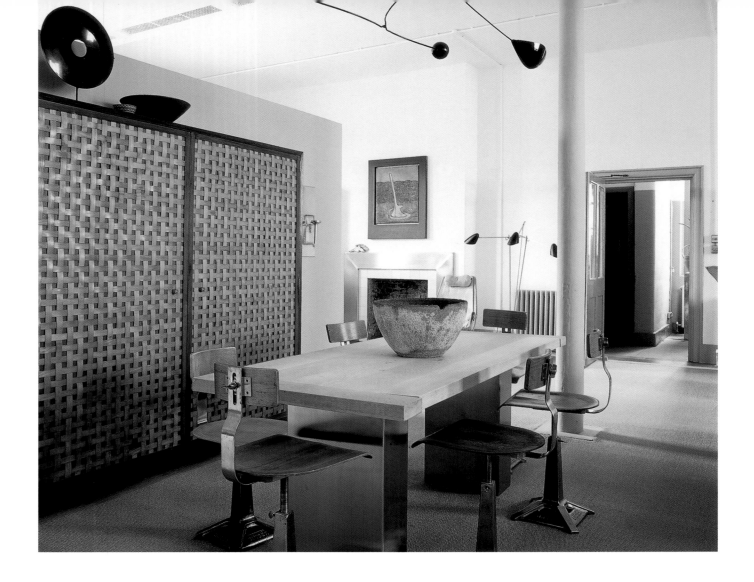

of reference, bringing in influences from both sides of the Atlantic, from Africa, from the East. And they were also strong advocates of comfort, luxury and good craftsmanship.

Not surprisingly, the Depression and the war years that followed suppressed much of this hedonistic design ethos. There followed instead a period of utility, when the great Modernist architects came to the fore with their ambitious plans for new kinds of housing, new ways of living. There was a key group of architect designers – Marcel Breuer, Le Corbusier, Mies van der Rohe, Frank Lloyd Wright – who, again, were multi-disciplined and full of invention. Yet during the 1950s and 1960s many disciples of Le Corbusier and Bauhaus lacked their teachers' crucial insistence on the value of the interior as part of the whole, paying little attention to and often looking down upon the work of interior designers as insignificant.

Fortunately we have moved beyond such an attitude. Now, while respecting the greatest of the Modernists and their lessons on space and light – and drawing upon the important lessons of the 1920s and 1930s – many interior designers are entertaining their own spirit of reaction. Being influenced by an older generation of designers – David Hicks, Madeleine Castaing, Billy Baldwin – the designers in this book have also set about creating a new home landscape rich in texture, fine materials and comfort, informed by an attentiveness to proportion, scale and technology. Many possess solid architectural awareness or training. They are interior architects, lighting designers, furniture designers, paint specialists, art collectors, as well as psychologists, all rolled into one, showing that interior design has now moved on as a trade.

The list of designers in this book does not claim to be exhaustive or comprehensive, but this is an assembly of many of the best, most innovative, provocative and influential interior designers working in Europe today, viewed through their own homes, both personal and inspirational. The hope is that you will enjoy looking through the wide open doors of this book into their unique and private living spaces.

LEFT AND RIGHT
Symmetry brings order and cohesion to the living rooms of John Minshaw (left) and Kelly Hoppen (right), but with many contrasting ideas for texture, tone and ambience.

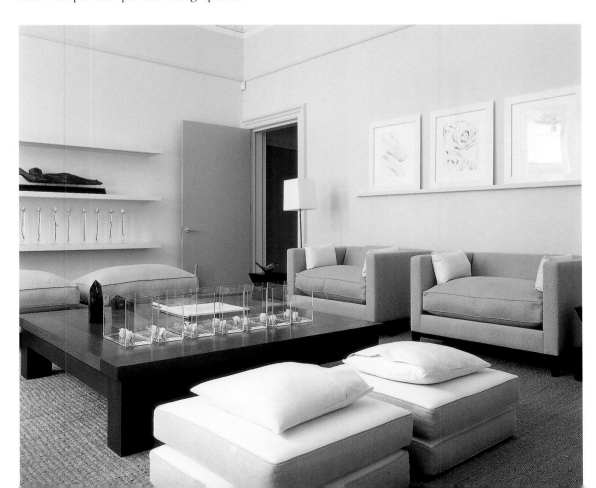

New Classic

DESIGNERS IN THE NEW CLASSIC MANNER ARE NO SLAVES TO HISTORY. RATHER

THEY DRAW ON THE PAST FOR INSPIRATION, UPDATING AND REINTERPRETING

PERIOD STYLES FROM A CONTEMPORARY PERSPECTIVE, MAKING THEM RELEVANT

TO TODAYÍS WAY OF LIFE, TODAYÍS APPROACH TO THE HOME. FROM THE EPIC

GRANDEUR OF JACQUES GARCIA TO THE MODEST, ORIGINAL ECCENTRICITY OF

CHRISTIAN DE FALBE, THESE ARE DESIGNERS WHO VALUE MANY CLASSICAL PRIN-

CIPLES OF PROPORTION AND SCALE, PERSPECTIVE AND SYMMETRY, BUT KNOW

THAT RULES ARE MADE TO BE BROKEN.

Alidad

IT WAS A LOVE FOR TEXTILE DESIGN, FOR COLOUR AND PATTERN, THAT SET ALIDAD ON THE PATH TOWARDS INTERIOR DESIGN. HIS CAREER BEGAN AT SOTHEBY'S, THE AUCTION HOUSE, WHERE HE ATTENDED A COURSE IN DECORATIVE ARTS AND THEN TOOK UP HIS OWN POSITION WITHIN THE COMPANY, SPECIALIZING IN ANTIQUE TEXTILES. HE SPENT EIGHT YEARS AT SOTHEBY'S IN ALL, BECOMING DIRECTOR OF THE DEPARTMENT OF ISLAMIC ARTS AND TEXTILES.

The big impetus for change came when Alidad started redecorating his London apartment, which he bought in 1980. The first room he designed was his red sitting room, a havenlike space with layer upon layer of patterned fabric. The core of the home, it is a room for talking, reading and music, and comes alive at night with candlelight throwing shadows around the room and playing on the vibrantly patterned walls, their hand-painted design a blend of references from a handful of mosques and Islamic houses.

'When I did this room it really encouraged me to begin work as an interior designer,' says Alidad. 'It wasn't done consciously, but naturally, and that's why it came out well. I decided I would become a decorator, although I had no idea what that really meant; I just thought I could do it. In a way that was perfect, because if I had known about how difficult it might be, perhaps I would never have had the courage to leave Sotheby's.'

The experience and knowledge that Alidad gained during his time at the auctioneers became a foundation stone for his work as a designer. With no formal training, his approach was instinctive and he soon evolved an individual style that fused Islamic influences with elements of traditional English or European design. Rooms are treated like canvases, and Alidad works like

RIGHT The red drawing room is the heart of the apartment, glimmering at night when the gold and jewel reds of the painted walls flicker and sing. As elsewhere, here Alidad has recycled fragments of damaged kilims and carpets for upholstery or throws, creating many subtle layers of pattern and colour.

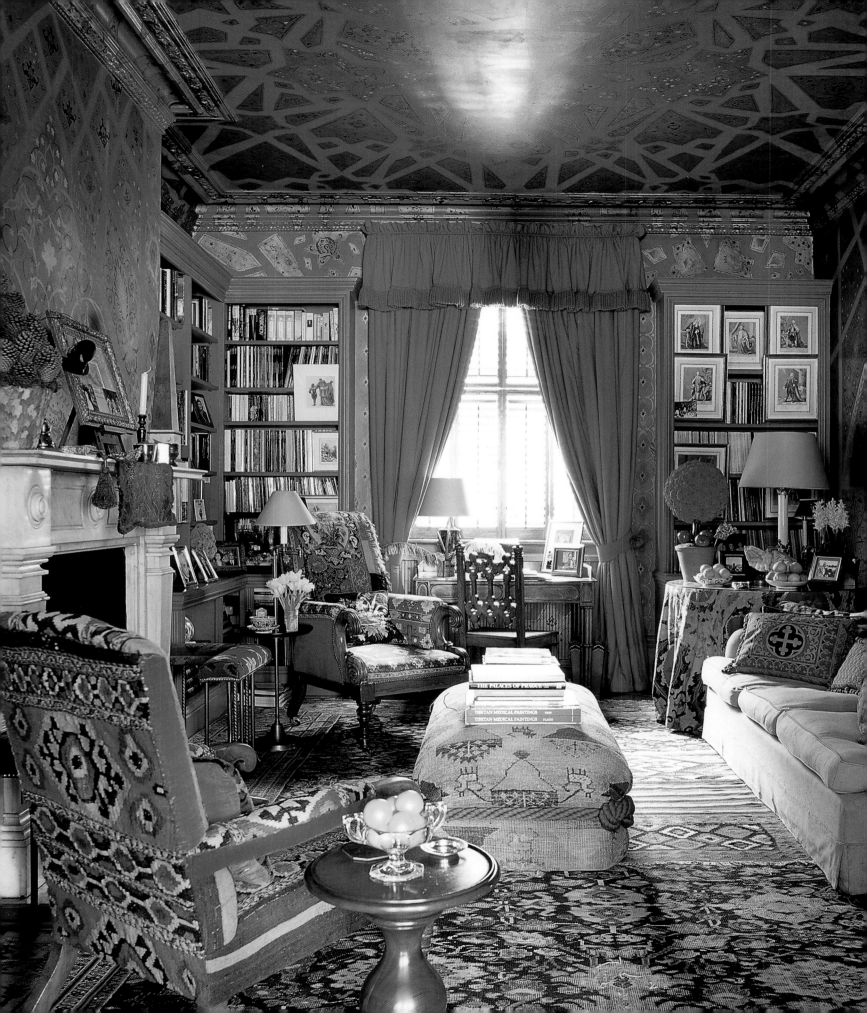

a painter, beginning with a base colour then introducing a main choice of fabrics for upholstery, carpets and curtains and adding layers of secondary fabrics and antique textiles until he knows it is time to stop.

'In a way, for me it was the reverse of what many decorators do, in that they start decorating and then learn about antiques, about textiles. With me it was the opposite and I was doing whatever came most naturally. I wanted my rooms to look as though they were done by one person, to look cohesive, and I didn't want them to look as though they had been designed yesterday but to seem as though they had been there for a very long time.'

Born in Tehran, Alidad and his family moved away from Iran to Switzerland when he was fifteen years old, and then on to England in the early 1970s. Although his break with Persia occurred long ago, the region has remained an influence. Persian textiles may sometimes be too finely made, too detailed, for a man with a love of bold patterns and large designs (though nineteenth-century Ziegler rugs from Persia are particular favourites) but his love of intense colours, of shades of red especially, stems from childhood.

'I remember my grandmother's house,' says Alidad, 'and she had a lot of red velvet, so perhaps that has

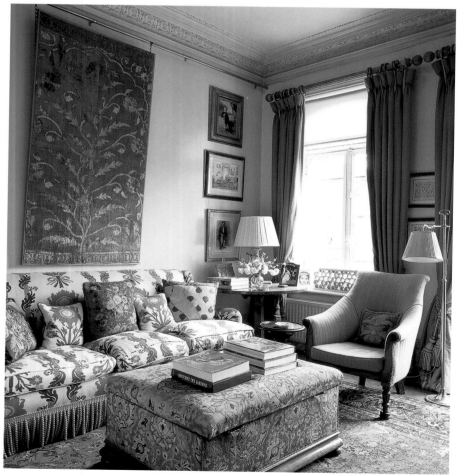

LEFT AND RIGHT Alidad's yellow drawing room (left) functions as a lighter day room, with fabrics presented like artwork on the walls to add texture. The walls were varnished for a richer flavour, while still forming a neutral base for adding further character and colour — rather like the stone-coloured sofa in the sitting room (right) which acts as a foundation for a rich variety of patterns.

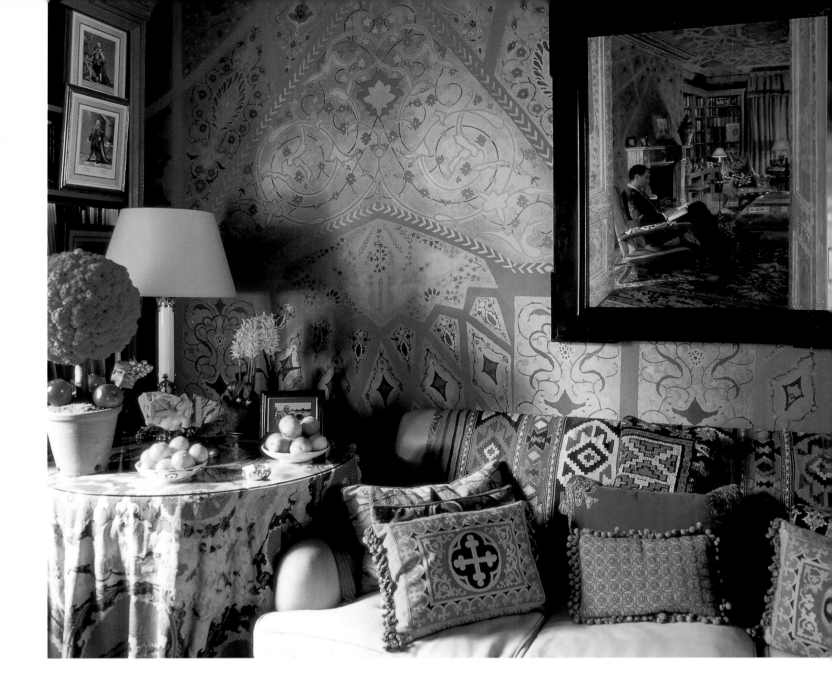

something to do with it. I have good memories, but it's more to do with simply being a child, wonderful summers and being very free. I did go back to Iran a few years ago, as a tourist, and it was emotional and difficult, but I was amazed by what I saw. The countryside was so unbelievable, each town so different. I have never seen cities so grand. At Shiraz I could understand why it was called the land of the poets. It's all about wonderful hidden gardens, like a paradise.'

Yet Alidad's style is also heavily influenced by English design, especially by principles of comfort, which play a strong part in his philosophy. The

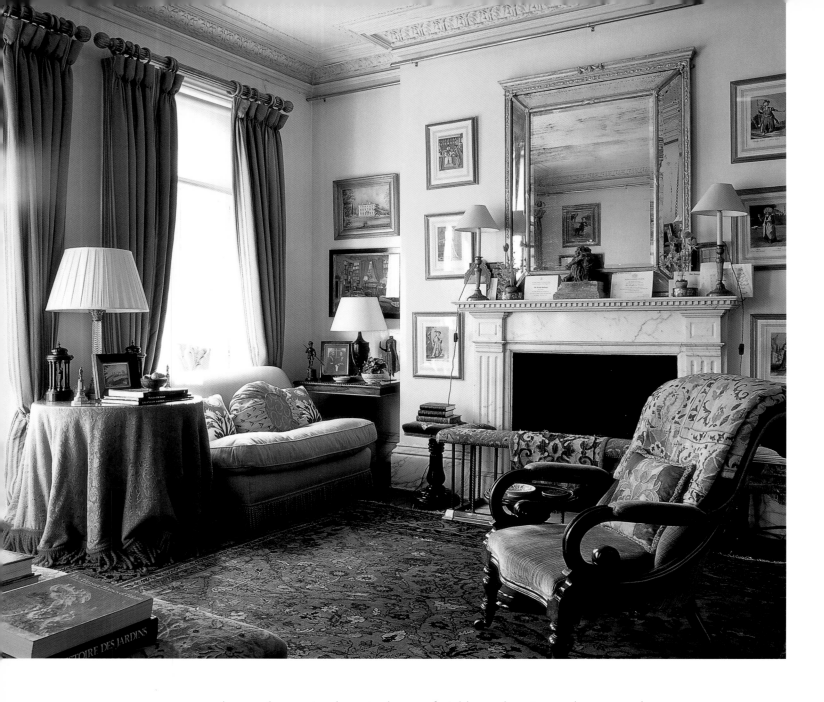

houses he creates have to be comfortable, welcoming and warm and are
usually laid out in traditional English seating plans, often oriented around a
fireplace. He labours to indulge the senses, creating spaces that are not only
visual fantasies but are also tactile, luxurious and hospitable. His favourite
period for furniture is William IV – post-Regency and pre-Victorian – when
the style was strong but crisp, while English Gothic revival pieces of a similar
era also feature strongly in his apartment. Italy plays an important role, too,
with classical references often finding their way into the mix. The look
becomes a mixture of different worlds, applied on an international scale, with

his work – which is purely residential – taking him to Italy, the Middle East and beyond, along with constant commissions in the United Kingdom.

As well as original inventions, there have been restoration projects that take advantage of Alidad's grounding in the history and method of decorative art. There was the sensitive work to restore the Sir Edward Burne-Jones room at Buscot Park, Oxfordshire, for instance, created around a sequence of four of the Victorian artist's paintings. Yet even contemporary projects have a timeless quality, beyond fashion, even though they may make the most of new technology and a modern approach to space and light.

'I have just finished a very large house in London and done so much to it, everything you can think of,' says Alidad. 'But if you saw it now you would never believe it, because the art of doing a successful job is when a home looks natural, as though that's the way it should be.'

Alidad's own apartment suggests the importance of character, and the essential nature of comfort. Imperfection is part of the charm, with Alidad being happy for walls to show marks of age and simply to throw another rug over a worn piece of carpet. Rooms have been designed around purpose and atmosphere, such as the evening rooms – the red and gold sitting room and the dining room – or day rooms such as the more formal main yellow salon. Structural changes have been limited, although five years after moving in he bought a neighbouring flat and combined the two spaces.

In the yellow salon panels of fabric are presented on the walls like artwork: there is a segment of eighteenth-century velvet that was part of a Moghul tent, along with Spanish, Turkish and Italian textiles, all adding colour and texture. Lighting here, as elsewhere, is largely ambient with harsh downlighters or ceiling lights avoided. There are lamps and candles, while in the dining room there is no artificial light at all, simply flames and firelight. The dining room is rich in exotic fantasy, the walls covered in leather panels that have been hand-painted to Alidad's design. Oversized pieces such as the vast English dining table, the Victorian dresser and a Gothic sideboard fill the room.

'If I have a small room I usually put big things into it – wallpapers with big patterns, at least one large piece of furniture – because it is so easy to

LEFT AND ABOVE Rooms are always designed with a floor plan, and furniture is placed according to the flow of human traffic through the home. Function and comfort converge, as in this arrangement around a fireside. Classical elements, such as statuary, add another dimension to the look of the room, with its mix of English and Eastern influences.

trick the eye. And I always like to create a fantasy with a dining room, as you are only there for a couple of hours and it's a time when you can let go in a different way. I agree that dining rooms can be dead spaces for our way of life, but that's why I take them a step further – if you are lucky enough to have one, create something beyond a normal room.'

In the main bedroom the walls have been painted a shimmering emerald green, while a fireplace was added to reinforce the impression of warmth and indulgence. Panels of red damask and fragments of tapestry decorate the walls, along with a painting – hanging above the William IV sofa, covered in an old Fortuny fabric – that is a copy of an eighteenth-century picture at the Topkapi Palace Museum in Turkey.

Each room in the apartment tells its own stories, talks of its own theme. They are spaces full of interest and character, yet they are not intimidating or remote, which is key to Alidad's ambitions for his work. 'A room can be incredibly grand, but it should also be comfortable and never frightening,' he says, 'and that can be difficult to achieve. I need to have warmth, that womb-like effect. You come into a room and you want to be part of it.'

LEFT AND RIGHT Although Alidad savours the moods and illusions that clever artificial lighting can create – using both soft, warm lamps and very high-tech flexible lighting systems – here in the dining room there is only candlelight for a unique atmosphere. This is an indulgent fantasy room, with the flames playing on the hand-painted, silver-leafed leather wall panels and mirrors.

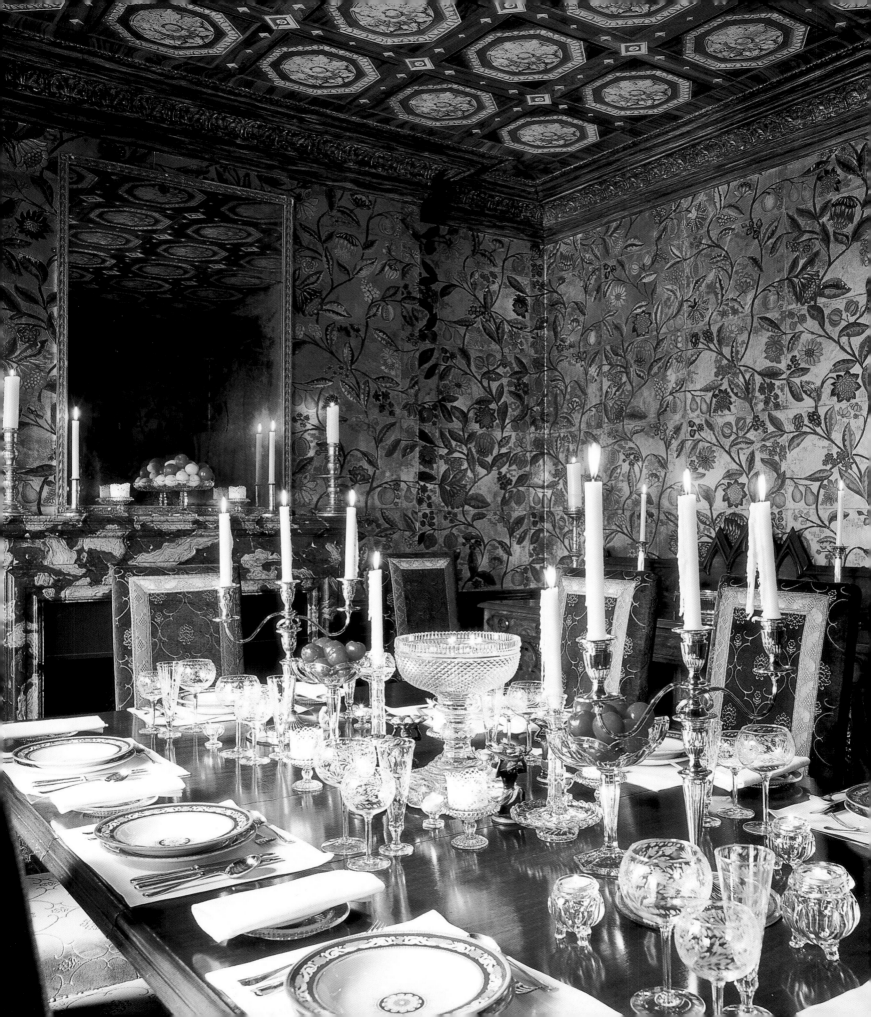

Anthony Collett

THERE IS A TOUCH OF THEATRE IN THE WORK OF ANTHONY COLLETT. THIS IS ESPECIALLY TRUE OF HIS OWN LONDON HOME WHERE EVERY ROOM HAS A SENSE OF DRAMA, CREATING AN IMPRESSION OF TEMPERED OPULENCE WITH ITS COMBINATION OF VIBRANT COLOURS, SUMPTUOUS TEXTURES AND ELEMENTS OF BOHEMIAN EXOTICISM. WALK FROM THE HALLWAY INTO THE TWO MAIN ROOMS OF THE HOUSE – AN ADJOINING SITTING ROOM AND A FORMAL DINING AREA – AND YOUR ATTENTION IS INSTANTLY ARRESTED BY THE SHIMMERING GOLDEN WALLS AND A COLLECTION OF NINETEENTH-CENTURY STUDIO POTTERY LINING ALMOST EVERY SURFACE AND CLIMBING THE WALLS, SUPPORTED BY A MINIATURE ARMY OF WOODEN SCONCES.

'I started collecting in the 1980s when we had our first child. To give my wife, Julia, a break I would take the baby out in the pram and end up in Portobello Road and go to the market,' says Collett. 'I always had to buy something and the prices were very reasonable then, so I bought Moorcroft, Bretby and Ruskin pottery. I was also very friendly with Gilbert and George in those days and they put me onto this because they have one of the largest collections of these kinds of ceramics in the world.'

Building this collection – with the rich glazes in cobalt blue, ruby reds and sunflower yellows – influenced not just Collett's home but also his work generally, as the intense colours helped change his attitude to interiors. 'It is something I came to quite late in life because I had always feared colour enormously,' he says. 'But collecting these vases made me realize that if colours were good they could be put together; that if a colour is good enough it can go with virtually any other. It was my big breakthrough, in a way.'

RIGHT The chessboard dining table and ceiling light were both designed by Collett, and blend with a set of Arts and Crafts dining chairs. Behind, set against golden walls, Moorcroft and Ruskin china – set on sconces – create a design of many jewel-like colours and a mood of opulent drama.

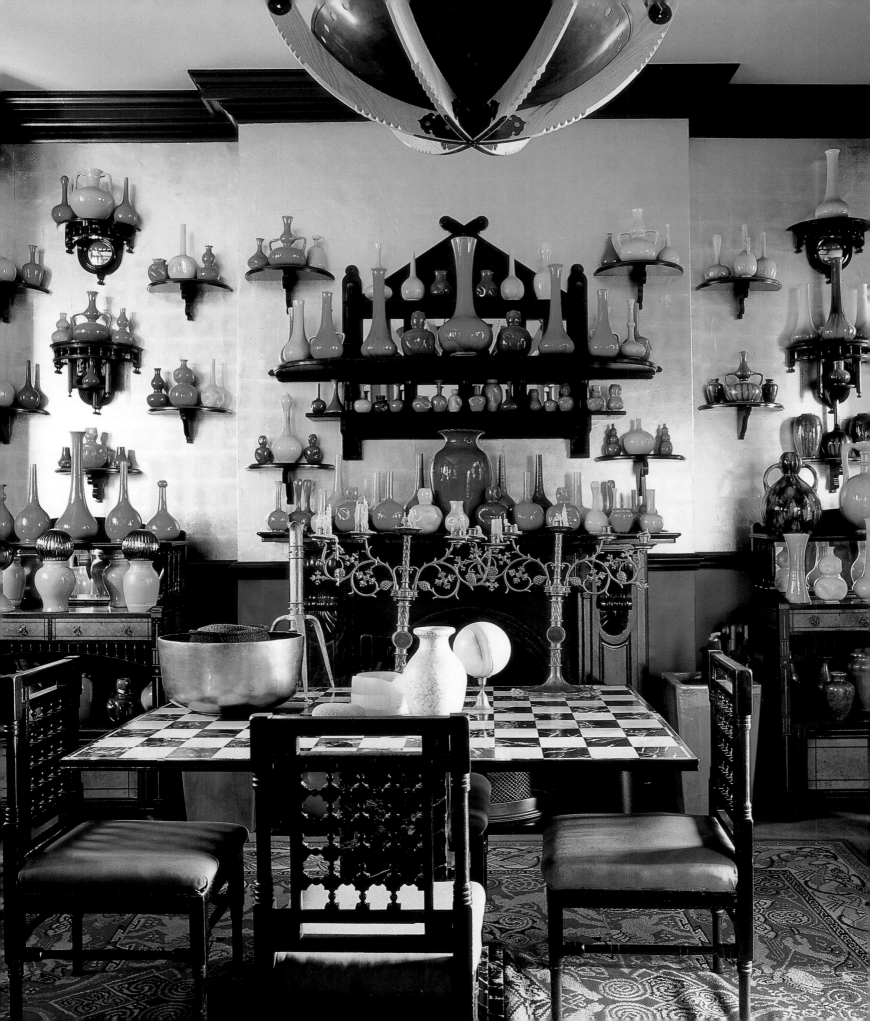

ABOVE The large panelled bathroom also serves as dressing area and common room. The Arts and Crafts armchairs, side tables and artwork help to create the atmosphere of an elegant extra living room.

Across the walls of Collett's house, then, you find not only gold but rich reds and purples; lilac on the stairway; a geometric pattern of yellow, red and green in the hall; and a dark British racing green for the tongue-and-groove walls of the basement dining room. Collett bought the large Victorian terraced house in the early 1980s. Initially structural changes were limited to creating a set of double doors between the hall and the raised ground-floor dining-sitting room, which was turned from two rooms to one, with a light division created by a pair of golden, studded pillars and a folding screen.

When the Colletts first bought their home, the basement was a separate flat, which then had to be integrated with the rest of the house. An old tongue-and-groove kitchen situated on the first floor was converted into a large bathroom, preserving the wooden panelled walls. This is bathroom as living room, large enough for Arts and Crafts armchairs as well as the claw-foot bath, and it is used as a semi-social space by the whole family. In the basement Collett designed a new kitchen with oak panelling and a marble border around the recessed kitchen range, while the adjoining dining room was anchored around a salvaged vestry cabinet that Collett found and which now stretches across one side of the room.

ABOVE LEFT The kitchen table is another Collett design. Oak panelling has been added to the walls, including a ledge at picture-rail height to display ceramics.

LEFT Out in the garden is the new studio-summer-house, which — with its high ceilings and strong sense of natural light — is sometimes also used as an exhibition space. A pewterware collection sits around the central fireplace.

Six years after moving in, Collett had the opportunity to buy a section of neighbouring land and he both enlarged the garden and designed an independent studio as a fusion of workroom, playroom and summerhouse. With high ceilings, arching beams, wooden floors and alluring fireplace, the studio — with its many Arts and Crafts flavours — is both sympathetic to the style of the main house and a modestly scaled architectural statement in itself.

It is true to say that professionally Collett is happier to work on a project if he can take charge not only of the interior design but also of the architectural dimensions of the job in hand. His practice — Collett-Zarzycki — is a combined office for architecture, interior decoration and bespoke furniture, breaking down borders between home-design disciplines. 'It's very rare that we take on a decorating project without doing the architecture,' says Collett, 'We do tend to bring a strict order, geometry and structure to bear, although we are always open to an offbeat, out-of-rhythm element. If you compare

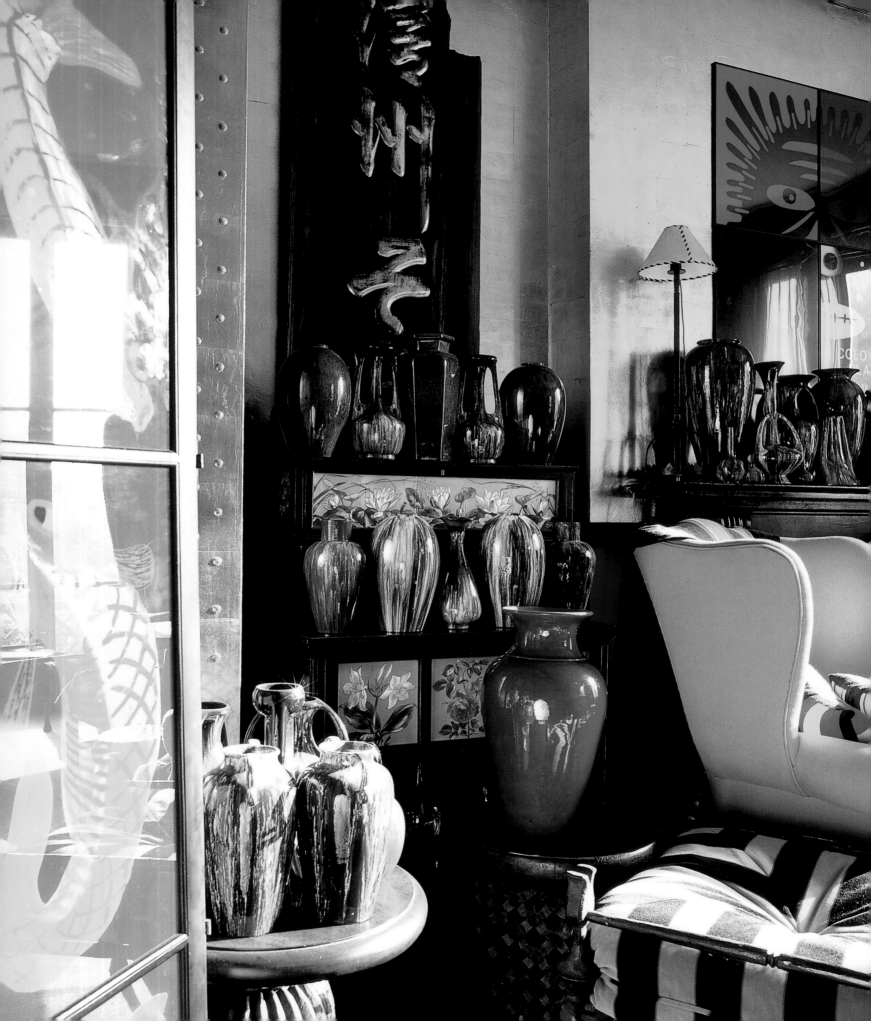

design to music, there's the main thrust of the beat but then there's the odd cello going off on its own and that's fine, but it's also acknowledged and controlled.'

That main beat is based on classical traditions, yet there is also an eclectic modernity to Collett's style. Southern Africa has been an influence, as Collett was born in Zambia (or Northern Rhodesia as it was at the time). He went to boarding school and university in South Africa and then came to Britain to study fine art and sculpture at the Hornsey College of Art when he was twenty-one. But the importance of an African upbringing left its mark.

'I suppose subliminally I was influenced by Africa and African art. I lived in a small rural town – the bush started at the end of the garden. My brother and I had male nannies so we did things these nannies would do and were taken off to see the bush, to experience it. I was born near the Congo, so there was an enormous influence in art, music, tribal theatre.'

After Hornsey College, Collett worked as a sculptor, but he gravitated towards interior and furniture design as a more commercial outlet for his creativity. There was work with an architectural practice, work as a chef and three years studying design at the Royal College of Art, where Edward Jones – one of the architects responsible for the redevelopment of the Royal Opera House in London's Covent Garden – was his tutor and mentor.

Another mentor was interior designer John Stefanidis, whose company Collett joined after leaving the Royal College, helping to establish an architectural wing to the Stefanidis decorating business. 'Working with John was a great education for me,' says Collett. 'I was with him for about seven years and he was extremely encouraging. I learnt a lot from him – he had this amazing ability to create the most sensual, luxurious of interiors from the most simple ingredients.'

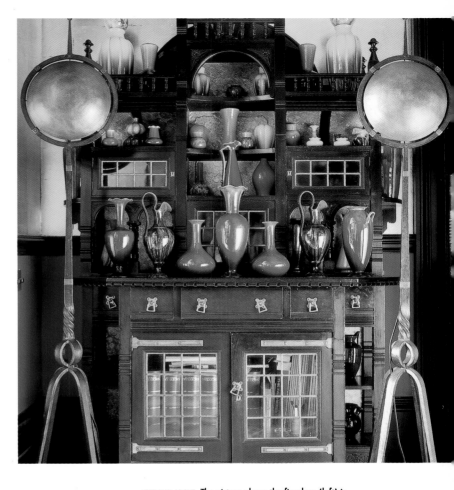

LEFT AND ABOVE The picture above the fireplace (left) in the sitting room was a wedding gift from artists Gilbert and George. Much of the furniture – the surfaces often covered by china – is by Collett, including many prototypes. The painted screen provides flexible separation between the sitting room and the adjoining dining area (above), where symmetrical arrangements help to create painterly compositions in corners and alcoves.

Just as Collett was about to leave John Stefanidis, the company won a competition for a major house project in Belgrave Square, which demanded a great deal of architectural input. Stefanidis asked Collett to manage the project, even though he was leaving, and it became Collett's first freelance commission – one that launched an independent career.

Since then he has tackled a mixture of residential and commercial projects, such as the Bath & Racquets Club in London, auction rooms for Christie's, restaurants and hotels. There has been work in Britain, Italy, Austria, Switzerland and South Africa, ranging from converted farmhouses in Tuscany (where Collett also has a second home) to a new-build lodge on an African game reserve.

'Much of what we do depends on where we are,' says Collett. 'I change my rules and my personality, the way I see things, according to where I am. I have been asked to sort out a penthouse in Richard Rogers's Montevetro building, and I will approach that in a different way from doing a farmhouse in Italy. So we are chameleonlike – we will adapt our vocabulary according to the situation. But at the same time there are words I would use about our work: classical, contemporary, traditional, eclectic. Some are contradictions, but they apply and we avoid things like pastiche and reproduction.'

Collett's business has been through a number of incarnations, including creative partnerships with designers David Champion and now Andrzej Zarzycki. Yet there has always been a constant emphasis on originality, precise detailing, good craftsmanship and fine materials, combined with a very individual approach to creativity. Much of the furniture and lighting for Collett-Zarzycki projects, for instance, is bespoke and Collett's own house features a wealth of prototype pieces and limited-edition designs.

In his dining room-drawing room a Fortuny standing light and Arts and Crafts dining chairs mix happily with a Collett dining table and ceiling light, a Collett gold and black striped sofa and a mixture of his stools and low seats. There are ethnic touches, contemporary artwork and Victorian ceramics; there are flamboyant places and quieter, calmer spaces. And yet the whole comes together with order, elegance and charm.

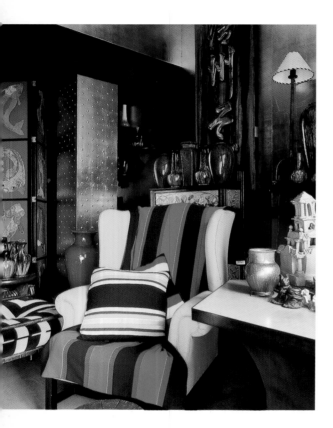

ABOVE AND RIGHT A view looking back from the sitting room to the adjoining dining area (right) reveals the theatrical boldness of pattern and colour. The golden walls and the studded pillars between the two spaces are glamorous, but also form a relatively calm back-drop, which makes it possible for other colours and patterns to come alive without confusion.

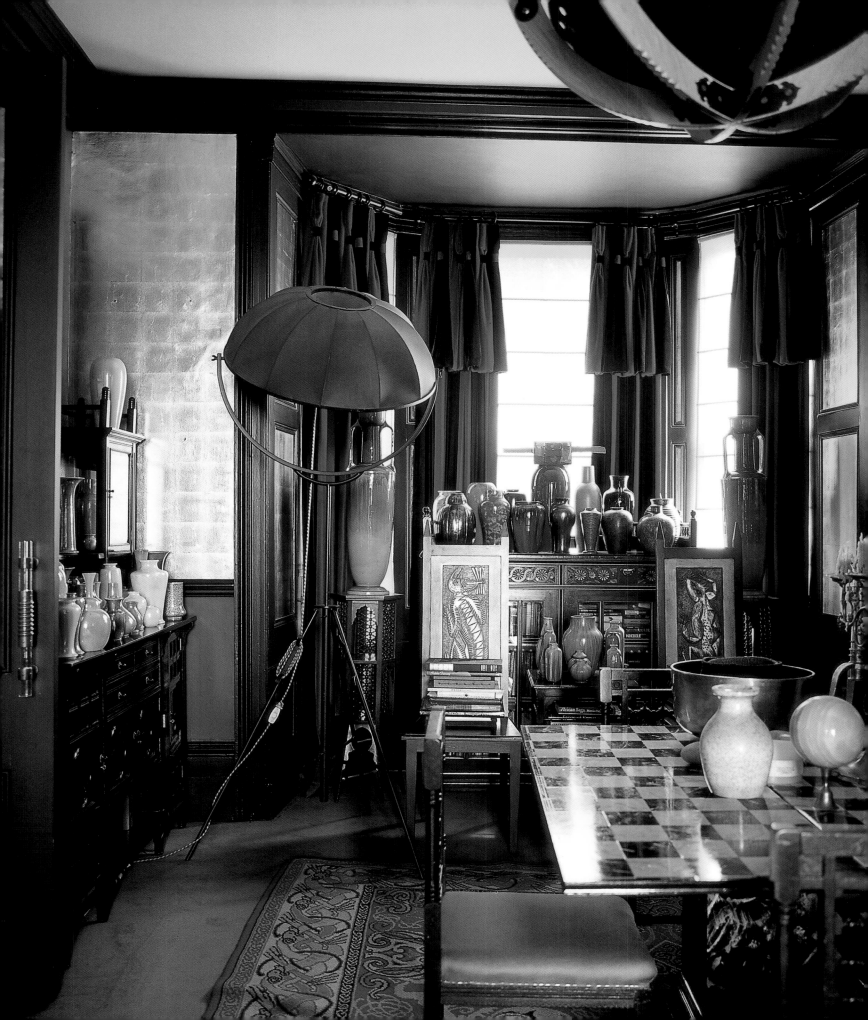

Christian de Falbe

IT WAS COLOUR THAT OPENED THE DOORS INTO A WORLD OF INTERIORS FOR CHRISTIAN DE FALBE. RICH COLOURS, CONSIDERED COLOURS, EXOTIC COLOURS THAT COULD NEVER QUITE BE DEFINED, FOR THEY BELONGED IN THE BORDERLANDS BETWEEN MORE FAMILIAR SPECTRUM SHADES. THEY WERE COLOURS THAT LOOKED LIKE SAND-STONE, AMBER, ALMOND OR VERMILION, BUT WERE ALSO LAYERED, FULL OF TEXTURE AND SUBSTANCE. THEY WOULD NEVER LOOK BRAND NEW, BUT AS IF THEY CARRIED WITH THEM THE PATINA OF DECADES.

'I do like colours that are hard to decide exactly what they are,' says de Falbe. 'Is it blue or green, pink or lilac? Colours that are on the cusp between one thing and another. And I like paint finishes to be broken up, just as I like fabrics that have a pile to them. They should be slightly light-reflective, interesting to the touch, interesting to look at. And I don't like paint finishes that look too much like paint finishes.'

This passion for colour was sparked in the early 1990s, when de Falbe began working as a specialist painter, for private clients but also for interior designers such as Christophe Gollut and Ghaban O'Keefe. This led, by an inevitable logic, into de Falbe being asked to broaden his range, taking on every element of interior design and applying to it a trademark flamboyance and sense of humour. Since then there have been projects in India and France as well as England, where high-profile clients have included Julia Ormond, and restaurant commissions have been for Momo's, Club Gascon and Riva in London.

RIGHT The authentic-looking fireplace (above) in the living room is a plaster reproduction, whipped with bicycle chains and rubbed with wire brushes, then painted with a dark shade overlaid with a lighter tone for an impression of solid stone marked by the patina of age. De Falbe's cats (below) savour a 1950s wrought-iron seat bought at an antiques market, with cushions by David Gill.

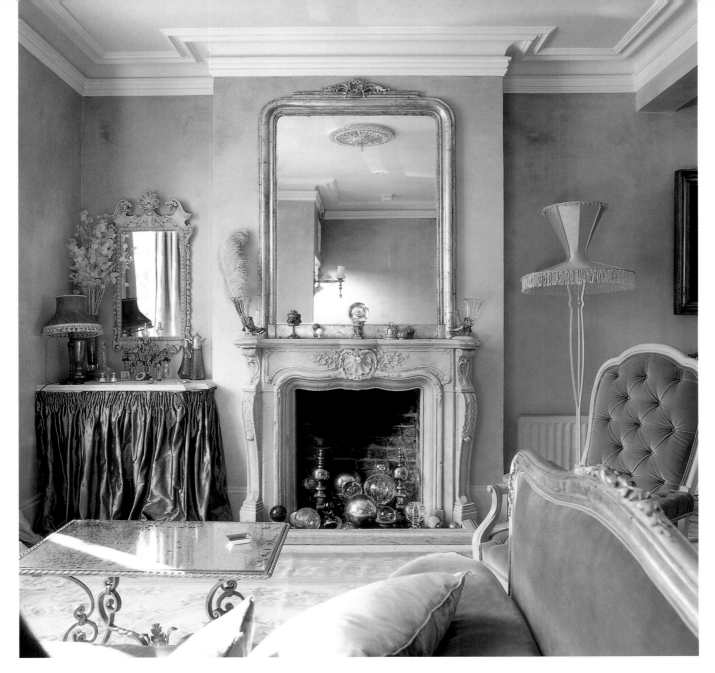

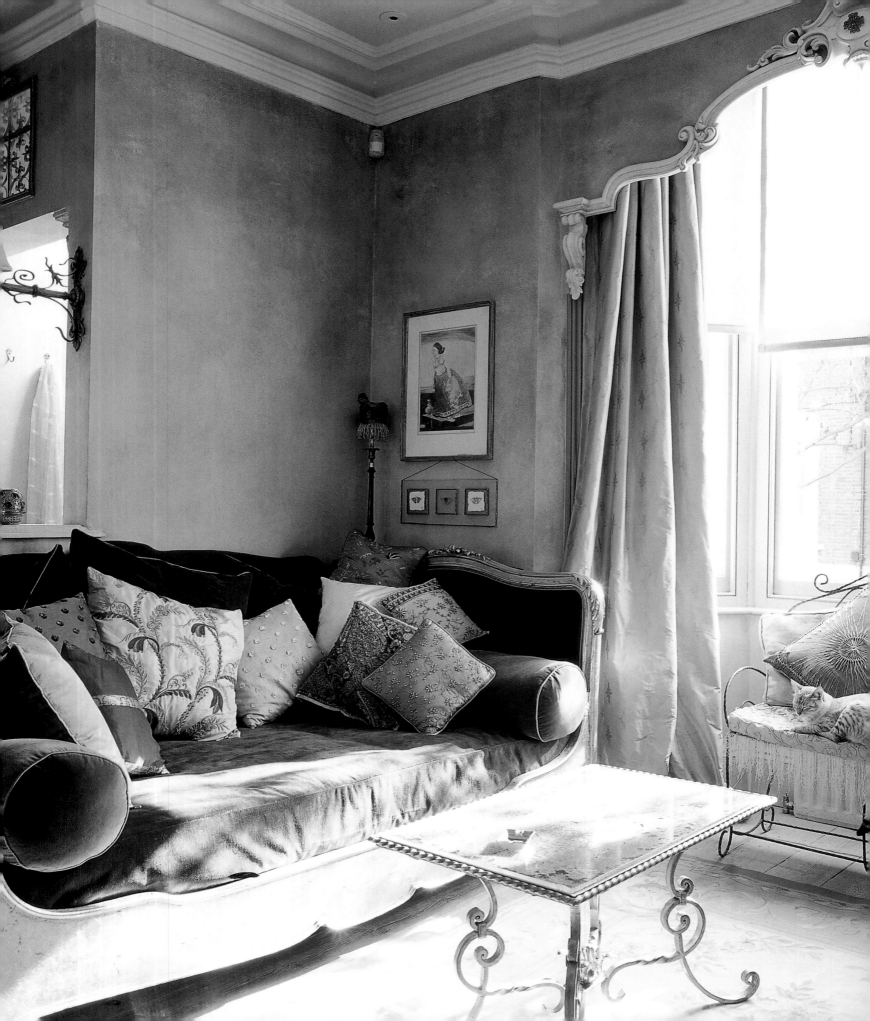

'My instinct is to make a surprise of every room I do,' says de Falbe. 'I never want to do the same thing twice, although that means reinventing the wheel every time I get a new client. But I think it's important not to assume anything – if you are asked to design a table, why assume it should have four legs? Or if I am designing a lamp, I would rather throw away all my previous lighting designs and start again. Otherwise you end up doing what everyone else is doing, and I'd like to think that every job I've done was original, that it came from me and my client.'

De Falbe's design ethos has its roots in classical and Palladian thinking, with a particular love of French *grand siècle* and eighteenth-century style. Yet he also has a great respect for contemporary Parisian designers such as Jacques Grange and Frédéric Méchiche, and a very contemporary attitude to space, light and sheer invention. His own London home, a converted Victorian terraced house, exhibits his delight in mixing eras, with neo-classical flourishes (such as the Romanesque ceiling mural in the bathroom)

that are juxtaposed with pieces of architectural salvage and various junk-shop treasures, all woven into the overall look.

'The style here has really invented itself from the beginning,' says de Falbe, who, along with his wife Jody, bought the house in 1997. 'I am a great collector of things; I like going to the flea markets of Paris and not being able to resist a bargain. If I see a nice piece of metal balustrade I will somehow find the slightest excuse to buy it. I already had quite a lot of nice French bric-a-brac, and I thought why not use it?'

In the living room, then, the blue velvet sofa was made with two foot ends from French nineteenth-century beds. The carved surround above the bay window came from a mahogany sideboard mirror that once belonged to Christian's father and now, painted over, has been incorporated into the design of the room. The section of ironwork balustrade on the stairs and the metalwork wall-to-ceiling bracket nearby, draped with handbags, were stray pieces of Parisian salvage. All are set against the background of the blue-tinged walls that have the faded opulence of a Venetian palazzo.

'My last sitting room was a marmalade red and I wanted to do something different here, something that I had never done before. These walls were painted an ultramarine blue, and then I put layers of opaque glaze on top of it to knock back the blue and take it to this chalky white in places. Downstairs we opened up the space, but architecturally we tried to avoid that long train-carriage look – which you often get when a house like this is altered – by building a library area, with a screen wall to divide it off partly and alter the proportions.'

There is a look of grandeur to the salon, much of the effect achieved by bespoke ingenuity. The console table plus radiator cover by the stairway, for instance, was made with a mounted fireguard, bought at an auction, bordered by an antique silver braid and then hung with organza and beads. The bases of the two console tables by the entranceway to the library are further inventions, using marble tops and old fireguard chainmail bunched below. Pieces of furniture such as the pea-green velvet sofa or the lilac armchair were bought in a sorry state and then reupholstered and repainted.

ABOVE AND RIGHT Salvaged pieces from reclamation yards and auctioneers are put to new uses. The bleached pine floorboards were laid on chipboard so that they could be placed lengthways, rather than widthways across the floor beams, helping to create an illusion of space.

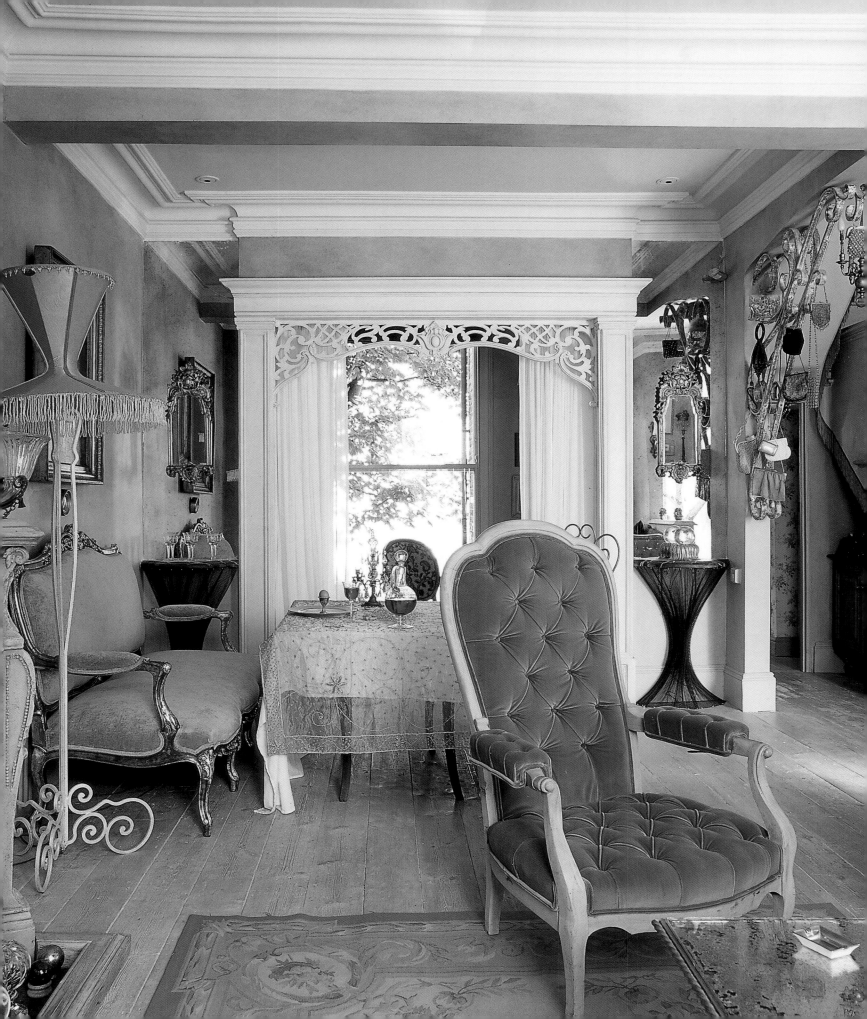

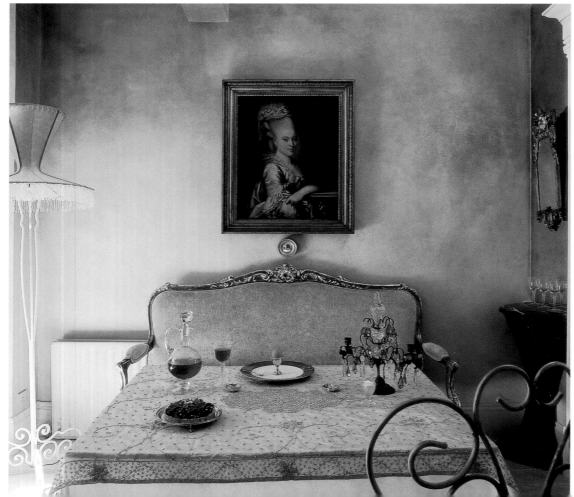

'The temptation to paint something when it becomes mine is extremely strong,' says de Falbe. 'It's always been like that, even when I got a new bicycle as a child. I'd have this brand-new yellow bicycle and it would be blue in two minutes. I like to stamp things with my own identity.'

Family portraits reinforce the personal character of the house and include one of a Danish ancestor – an eccentric-looking lady to the right of the fireplace. De Falbe himself is an Anglo-Danish fusion; his grandfather was the Danish ambassador in London, his father of Danish blood. He grew up in London and Hertfordshire and went to Oxford to study languages, looking as though he might well embark on the most traditional of career paths. Yet he became interested in fashion and went into the knitwear business in the early 1980s, building a company that produced handknits, contemporary knitting patterns and published a Christian de Falbe knitting magazine.

When he sold the business some years on, he bought an old chapel in London's Battersea and as he worked on renovating and replanning the house he became intrigued by the possibilities of paint effects and interior design. The chapel – much photographed and praised at the time – was the first expression of de Falbe's ideas for the home, each room with its own theme and thoughts.

The same is, of course, true of the new house, where the kitchen is in marked contrast to the main salon next door. Here the story is a take on a classic English scullery kitchen, with Colefax and Fowler wallpaper and a limestone floor. But again everything is not quite as natural as it might seem on first impressions. The sink is a French flea-market piece with old brass market taps and a white marble splashback, plus an old brass coatrail as drying rack, while the glassware cabinet above is an old library display cupboard turned upside down and painted a shade of cream. To the right, a nineteenth-century baroque shrine was pasted together with an old office utility chest of drawers to form a kitchen cupboard.

Upstairs an old etched-glass door from a French hairdresser's salon now opens into the bathroom – painted with elements of turquoise, crimson and ultramarine blue – with the walls of the entrance reconfigured around this

FAR LEFT AND BELOW LEFT A small semi-separate library snug (far left) was designed at the end of the living room, partly to counter the feeling of one large prairie space downstairs yet without obstructing valuable window light for the dining area (below).

ABOVE LEFT In the guest bedroom translucent curtains allow sunlight to spill over the peachy walls, with the space dominated by a nineteenth-century French double bed.

one piece of architectural salvage. A limestone countertop with mirrored splashbacks forms sink unit and dressing table in one, while shimmering curtains below the counter hide utility machines in decorous fashion. In the main bedroom a sandy pebble colour covers the walls, with hard pieces of ironwork for headboard and radiator grills balanced by softer, feminine touches such as the woolly 1940s stool by the dressing table and luxurious pink velvet curtains.

Here, as in so much of de Falbe's work, the elements are so disparate, so individual, yet the room itself – and the house as a whole – comes together seamlessly. For a Victorian house the look may be incongruous, but for a home it seems natural, with the distressed finishes and imperfect, textured surfaces, the patina to mirrors or marble, making it feel as though it has been this way for a long time. And everything is done with de Falbe's tongue faithfully in his cheek. 'A sense of humour is a vital part of it,' he says. 'I don't mind anachronisms and mixing old and new, because I don't think houses look comfortable if they are set pieces where all the rules are followed. There have to be new ideas and you need to throw the rules away.'

LEFT The kitchen is a tongue-in-cheek version of a classic English country-house scullery.

RIGHT An etched-glass door marks the border between landing and bathroom, which, with its Romanesque ceiling mural and lounge chairs, combines utility and indulgence.

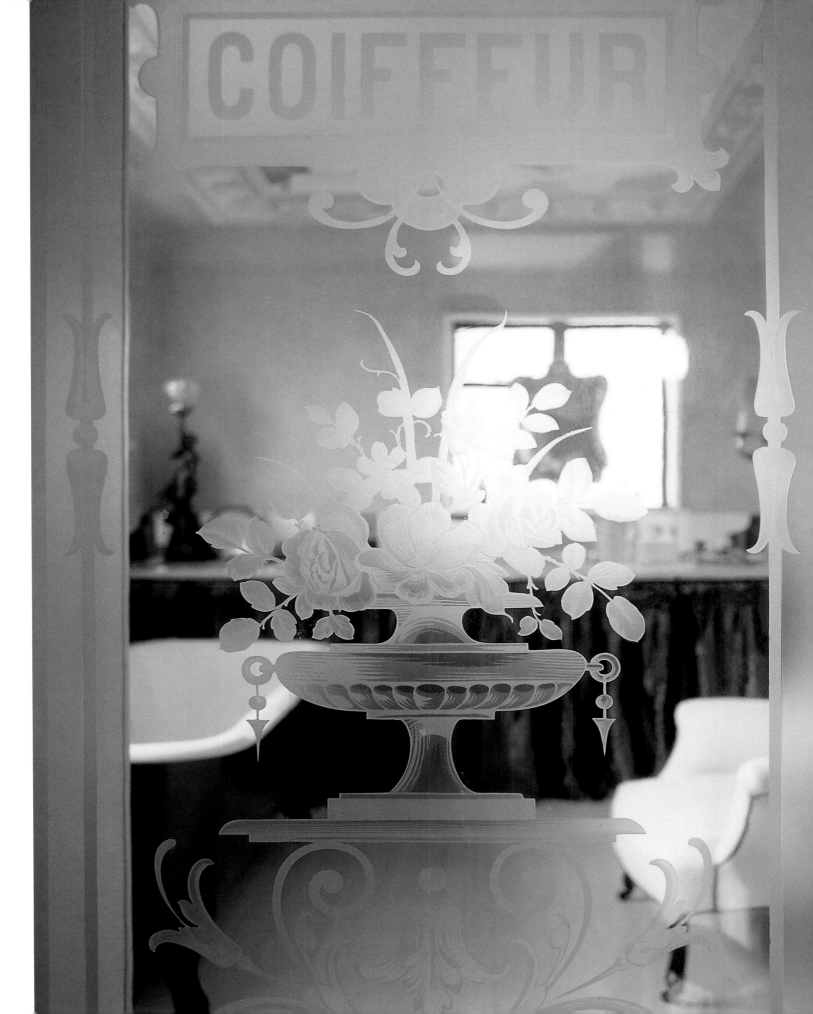

Ashley and Allegra Hicks

TO ONE SIDE OF THE LIVING ROOM OF ASHLEY AND ALLEGRA HICKS IS A MYSTERIOUS GREEN-GREY CABINET, LOOKING RATHER LIKE AN ELEGANT SMALL BUREAU OF UNCERTAIN AGE. BUT OPEN UP ITS FOLDED TOP AND INSIDE YOU WILL FIND A RACK OF MINIATURE PLASTER FRIEZES, MOUNTED IN RANKS TO BE TURNED LIKE THE PAGES OF A BOOK. THESE ARE REPRODUCTIONS OF THE CARVED MARBLE PANELS THAT ADORN THE PARTHENON, ATHENIAN TREASURES IN AN EASY, BITE-SIZED FORMAT, STILL BEAUTIFUL DESPITE THE OCCASIONAL CRACK AND CHIP.

They are the result of a visit to a junk shop, where Ashley Hicks found the mounted pieces of plaster on the floor, neglected in a corner. He took home his strange salvage, restored the framing and created a cabinet around the plaster pages, with drawers underneath and legs to support them. Something classical, something old and neglected, had been brought up to date and given a contemporary setting, a new relevance.

The same applies to the style of the couple's design: they take classical principles of symmetry, proportion and scale and apply them to a contemporary way of living, emphasizing comfort and warmth, and adding modern pieces of furniture and art, as well as fabrics and patterns inspired by trips to India and North Africa. It is a tailored and precise approach – with an emphasis on crafted detailing – but the results have a real humanity and flexibility about them.

'What we do is very much inspired by classical architecture and decorating,' says Ashley, 'and it's certainly not triggered by contemporary

RIGHT The miniature Parthenon friezes live in the cabinet between the windows in the sitting room. The leather chair is an Egyptian-inspired design, 'Klismos', by Ashley Hicks. On the table is a glass box containing Roman perfume bottles. The cotton dhurrie, 'Spheres', is Allegra's design, laid on black, painted floorboards.

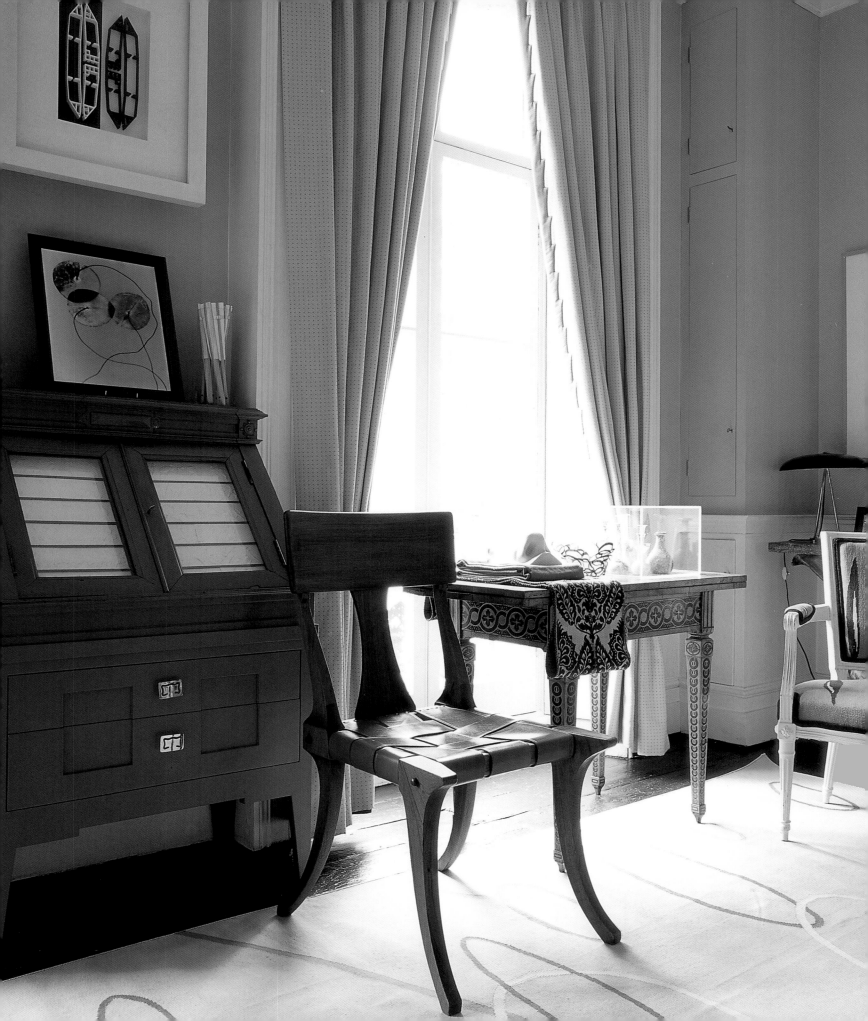

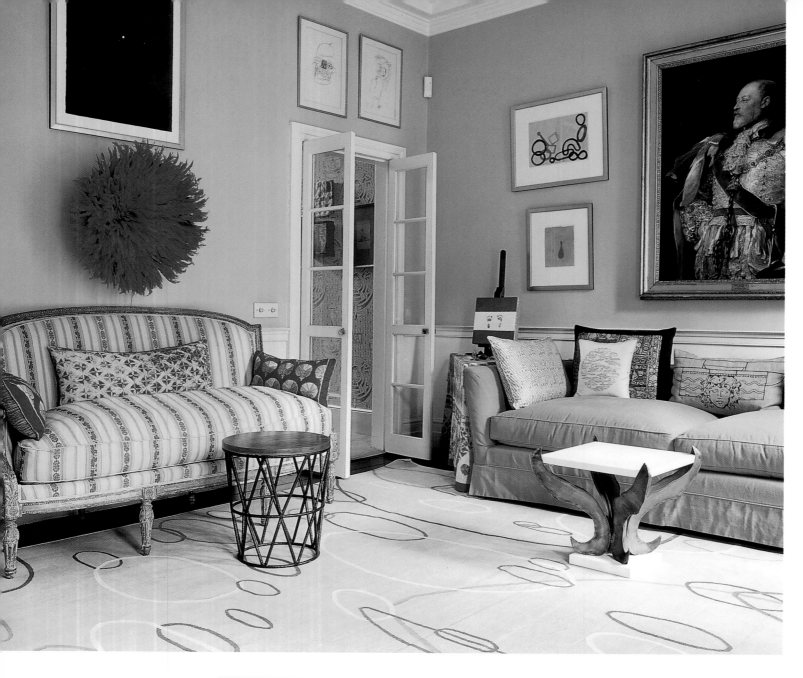

ABOVE LEFT The blazing-red hat from Cameroon — above which hangs a picture by Anish Kapoor — shines out against the sandstone walls. The sofa below is an eighteenth-century French piece, given to Ashley by his parents. The couple designed the two small coffee tables.

BELOW LEFT In a corner of the sitting room a photograph of Ashley's grandmother, Countess Mountbatten, by Cecil Beaton, sits on a copper-based console table painted by Allegra to give a granite effect.

fashion or magazines, or any of the things that inspire people who are doing velvet with gilt tassels one year and white boxes five years down the line. We do have a strong style, things that we love, and in a way our main inspiration is the continuity of style over time, because designers work very much in reaction to what they find around them, what they grew up with. But focusing on one particular historical period is dead and boring; our work is more eclectic, we absorb many different influences.'

Take the sitting room, which was redesigned with an almost obsessive eye for symmetry when Ashley and Allegra Hicks bought their 1850s London townhouse in 1992. Ashley reconfigured what had been an L-shaped room into a properly proportioned main living room, plus a small, separate library, using sections of false wall, introducing new glass doors and designing new cornicing. He applied a strict set of classical dimensions to the room, but then the couple introduced Allegra's fabrics and one of her carpets – which is very contemporary in mood – while furniture designs by the two of them mix with eighteenth-century pieces and a fiery-red feather hat from Cameroon on one sandy wall for a bolt of colour.

Allegra Tondato was born in Turin, her father a businessman with a passion for music and design. She grew up in a modernist environment, a family house built in 1967, inspired by the architecture of Frank Lloyd Wright, and boasting an impressive collection of twentieth-century designer furniture. She studied design in Milan, later learnt the craft of trompe l'oeil in Belgium and then worked as an artist's assistant for Donald Baechler in New York. She turned to fresco painting, followed by furniture and fabric design.

Ashley's childhood was also extraordinary; he, too, was immersed in a world of design. His mother is Lady Pamela Hicks, daughter of Earl Mountbatten, while his father was the late David Hicks, the most influential and innovative interior designer of his generation. Through his books and his work David Hicks encouraged many others, especially those who worked under him such as the celebrated American designer Mark Hampton, who died in 1998, and contemporary designers Stephen Ryan and Charles Bateson. He could not help but guide the direction of his son's interests.

ABOVE AND RIGHT In the dining room (right) Allegra painted the walls with a trompe l'oeil of flowing curtains, inspired by a Turkish fabric in London's Victoria and Albert Museum, with hints of a view beyond. The Jantar Mantar trellis étagère (above), designed by Ashley, comes apart to form three small stacking tables.

'We used to hear every detail of my father's work,' Ashley says. 'He would come home and want to regale everyone with tales of how ghastly some new client was or how clever he had been, the sort of things he had done. And he did encourage me like mad, giving me drawing lessons in his spare time and things like that.'

Along with his two sisters, Ashley grew up at the family home in Oxfordshire – Britwell Salome – constantly surrounded by designers, journalists and photographers. It was one of the most photographed houses in the world, continually being reinvented and remodelled.

While Ashley was a child there was an assumption that he would follow his father into the business, take on the mantle, but there was no practical insistence on a holiday apprenticeship working in the Hicks design studio. Only when Ashley had become a difficult teenager did the subject arise, by which time it was too late. He wanted to go his own way.

So, after schooldays at Stowe, Ashley went off to art school for four years, then on to the Architectural Association to qualify as an architect. He launched a small architectural practice, working on residential projects, but soon found himself becoming more and more involved in interiors. By the time he and Allegra married in 1990, interiors were winning ground. Architecture was put to one side and the two began working together as a partnership.

'Ashley has a wonderful understanding of space, so normally he will do most of the three-dimensional planning, the proportions, on his own,' says Allegra. 'And then we work together on the colours, patterns, furniture and so on. By now we do have pretty much the same taste, the same outlook. My parents may have been purists about modern design but I'm much more interested in embracing different things – an eighteenth-century sofa next to a contemporary piece of furniture.'

David Hicks became internationally famous for reinventing the English country-house look with a bold approach to colour, introducing contemporary elements, fabrics, patterns and modern art into the mix. Yet Ashley and Allegra's approach is more subtle, more reserved in some ways. 'My father was a genius – everything he did was extraordinary,' says Ashley.

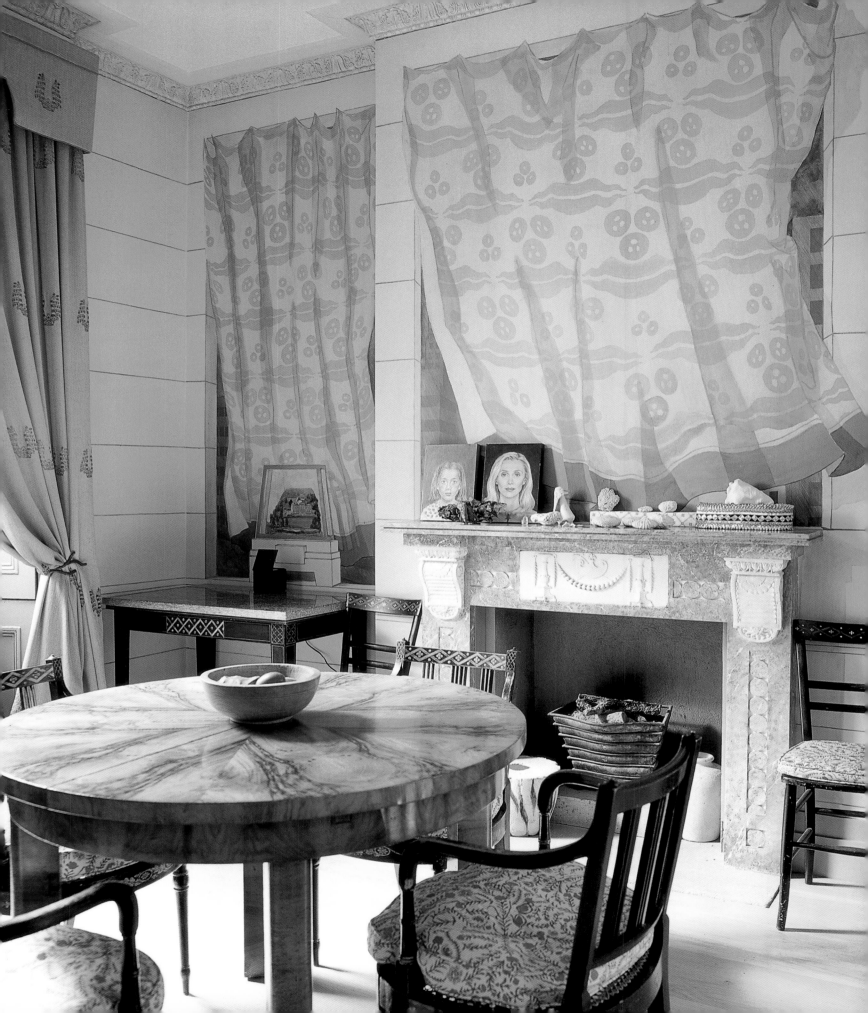

'But we start from different aims. With my father the aim of every single interior was to amaze, to make a statement. We work for people who have to accommodate family life, who need somewhere that is very livable, very comfortable and relaxing. I think it's more important to have that than make an impressive, astounding image that will stick in people's minds.'

In Allegra and Ashley's home, then, colours tend to be calming and restrained. The sitting room and library are painted the same warm, sandy tone with upholstery and curtains introducing subtle contrasts of shade and texture. The main bedroom is painted a soft pink, complemented by the reds of the curtains and fabric canopy over the bed to bring a comfortable cohesion to the room. The stairway is distinguished by a lightly realised wallpaper specially designed for the house by husband and wife, marrying alchemical motifs with their own initials. The dining room introduces a more theatrical note, its walls painted by Allegra with a sequence of trompe l'oeil billowing curtains.

Examples of Ashley's and Allegra's own designs abound in almost every room throughout their home. Since 1997 Ashley's furniture has been sold under the name of Jantar Mantar. Allegra's fabric collections and rug designs

ABOVE AND RIGHT The hall and stairway feature a wallpaper designed by husband and wife (right), incorporating their own initials and alchemical symbols. The ceiling light (above) is by André Dubrueil.

ABOVE In the bedroom
– a calm, warm and
feminine space – the
canopy, bedspread and
curtains are in a
matching fabric inspired
by a Fortuny pattern
and printed especially
for the room. The
picture on the left is
by New York
photographers the
Douglas brothers.

have been on the market since the mid-1990s, mixing many of the same organic, ethnic and more traditional references.

Additionally there is the interior-design work – all of it residential – which takes them not just around Britain, but to Italy and other parts of Europe. Travel is a formative influence on them both, suggesting ideas for furniture, fabrics and colours but not dictating a purely ethnic style.

'Travelling is part of working, in a way,' they say. 'We decorated our cottage in the country entirely in a strange, dirty green and a funny faded pink and it didn't occur to us where these choices had come from. They are soothing, earthy colours. Then we went back to Jaipur, where we had been on our honeymoon, and there it was: they are the two colours of the entire city. Like most of our work, it's not something that shouts at you. It's not overdecorated. You can move into it, live with it. And it changes all the time.'

Jacques Garcia

THERE IS SOMETHING OF A FAIRYTALE QUALITY TO THE LIFE AND TIMES OF JACQUES GARCIA. TAKE THE STORY OF CHAMP DE BATAILLE, THE NORMANDY CHÂTEAU THAT WAS ONCE HOME TO THE COMTE DE CRÉQUI AND THE DUCS D'HARCOURT. ONCE UPON A TIME, AS A CHILD, GARCIA VISITED THE HOUSE WITH HIS FATHER, WHO HAD A PASSION FOR INTRODUCING ARCHITECTURE AND THE DECORATIVE ARTS TO HIS SON. FAMOUSLY, THE YOUNG GARCIA TURNED FROM THIS HOMAGE TO GRAND SIÈCLE STYLE, FACED HIS FATHER AND TOLD HIM THAT ONE DAY HE WOULD OWN THE PLACE. NOW HE DOES. IT IS HIS CROWNING GLORY, A 'LABORATORY OF IDEAS', PAINSTAKINGLY RESTORED AND REINVENTED EVER SINCE GARCIA BOUGHT THE CHÂTEAU BACK IN 1992.

'I wanted to buy it because I knew it was a very rich building, in terms of decoration and design,' says Garcia, 'and also I knew the furniture I wanted to put in would fit very well. But it had been a hospital for forty-five years, with room after room painted in white. Only three rooms were still much as they should have been so I had the paint removed to find the original decoration. When those rooms were back to their original state I designed the others in a similar way and that gave the house a sense of oneness.'

Partly open to the public and partly private, Champ de Bataille is quite extraordinary. But it is no exact, slavish recreation of seventeenth-century manners and aesthetics. It is more than that, bearing the stamp of Garcia's imagination and a relevance to today. It is not a museum with antiques and art pristinely placed and out on display, but a living home that is constantly changing, continually evolving. Garcia's private quarters, especially, have a

RIGHT The marble salon on the first floor of Champ de Bataille, with a replica floor in period marble modelled on a room at the Château de Clagny. The porphyry and white marble bust on the mantelpiece is of the emperor Nero.

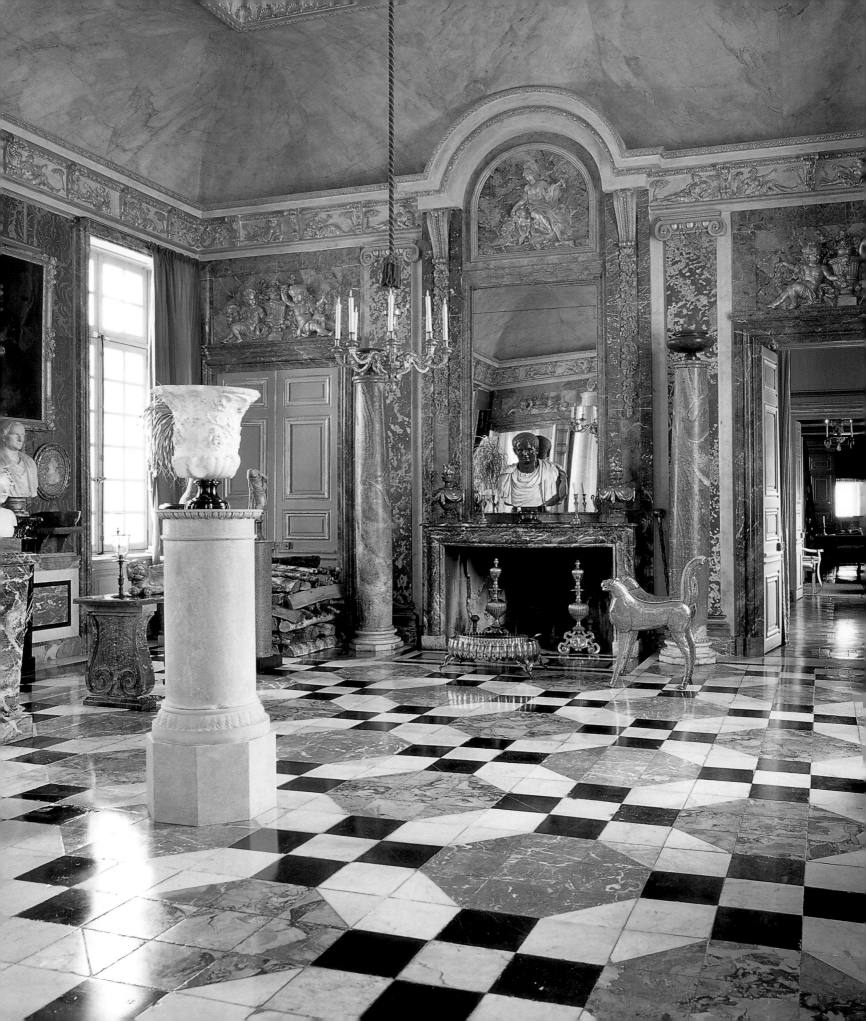

modernity to them, with contemporary art and furniture added to the more classical choices. Behind a door down one quiet corridor on the ground floor there is a beautiful *hammam*; behind another is an exquisite swimming pool.

'You need to add a touch of the twentieth century, a new vision,' says Garcia. 'For instance, I'm now working on a garden at Champ de Bataille that is a modern vision of a seventeenth-century garden. It's not an exact replica of how it used to be. It's my imagination at work – designing on a historical basis, indeed, but I am developing something that can only be modern. We can never leave our own century behind.'

This glamorous combination of French classicism and a contemporary outlook characterizes the majority of Garcia's work and has taken him to the top of his profession. He is much in demand. There have been hotels, headed by the prestigious Hôtel Costes in Paris (opened in 1995 by restaurateur, hotelier and entrepreneur Jean-Louis Costes) with its dramatic Italianate courtyard and opulent bedrooms with their individual reinterpretation of

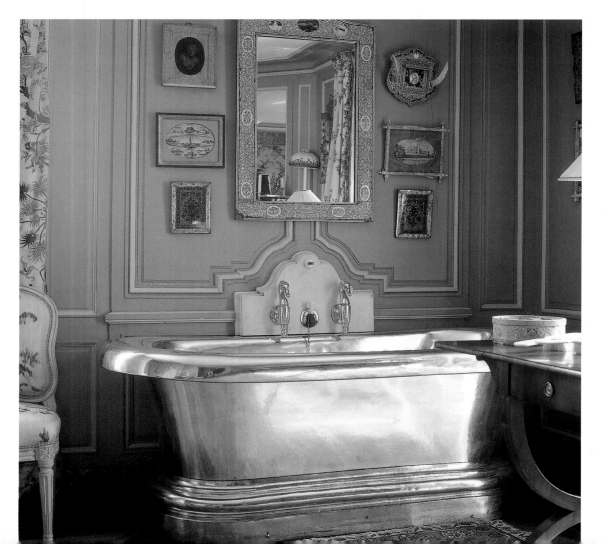

LEFT In the main bathroom, the silver-plated copper bath is by Ledoux. The mirror above the bath, hanging against the painted wooden-panelled walls, is from Agra.

RIGHT The stairway, lined by lanterns, leads up to the main formal rooms of the château, including the main dining room and the marble salon.

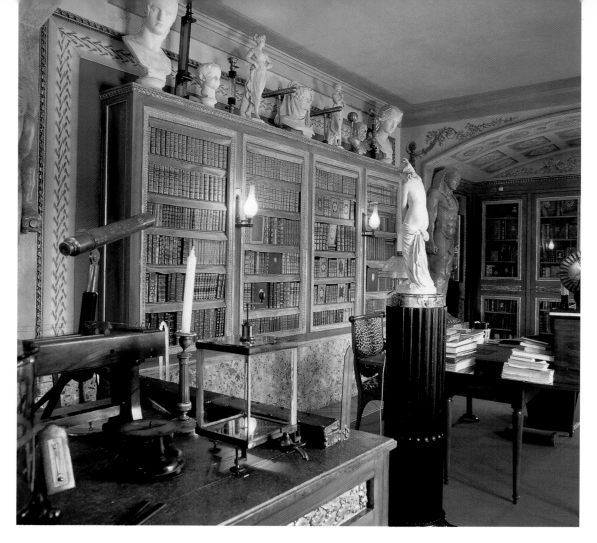

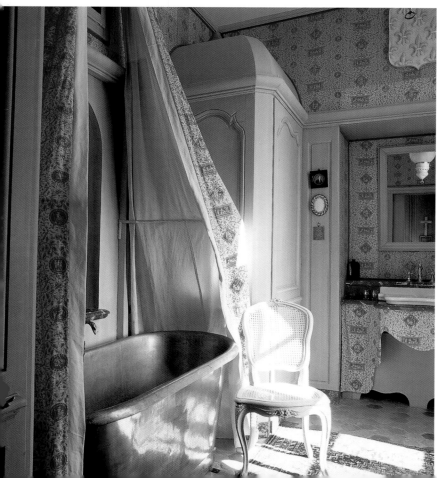

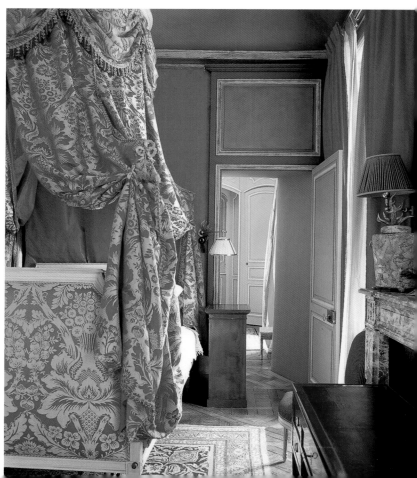

ABOVE LEFT In Garcia's study vast Egyptian figures appear to hold up the ceiling. The shelves are framed with mahogany.

BELOW LEFT The en-suite bathroom for the 'Mailloc' guest bedroom on the ground floor (far left) has a pair of wooden pavilions concealing toilet and showers. In one of the upstairs bedrooms (bottom left) parquet floors, painted wooden walls and marble fireplaces are softened by deep-coloured fabrics.

Second Empire style. There are twenty or so restaurants to Garcia's credit, including L'Avenue, Le Fouquet, Ladurèe and La Grande Armèe in Paris plus Le Danube in New York. And public projects, too, such as the Paris Musée de la Vie Romantique. But residential work still accounts for half of his time, including high-profile commissions such as a Parisian home on the Place Vendôme for the Sultan of Brunei. He has made his fortune designing for the elite, not just in France but in America, Germany, Russia and Beirut as well.

Yet Garcia's upbringing was modest. His parents were shopkeepers in the Parisian suburbs, with Spanish roots on his father's side. His father was a practical man, but also creative, cultured. He encouraged his son's growing talent for drawing and an interest in the arts. They would note together the achievements of the great architects and tour museums. Garcia would often help his father clean out the attics of neighbours and friends, an opportunity to spot and trade antiques, and he developed a detailed knowledge of period furniture and objects. By the age of fifteen he was an active antiquary.

From early on Garcia knew he wanted to be an interior designer, and after school, where he supplemented his lessons by poring over books on antiques and architecture, he studied at the Met de Penninghen and then the École des Métiers d'Art. Even as he studied he was working successfully as an antiques dealer and buying modern art cheaply by conceptualists such as Yves Klein, Lucio Fontana and Josef Albers, selling them on as prices rose in order to buy seventeenth- and eighteenth-century decorative art. At the same time he was earning acceptance into a new social world, which would in turn provide him with employment, pleasure and a soaring reputation.

His design career began with shops in the early 1970s, followed by hotels and then private homes. All the time he was developing an individual style: an emphasis on a solid, structural foundation to a home, to a space, then layers of fantasy, indulgence and comfort using elements of neoclassicism and orientalism, references from the *grand siècle*, the Second Empire and the Belle Époque, but with an insistence on fine craftsmanship. Towering in the background was the example of the grand architect of Versailles, the Superintendent of Royal Buildings, Jules Hardouin-Mansart. The two men

have often been compared, not least because Garcia made a home of Mansart's self-designed Paris mansion on the Rue de Tournelles, overseeing its rebirth. 'I do identify with Mansart, simply because for many years I lived in the house that he had built specially for himself in the Marais,' says Garcia. 'Then I was instantly accused of being a man of just the seventeenth century. They said, "He is the man from the *grand siècle* and the rest is nothing." But when I did the Hôtel Costes I was "the specialist on Napoleon III" and so on. I am not a specialist. I have a sense that leads me to think and reflect on the philosophy of a specific time, but that is something very different.

'Even if for my own pleasure I have been attracted by houses from the seventeenth and eighteenth centuries, it was because my collecting drew me to them: it is easier to have a seventeenth-century home for seventeenth-century art. But, as at Blenheim or Chatsworth, each generation adds a new layer, without damaging what has been done before.'

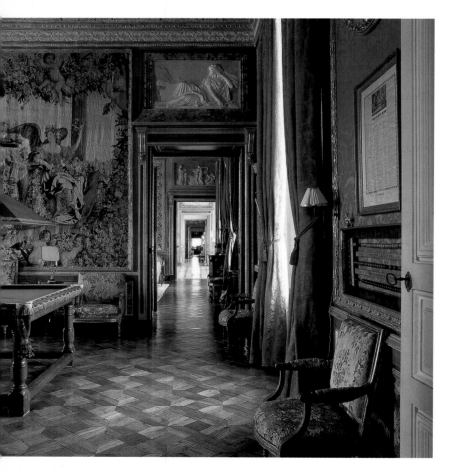

Certainly that is the feeling at Champ de Bataille. Even though the house may feel as though it has been untouched for years, in reality Garcia has truly made his mark. The closer you look the more you see and, despite the impression of cohesion, there is a mélange to the elements of many rooms, especially those less formal spaces that remain off limits to the public.

LEFT AND RIGHT The billiard room (left) and the Grand Salon (right), designed in Louis XVI style. Louis's brother and wife stare down from the portrait by Antoine Mathieu, while pieces by master craftsmen Boulard, Delanois and Sené grace the furniture collection.

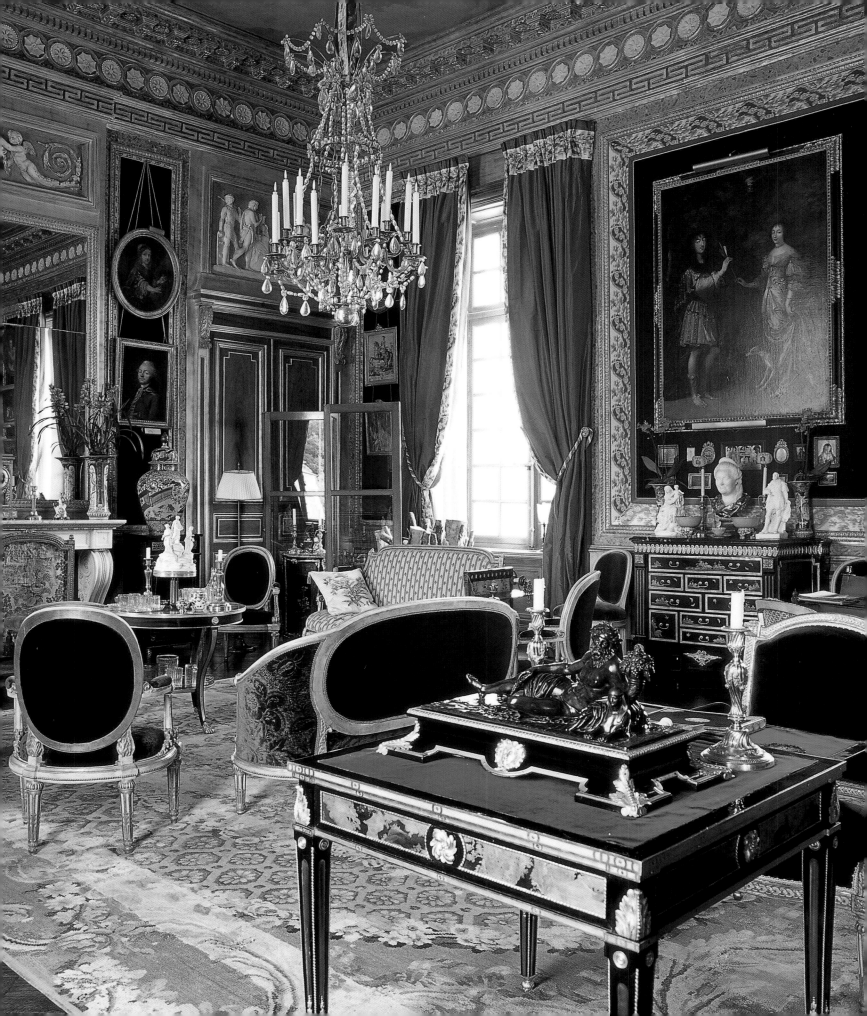

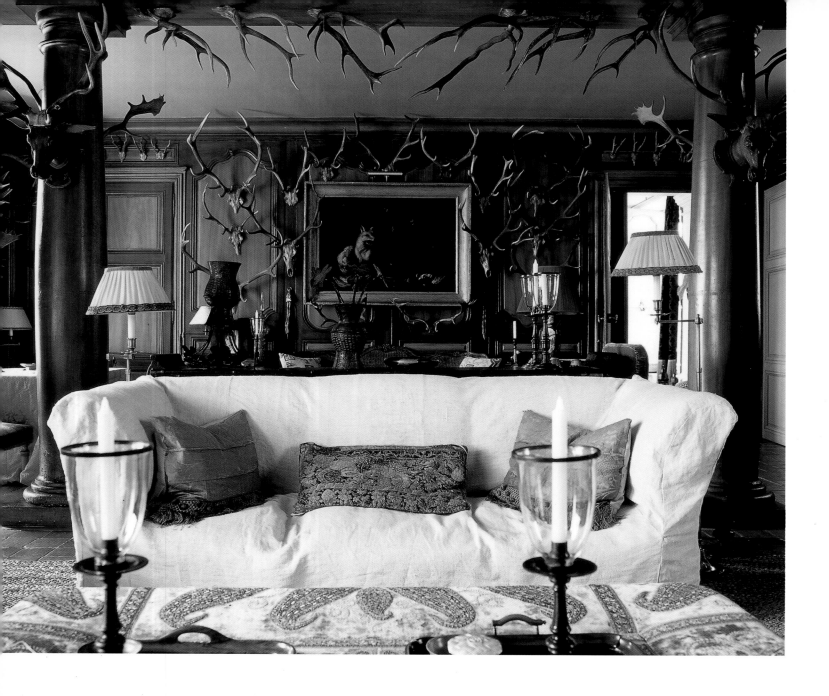

In Garcia's wood-panelled sitting room, for instance, sofa and armchairs are simply covered in calico to contrast with the more luxurious velvets of a chaise-longue and other upholstered pieces. A natural coarse-weave matting covers a terracotta blocked floor, while ranks of antlers and other hunting trophies give a country-lodge atmosphere to the room. Occasionally more contemporary pieces of artwork and furniture seep in; Garcia's interest in design and art spans the twentieth century and beyond.

A dining room next door is a hymn to the naturalist's art, with a framed collection of herbs and fauna on the walls and a striking aviary motif, with

LEFT AND RIGHT On the ground floor is a set of intimate rooms such as the informal sitting room (left) and the dining room (right) , where the design is modelled around the collection of birds and framed fauna and herbs.

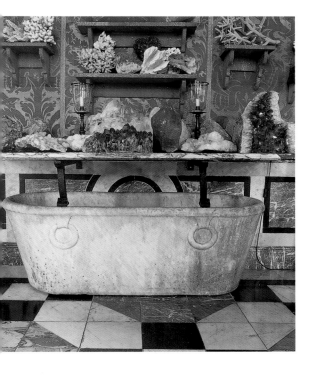

ABOVE A detail of the marble salon, with a stone bath supporting a marble counter laden with a collection of crystals and geological trophies. A collection of corals is ranged on sconces against the ornate flock wallpaper.

birds staring down from the chandelier and iron perches, sporting on the mantelpiece, while frozen peacocks strut across the tiled stone floor. Here is evidence of Garcia as collector as well as storyteller, and the château is a haven for assemblies of fossils and crystals, butterflies and beetles, as well as countless pieces of furniture and tapestry amassed over decades. Look in Garcia's study and you see ancient telescopes and scientific instruments, Victorian greetings cards and skulls cut by the blades of ancient anatomists.

Upstairs are the more formal set pieces, both intricately conceived and epic in scale. There is the large formal dining room, overlooking the parterre

ABOVE AND RIGHT In the
formal dining room
upstairs – overlooking
the parterre and gardens
beyond – the open
windows, the walls,
mouldings and cornices
have been painted with
a marble effect.

and gardens below, with its circle of twelve dining chairs that once lived in the homes of Louis XV. There is the great marble salon next door, overseen by a portrait of Mansart who gazes down from between the windows. Again every corner, every object has its own exotic history: an eighteenth-century throne that belonged to the maharaja of Jaipur here, a porphyry table upon a pedestal commissioned by Napoleon over there.

Champ de Bataille is a life's work and it will never stand still. And it resonates with the zest of Garcia's sense of invention. 'What I have best achieved is at Champ de Bataille,' he says. 'It is a reflection of what I consider this period to have been all about, what I think grand French taste is really all about. And I have always fought against fashion; if you simply look at what your contemporaries are doing, just copying what they do, you don't really go anywhere. I prefer to discover the past. It's in the past that you discover the future.'

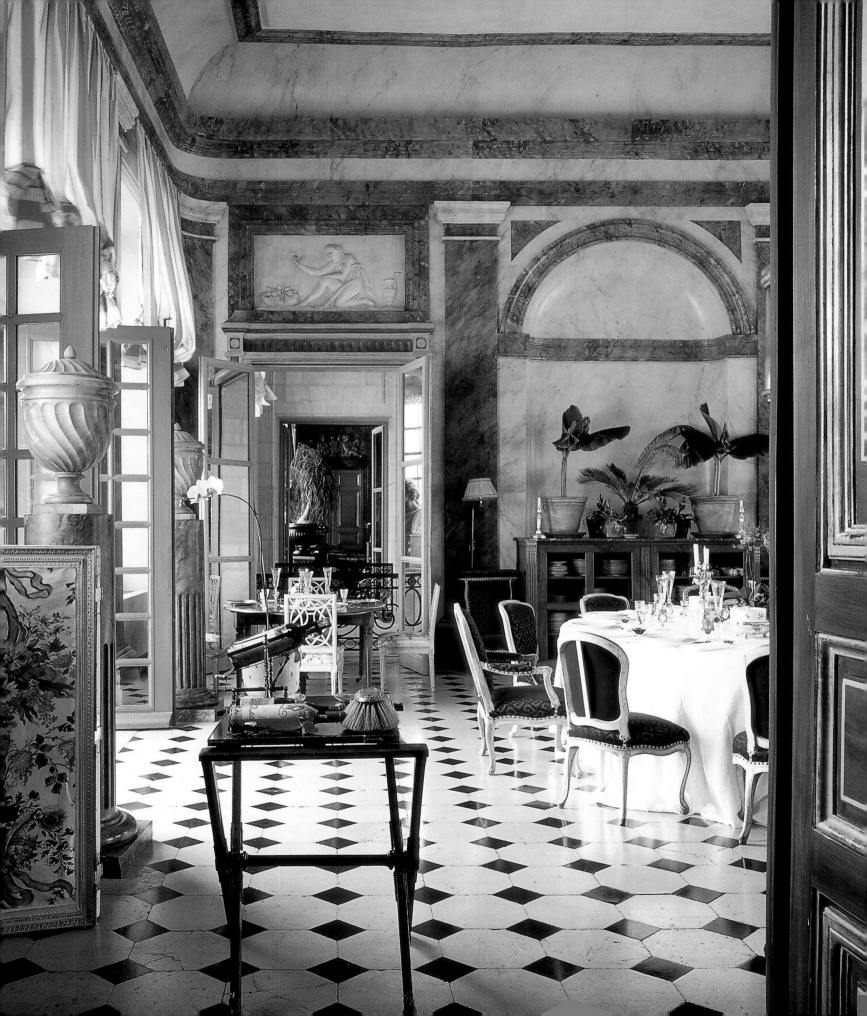

NEW CLASSIC

ABOVE AND RIGHT Where Colette once sat in her favourite place by the window overlooking the gardens below, there now rests Grange's own Napoleon III chaise-longue, covered in mohair velvet. Something of Colette's spirit lingers on, though, her image captured in a small bust by Fenosa.

ABOVE A photograph of Colette by Irving Penn in a red velvet frame is displayed alongside images by Picasso and Cecil Beaton.

RIGHT Through the windows, a glimpse of the Palais-Royal, the sandstone colour echoed by the walls of the apartment. On the chair, by Emilio Terry, is a photograph of Picasso by Jean Vidal Ventosa.

dining-room ceiling. A fireplace was changed, but the original was carefully preserved just in case it might be needed again one day. Canvas painted in a sandstone colour was placed on the walls, tying the various rooms of the apartment together and inspired by the colour of the stonework of the Palais-Royal itself. Then began the work of bringing furniture, art and fabrics together with a mixture of neoclassical pieces and twentieth-century designer classics.

Grange began buying pieces by Jean-Michel Frank in the 1960s when they were cheap and only a few people were seeking out his work, including Grange's friend Andy Warhol who would accompany him on hunting trips for Frank treasures. The flat is rich in pieces by Frank, Emilio Terry, Paul Iribe, Alexandre Noll and André Arbus. There are ceramics and artworks by Giacometti, Picasso, Christian Bérard and Sir Edward Burne-Jones, as well as photography by Irving Penn, Cecil Beaton and François-Marie Banier.

'I try to offer another manner of presenting the past for today, which is a modern attitude,' says Grange, seeking to define the nature of his work and his home. The sitting room is dominated by a triumvirate of a Grange-designed sofa, a nineteenth-century neo-Gothic mahogany screen and a 1930s tapestry in eighteenth-century style by Ernest Boiceau. There are gondolier chairs in Deco style by Iribe and wooden Moresque armchairs from the Villa Taylor in Marrakesh, dating from the 1920s, as well as artwork by David Hockney, Bérard and Banier. Every corner has a tale, exuberant in detail.

The adjoining library is the apartment's most extraordinary construction, distinguished by the tall bookcases and a large desk of slate and iron. Every surface is packed with gems: a vase by Picasso, white plaster pieces from the 1930s by Giacometti and a Lord Leighton bronze draped with a coral necklace crowd together on the dark slate. Opposite is a large display rack, packed with paintings and photographs, and beneath a Roman clawfoot there is a photograph by Banier of a younger Grange, looking like a star of the silver screen with his 'matinée-idol looks', as one commentator has put it.

'Idol' might be a vulgar word to apply to a designer, yet Grange is undoubtedly one of the most admired interior architects of his generation. His

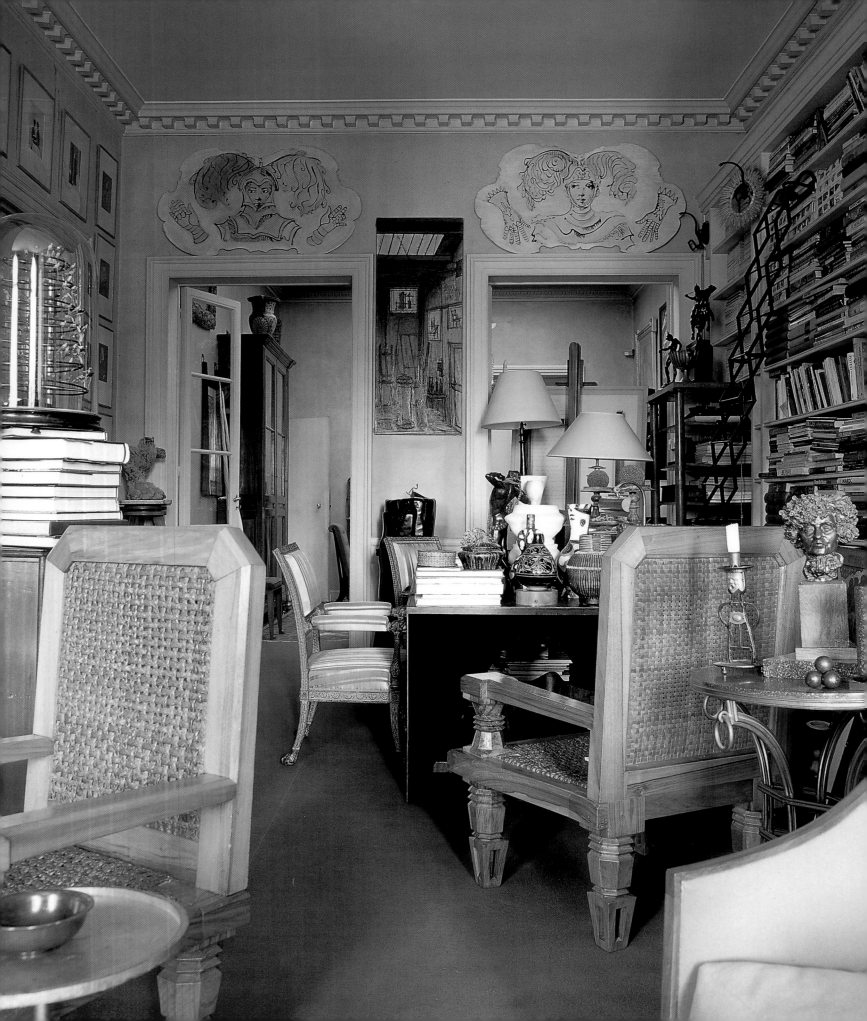

clients include Isabelle Adjani, Paloma Picasso, Johnny Halliday and Princess Caroline of Monaco, while his work now also takes him across the Atlantic constantly. He has designed premier suites for the Lloyd's building in London, contributed to decorative schemes for the Musée des Arts Décoratifs at the Louvre and has been honoured with a Chevalier des Arts et Lettres. Furniture design, meanwhile, has progressed from bespoke pieces for his many clients to include a range for the John Widdicomb Company in America.

He was born in a town south of Paris but has lived in the capital since he was a child. From the age of five he was interested in design, drawing and art and would go to extra classes that catered for his curiosity, as well as visiting countless museums and galleries, often drawing and recording pieces that caught his attention. At sixteen he went to the École Boulle in Paris, which specializes in design, art and decoration, and from there on to the École Camondo to study interior design. Almost as soon as he graduated from the Camondo, at twenty-one, he started worked with the well-known French interior designer Henri Samuel, staying for two years.

Working with Samuel, Grange was versed in a style of classical decoration, learning the importance of fine craftsmanship, of composition, and assisting with major projects such as the restoration of Le Petit Trianon at Versailles – commissioned by Louis XV for his mistress, Madame de Pompadour – and a Paris home for the Rothschild family. Then in 1967 he moved on to work with Didier Aaron, creating a design studio to run alongside Aaron's antiques business, and began to combine a more contemporary approach to interiors with period furniture and furnishings.

'At the same time I met Marie-Laure de Noailles, who was a very important arbiter of taste in Paris then,' says Grange. 'She had an important house in Paris and in the 1920s had commissioned another home in the south of France from Robert Mallet-Stevens. She and her husband

LEFT In the library Grange's desk is layered with pieces by Giacometti, Picasso and Burne-Jones. The panels above the doorways to the dining room are by Christian Bérard.

BELOW The light mahogany screen against the wall in the sitting room is French neo-Gothic, the painting is by Osbert and the candlesticks are Second Empire.

helped many artists – he funded Luis Buñuel's *The Golden Age*. And when I arrived at her *hôtel particulier* in Paris I discovered that she had a very important salon from the 1920s by Jean-Michel Frank, and this was a great shock. Frank was not fashionable at the time, but it was a very important influence on my work.'

Yves Saint Laurent, whom Grange first met around the same time, described Frank's salon for the Noailleses as 'the eleventh wonder of the world'. And it was Saint Laurent who became the most important client of Grange's career, from the early 1970s onwards, as Grange began working independently and developing his own style. There was a Paris apartment, a house in Normandy and another in Marrakesh, plus a recent home in Tangiers, all for Saint Laurent, who in turn encouraged Grange's interest in orientalism.

'I maintained the high quality of design that I loved when I started working with Henri Samuel,' says Grange, 'but from 1970 I started to discover what I like – I love the end of the eighteenth century, the end of the Louis XVI period. But I also love some artists of the Art Deco period: Frank, Emilio Terry, Pierre Chareau. It was all about mixing objects and furniture from different periods in homes that were comfortable, elegant. You can have great things but in a very low-key presentation.'

There was a third influential figure whom Grange met in the 1970s: the late doyenne of French interior design, Madeleine Castaing. 'She was very important to me. But she was a magician, not a designer. When I worked with Didier Aaron, he taught me the quality of the French *grand siècle*, but Madeleine Castaing taught me the poetry of a house.'

A photograph of Castaing, looking vulnerable without her usual black bobbed wig, presides over the dining room in Grange's apartment, while a chandelier that once belonged to her is in the bathroom. They add yet another tissue of interest to the home, layered as it already is with so many associations and stories.

'It is a very small flat,' says Grange. 'But I don't want to move, because the location is so magical. And because of Colette. It was a great opportunity to be able to live here. It's like living in St Mark's Square in Venice.'

ABOVE The photograph in the dining room, by François-Marie Banier, is of Madeleine Castaing (left). The screens are nineteenth-century Russian and the 1950s dining chairs (right) are by Marc du Plantier.

RIGHT In the sitting room the sofa is to Grange's own design, while the tapestry behind it, in eighteenth-century style, is actually from the 1930s, by Ernest Boiceau.

John Minshaw

SOME WOULD ARGUE THAT THE PRINCIPLES OF CLASSICISM AND NEOCLASSICISM UNDERPIN EVERY STRAND OF BOTH ARCHITECTURE AND INTERIOR DESIGN. THESE PRINCIPLES RELATE TO PROPORTION AND SCALE, SYMMETRY AND DETAILING, AND HAVE A CERTAIN RELEVANCE EVEN IN THE MOST CONTEMPORARY OF SPACES. BUT THERE ARE DESIGNERS WHO USE THE LANGUAGE OF NEOCLASSICISM MORE CONSCIOUSLY THAN OTHERS AND JOHN MINSHAW IS ONE OF THEM, ALTHOUGH HE HAS ADAPTED AND UPDATED THAT LANGUAGE TO HIS OWN ENDS.

'At heart I am a Graeco-Roman man and, yes, neoclassicism is my favourite period,' he says. 'But I also like mixing the best things from every period and I love new technology as well. When people talk of neoclassicism they sometimes think of a pastiche of how they imagine people lived in the eighteenth century, yet I'm not like that at all.'

Minshaw's own central London, five-storey terraced home pays testament to his style and his love of clean, accomplished spaces. It is a large Georgian house where many original features have been respected, but it is also a sophisticated environment with intelligent lighting and swathes of sunlight, open vistas and versions of restrained, controlled elegance for every room.

Minshaw and his wife, Susie, bought the house in 1997 and realized that it would be a major project. The building had been used as a rooming house and its condition was poor, so it meant reinventing the space while also restoring or reintroducing Georgian elements such as fireplaces and windows, skirting boards and architraves, cornicing and oak parquet floors. The kitchen

RIGHT In this segment of the L-shaped sitting room the voile curtains allow light to flood through, refracted by the eighteenth-century Irish mirror. The sofa is simply covered in artist's canvas, contrasting with the refined character of the eighteenth-century armchair nearby.

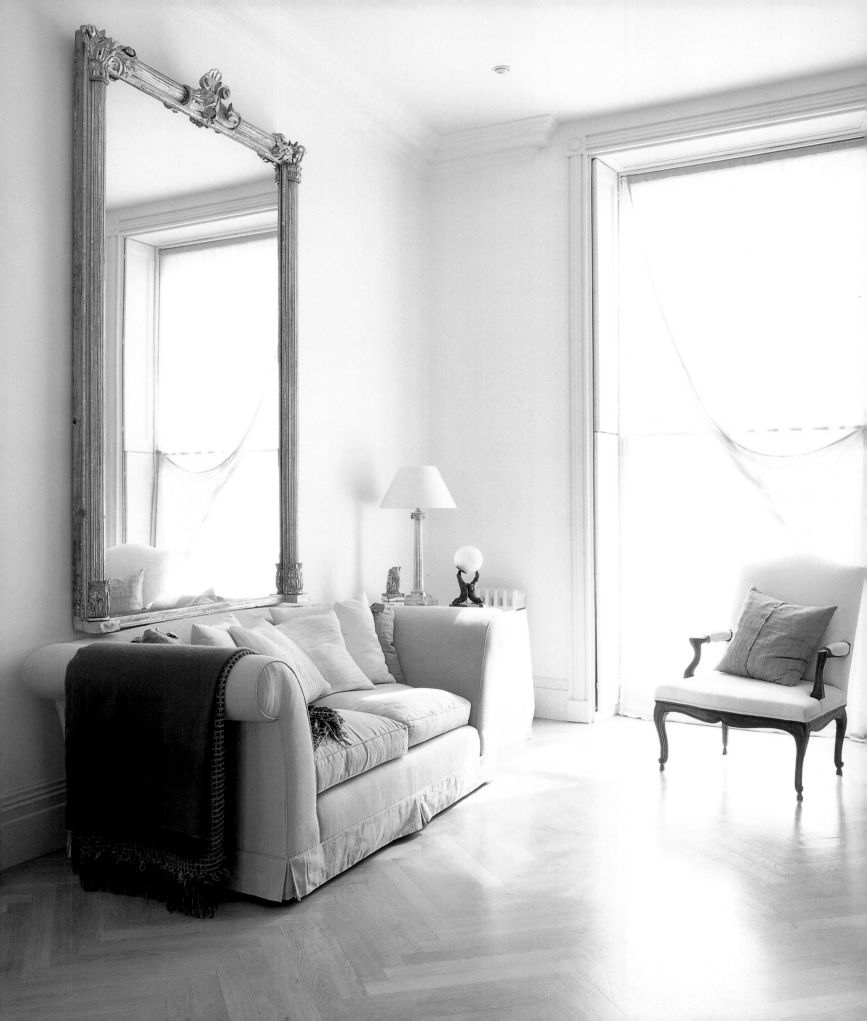

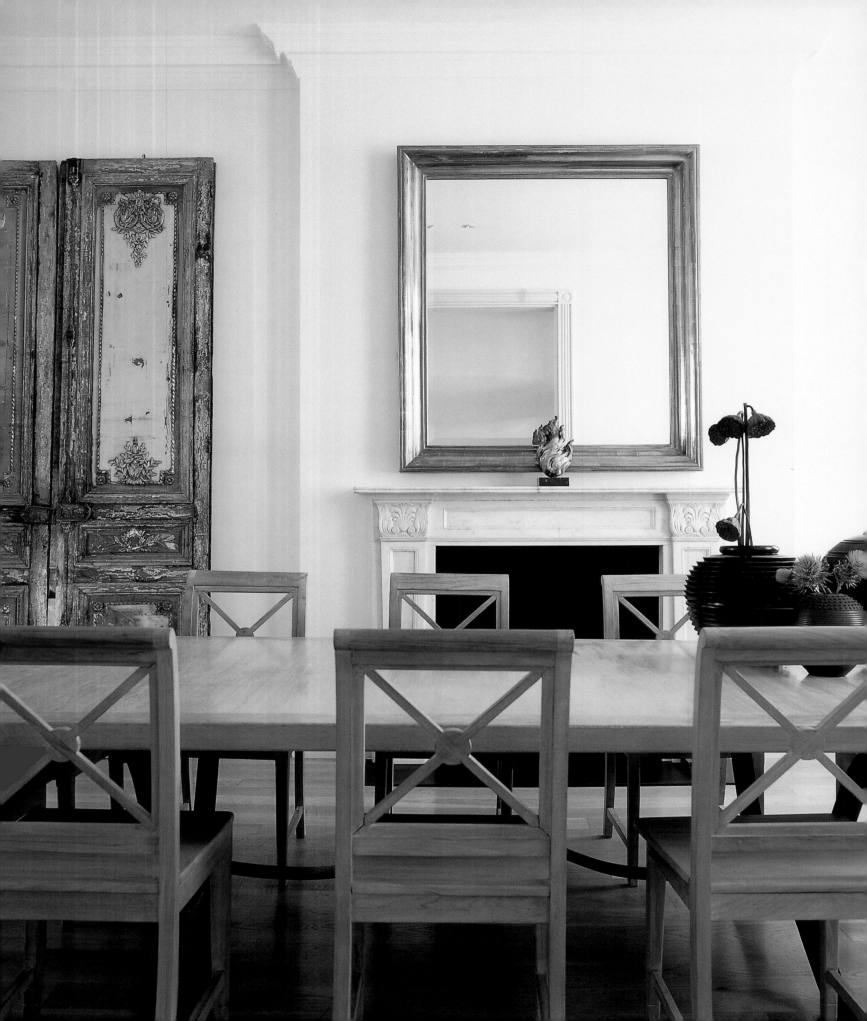

and dining room on the ground floor and the large living room on the first floor were rearranged and opened up, so that sunlight flowed through unimpeded from the front to the back of the house. Two small 1960s buildings at the back were removed to make way for a conservatory and courtyard, with french windows leading off from the kitchen.

'What we really love about this house is the light,' says Minshaw. 'Normally in England you live under a grey cloud but here the feeling is very different. Opening up spaces to let light flood in is very important, and if you open up a building front to back you do get those two light sources, which makes a big impression. And it's wonderful to have a summer room and that walk through from outside to inside.'

To preserve the flow of light Minshaw has avoided heavy curtains and swags and tails, opting for translucent and sheer fabrics at the windows. Artificial lighting tends to consist of recessed halogen downlighters, carefully zoned and set on dimmers to allow the creation of different kinds of ambience in various sections of a room. Spotlights highlight the colour and texture of a drawing or an intricate section of carved woodwork, rich with detail.

In the living room, where two rooms have been made into one, mirrors help promote the flow of light and create an illusion of larger dimensions,

LEFT The dining room table is by Minshaw, and is surrounded by Indonesian teak garden chairs painted with flat, grey oil paint. A pair of eighteenth-century french windows leans against the wall.

RIGHT In the summer room are ironwork Italian chairs from the 1840s and a Minshaw-designed side table.

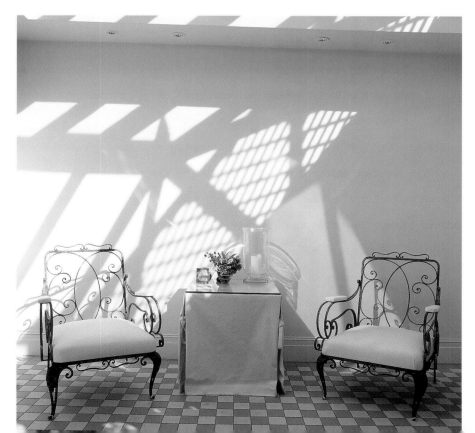

while designs by Minshaw – such as the black charcoal-lacquer cabinet, the barrel chairs or the pair of nickel, silver and granite coffee tables – mix with pieces from the eighteenth and nineteenth centuries, notably the French armchair by the rear window or the large Irish wall mirror nearby. 'What I do is try to buy some good antiques and put them in very pared-down interiors, and then design some bespoke furniture as well,' Minshaw says. 'What I like to think is that if we have a look, it is because virtually everything we do as a company is bespoke. We do buy in classics but mostly we make pieces ourselves and that makes a big difference.'

The treatment of colour in the house is careful and considered, with the majority of walls decorated in shades of offwhite or stone and rooms painted as many as seven times over until Minshaw is happy with the tone. But there are rooms – especially more functional rooms such as bathrooms or the kitchen – where there are stronger colours, particularly variants of green. Open a recessed door in Minshaw's hallway and you suddenly find a rich, Moroccan-blue cloakroom hidden under the stairs, standing out all the more in the restrained colour context of the hall itself.

'It is nice to have just one wall or one room that is a bright colour and that wouldn't be a shock or a surprise if there were not that neutral palette all the way around it,' says Minshaw. 'But if you throw thirty colours into a room, that will dissipate the kick. The joy of being spare is that it gives every object an incredible relevance. If you lived in a white room and there was a spot of dust on the floor it would become incredibly significant, but if the whole room was full of dust you wouldn't notice it.

'I'm very happy if the walls are a whole series of offwhites, and sometimes I will use the same colour in different finishes because they reflect the light differently. So I tend to use a lot of flat oil, which is an eighteenth-century technique really. In the sitting room there's emulsion, eggshell and flat oil all in the same offwhite colour, and I like those tricks.'

There are also many tricks with scale. The vast pair of 1920s black and gold framed mirrors in the sitting room – they once graced rooms in the London bank, Coutts – are another surprise and stand opposite a simple but

ABOVE RIGHT AND BELOW RIGHT Part of the pleasure of the sitting room is that it remains airy, uncrowded and spacious. The side tables and coffee tables (above) are by Minshaw, while the sofa (below) is covered in a Jim Thompson Thai silk with cushions in banana fibre.

ABOVE FAR RIGHT The console table in the hall, designed by Minshaw, is charcoal-lacquered with a Belgian fossil top.

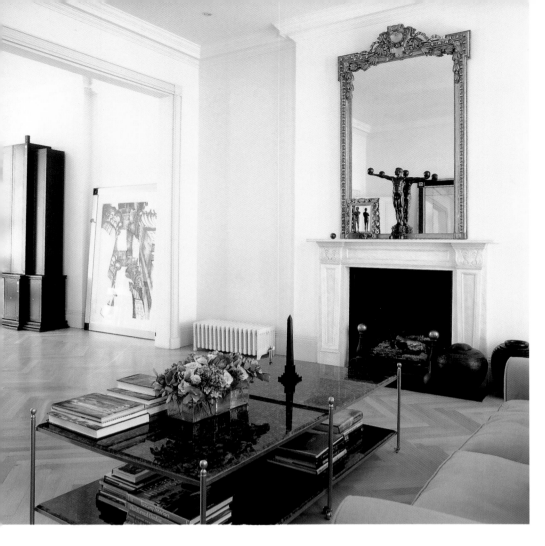

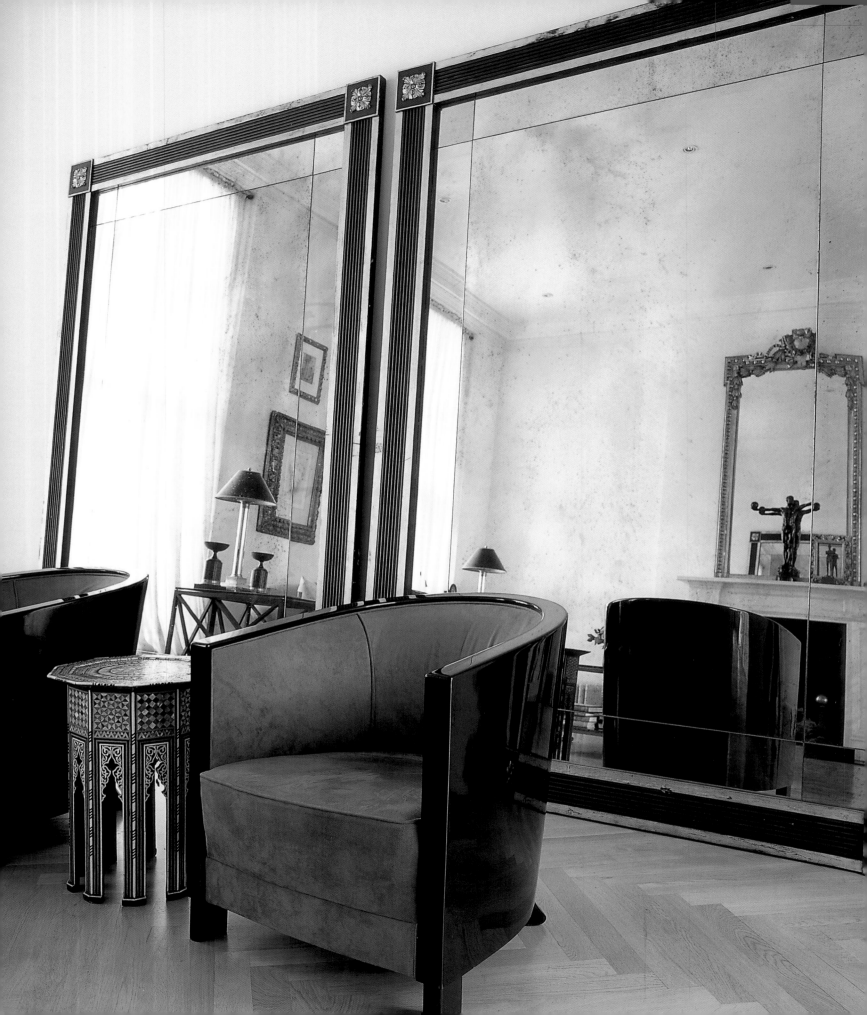

effective arrangement around the fireplace opposite, where a small mirror contrasts with the large, and a grander French nineteenth-century statue on the mantelpiece is paired with a smaller Art Deco figurine. These games with proportion add to the visual richness of the room, along with the emphasis on contrast, together helping to prove that Minshaw is no minimalist despite the calm, neutral backdrops to his ideas. The unexpected, too, is accorded real importance – the pair of eighteenth-century french windows simply leaning against the wall in the dining room, for instance, are full of character and create a certain drama.

The strength of such compositions might well spring from Minshaw's background as an artist. Born in Amersham, Buckinghamshire, he studied fine art at the Camberwell School of Art and then switched to ceramics where he was taught by Hans Coper and Lucy Rie, who both became firm friends. When he left, Minshaw was drawn into product design to earn a living, designing tiles and ovenware, as well as being asked back to Camberwell to teach ceramics, and also working as a sculptor. But gradually Minshaw

became more interested in furniture design and interiors, and in the mid-1960s he was asked by fashion designer Caroline Charles to design a home for her, which launched his career as an interior designer.

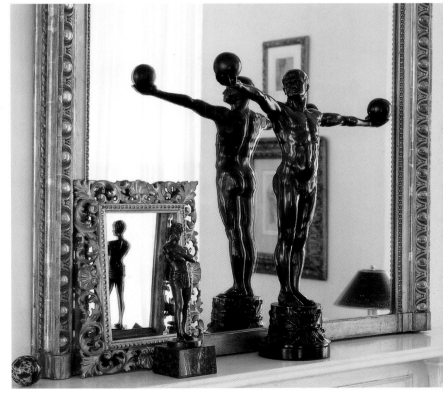

LEFT AND RIGHT Contrasts in scale bring added drama, as with the pair of vast 1920s mirrors in the sitting room (left) that dwarf the Deco-style barrel chairs in front and play a visual trick that seems to enlarge the room's proportions. Above the fireplace there are further contrasts in scale in the pairings of mirrors and statues (right).

For many years Minshaw successfully combined his work in interiors with furniture design, managing dedicated production workshops which made his own designs, both for individual house projects and for sale to other designers and architects. 'It's important not only to design but to make as well,' Minshaw says, 'because you then see the whole of it. If you have made furniture you then tend to make fewer mistakes in how you design it.'

Gradually, however, the interior-design practice grew to such an extent – with projects in the UK, America, Spain, Italy and Switzerland – that this manufacturing was passed on to others, while Minshaw concentrated on developing a fusion of architectural office and interior-design business as well as continuing to develop bespoke furniture.

'I dislike what has happened over the past hundred years or so whereby everybody has become so specialized – everyone now is a specialist. I really like people such as Sir John Soane or William Kent who to some degree would work on everything to do with design. I hate the idea of being contained – you should be able to do it all. I like working on the bones of something, the architecture, and then bringing everything else in on top of that. So we are designers and architects rather than decorators – as a practice we are not really cushion plumpers.'

Projects are now largely residential, with some all-consuming house projects across the English countryside. There are times when Minshaw will come across a piece of architectural salvage – a window, a door, ironwork – and, inspired by the craftsmanship, will design a whole room around it. There has been an extensive barrell-vaulted wine cellar for one remodelled country house, for instance, which was recently created around some French Art Deco ironwork fanlights.

'It is wonderful to mix the old and the new like that because it twists and changes your perception of exactly what it is that you are looking at. And what I find fascinating is that if you have a problem, say with moulding or architraves, you can just look back – to the eighteenth century, to the neoclassical era – and see how it was solved 200 years ago or 2,000 years ago. That will give you an answer.'

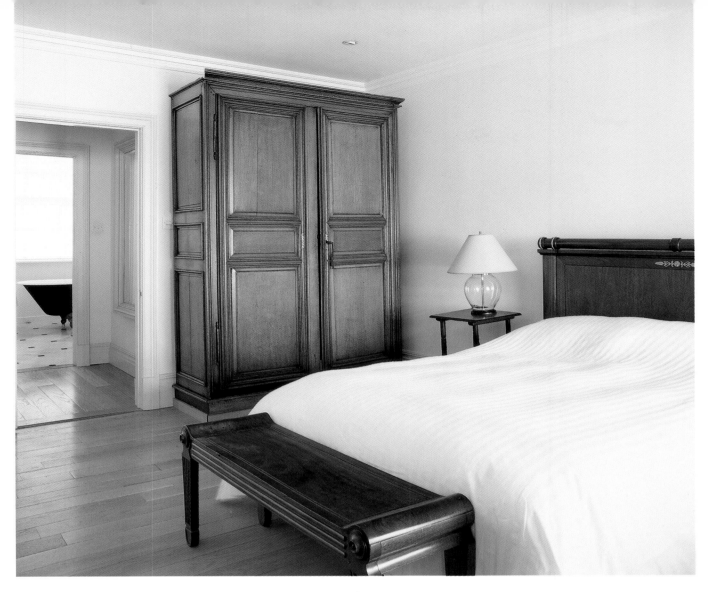

ABOVE AND RIGHT In the master bedroom (above) the bed is nineteenth-century French and the bench eighteenth-century English, set in the style of Thomas Hope on a floor of lighter oak planking. In the bathroom (right) white marble counters and splashbacks create an impression of elegant simplicity.

Fusion

TRAVEL HAS CHANGED THE WAY WE LEARN AND LIVE. WE TAKE INSPIRATION
FROM FAR-OFF PLACES AND EXOTIC DESTINATIONS, WE ADOPT AN OUTWARD-
LOOKING ATTITUDE IN WHICH POINTS OF REFERENCE COME FROM ALL POINTS
OF THE COMPASS. INTERIOR DESIGNERS IN THE FUSION MOULD ARE EXPERT AT
COMBINING THE BEST OF EAST AND WEST, EUROPE AND THE ORIENT, THE NEW
WORLD AND THE OLD, IN A SOPHISTICATED, CONTEMPORARY STYLE.
INTERNATIONAL AND ELEGANT, FUSION DESIGN IS RICH IN ASSOCIATIONS AND
MEMORIES, TEXTURE AND CONTRASTS.

Kelly Hoppen

TRAVELLING HAS ALWAYS PLAYED A PART IN KELLY HOPPEN'S LIFE. IN HER CHILDHOOD SCHOOL HOLIDAYS BROUGHT MANY NEW JOURNEYS AND EXPERIENCES AS HER PARENTS ENCOURAGED AN APPRECIATION OF OTHER CULTURES AND COUNTRIES. EVER SINCE, SHE HAS TRAVELLED OFTEN AND WITH ENTHUSIASM, PLUS A GROWING REALIZATION OF THE IMPORTANCE OF THESE TRIPS AS SOURCES OF INSPIRATION FOR HER WORK AS A DESIGNER AND THE DEVELOPMENT OF A STYLE THAT IS NOW DISTINCTIVE AND RECOGNIZABLE.

'We are like a sponge, soaking up influences from other places,' Kelly Hoppen says of herself and interior designers. 'As you are designing,' she continues, 'you begin to express that; travel can be a great inspiration when you are surrounded by beautiful things. I go to the East every year, to Asia, and I love the culture. I feel I need it. But at the same time I don't think anything is absolutely new – we all get inspiration from somewhere and you find that you are never really the first.'

Hoppen's book *East Meets West*, published in 1997, laid out a design philosophy based upon a personalized fusion of different aesthetic traditions, within a contemporary awareness of innovation in home technology, materials and fabrics. 'The whole idea of East meets West was a turning point for me,' says Hoppen, 'because I really knew what I was about, I knew what I was trying to get across. Possibly the success of my company is to do with the fact that the underlying philosophy is very strong and it's important to have that grounding rather than just a look.'

LEFT AND RIGHT In the living room (right) natural and neutral tones help create a sense of cohesion and calm, the sisal carpet providing a link through to the dining room beyond. The wenge coffee table is by Christian Liaigre, as is the sofa; surfaces and mantelpiece displays are composed with an expert eye for detail (left).

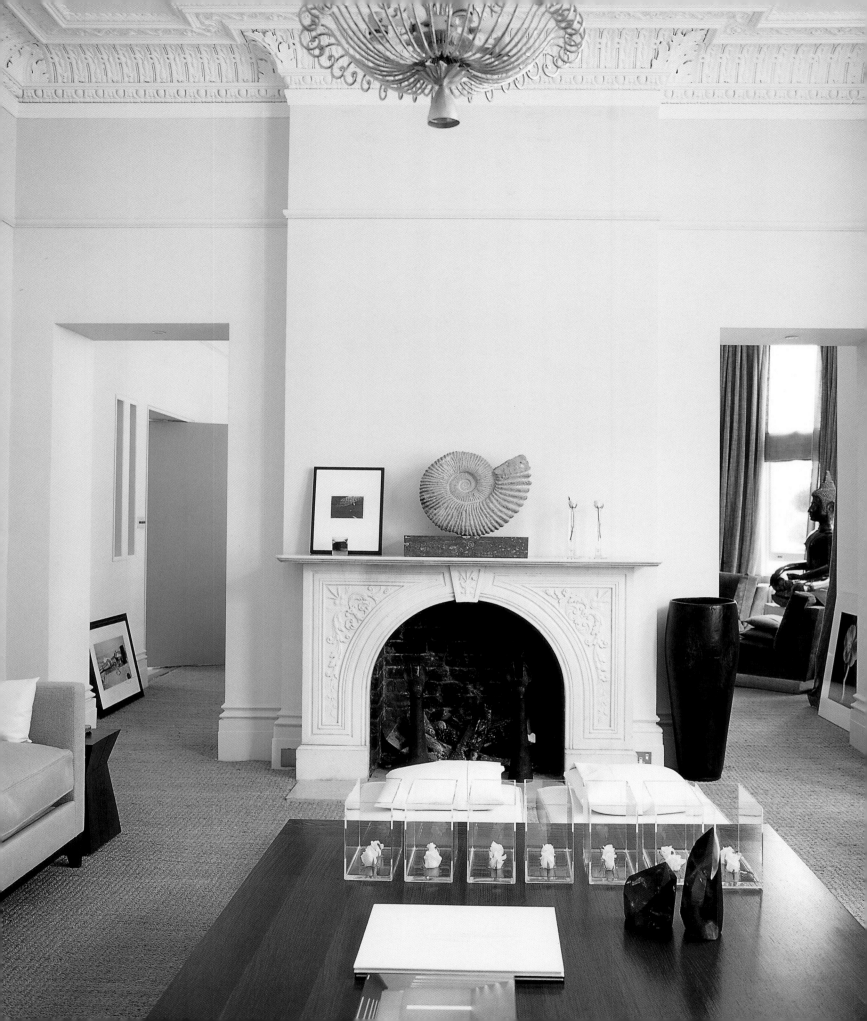

Her own London apartment, which she shares with her husband and daughter, is a characteristic blend of design ideas. Once upon a time it was four separate flats, but they have been knocked together into one, spanning the ground floor of two adjoining Victorian terraced buildings. Traditional English features, such as the fireplaces and cornicing remain, but they are combined with Eastern flavours such as statuary, Jim Thompson Thai silks and dyed sisal flooring, while the whole space has been filtered through the medium of feng shui. Enriching the mix come sophisticated designer pieces, including a Christian Liaigre wenge dining table or the Liaigre armchairs in the living room.

It is a home affluent in texture, contrast and especially comfort, and not simply a design statement. 'It goes back to that feeling of when you lived in your parent's house and there was that sense of security and safety. Every time I walk into my home I feel good because I have created that kind of space. I know from our clients that they love their homes and they say that when they move in they feel as if they have lived there all their lives.'

Hoppen bought her apartment in the late 1980s and it has been through a number of incarnations. Recently she became unhappy with a much darker

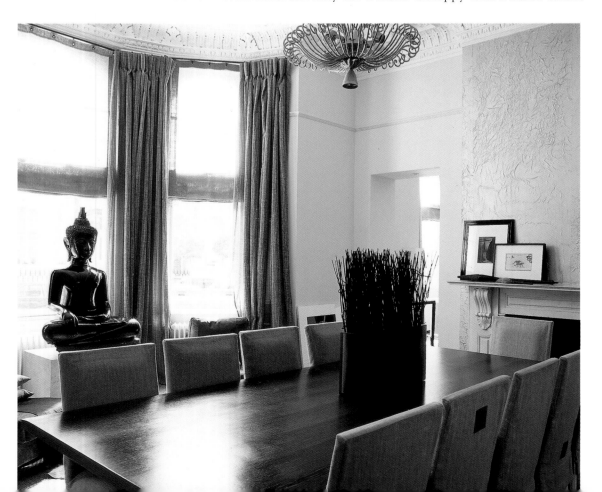

LEFT AND RIGHT Eastern influences seep into the mix in the dining and sitting rooms, not simply in statuary but also materials and finishes and the organization of the spaces themselves, taking into account principles of feng shui and ideals of openness and simple elegance.

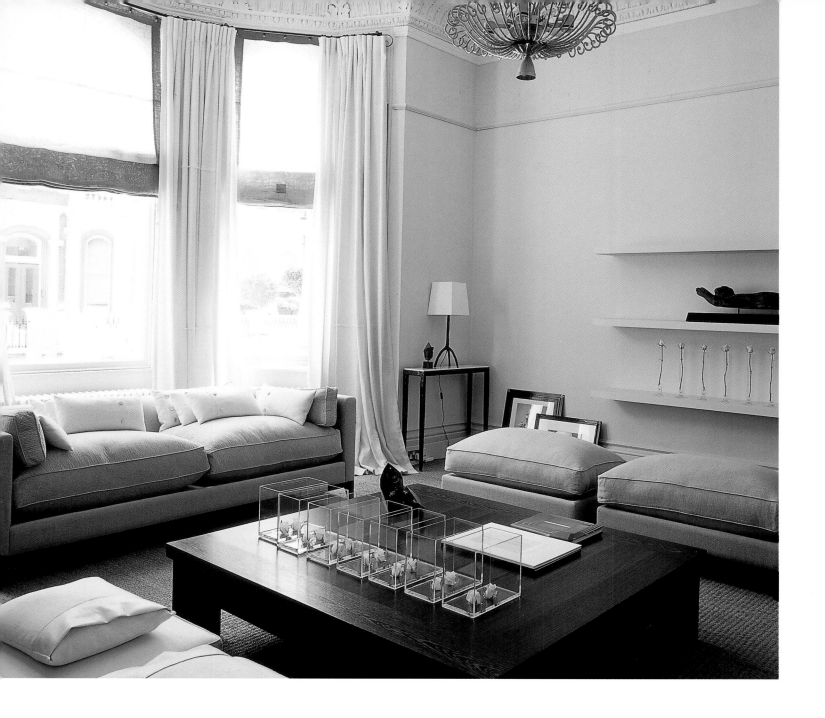

scheme for the flat, dominated by emerald greens and navy blues. Hoppen wanted a calmer, more neutral environment. 'I wanted something freer and easier because I have changed, I'm more relaxed. I'm constantly coming up with new concepts and it's not as though I was bored with what I had got before, I just wanted something different.'

The reincarnation of the apartment was combined with quite a major renovation, relaying services and making structural changes to the layout. Hoppen decided that she wanted to create a large and dramatic entrance hall,

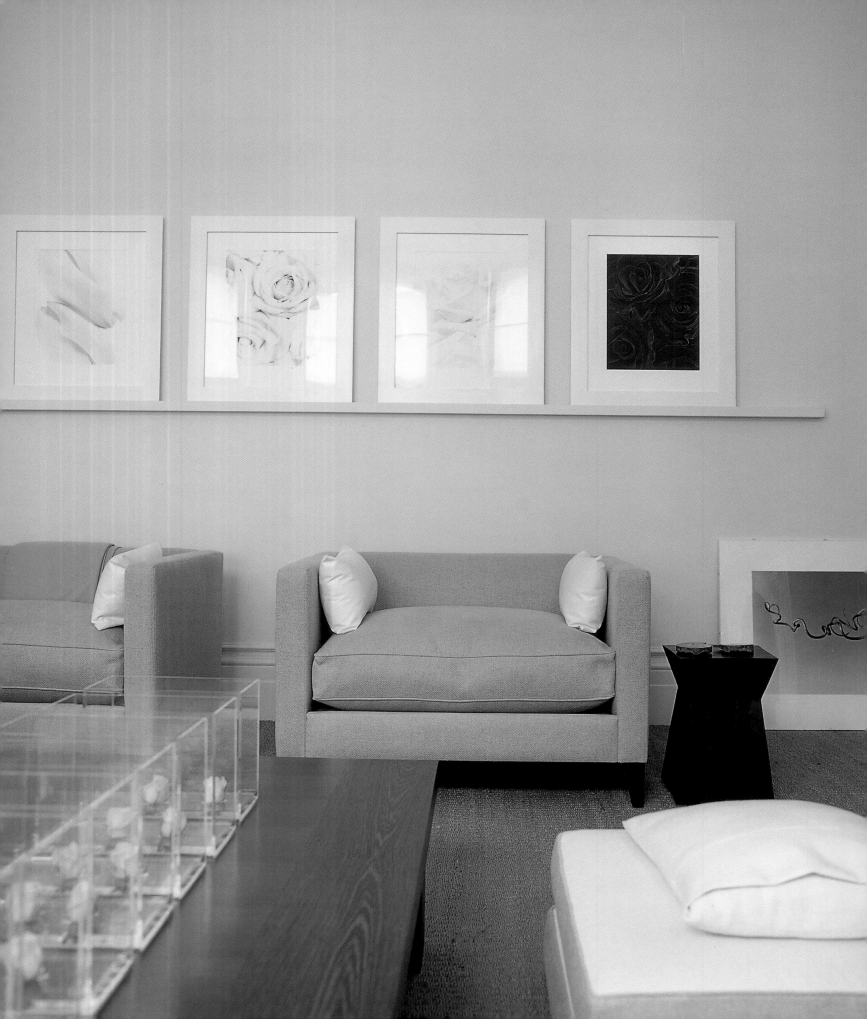

which meant siphoning away other sections of the living space. But the proportions of the key rooms – arranged in a horseshoe formation all around the hallway – remain generous, with an emphasis on fine materials, and on peaceful, neutral colours and soft, light, organic tones.

'When I first bought the flat I couldn't do all the things that I really wanted to do,' Hoppen says. 'I made the huge hallway because I wanted simply this space with nothing in it. When people come into your home it's lovely for their attention not to go anywhere else – it's a moment of communication when guests arrive, just you and them.'

Limestone floors tie the hallway and kitchen together, while the sisal carpets run through the interconnecting dining and living rooms. Here fireplaces have been respected as focal points, notably the one in the dining room that is high-lighted with a foil wall treatment. Plainer linens and canvas for upholstery and loose chair covers contrast with more indulgent silks and suedes, while lighting mixes dramatic pieces such as the ironwork chandeliers or the Mark Brazier-Jones standing lights at the far end of the dining room with atmospheric uplighters and sand-blasted, illuminated glass panels set into the walls.

'I have become more and more interested in lighting because there are so many incredible things that you can do with it,' says Hoppen. 'People are still

LEFT Avenues for displaying sculpture and art include ledges for pictures and simple cantilevered shelves. The armchairs are by Christian Liaigre, as are the footstools.

RIGHT The kitchen is dominated by a bespoke Hoppen dining table, using wenge and a steel strip, surrounded by classic Arne Jacobson chairs.

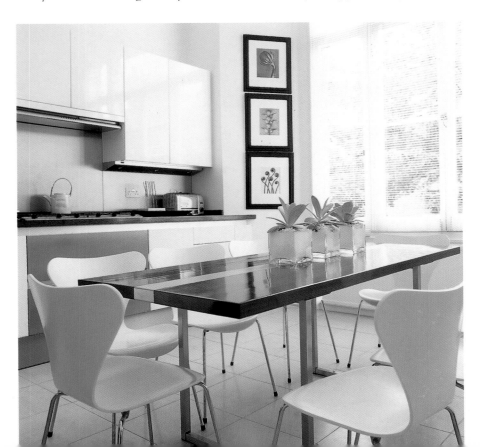

living in this old world where they get all the building work done and then buy some lamps. But you can change the whole atmosphere of a room with lighting, and that's something very important. So is looking at natural light. If you are an architect and you are building a house you always check the light and see where the sun rises and how it will move across the space. You have to consider the same concept inside the house.'

The main bedroom has been treated as a soft, luxurious zone. Lingerie satin has been used at the windows, while fabrics such as mohair and cashmere for bed coverings and cushions offer a sensuous quality, reinforced by a wool and sisal mix underfoot and a spacious en-suite bathroom where bathing is elevated to an indulgent, almost ceremonial act.

Even at the age of twelve, Hoppen was precociously remodelling her bedroom in her parent's house, experimenting boldly with chrome and

RIGHT AND BELOW The main bedroom (right) is an indulgent, soft world, contrasting with the intentionally vacant spaciousness of the hallway (below left). The dressing table (below right) and bedside tables are by London-based architect Spencer Fung.

earthy-brown felt. She was born in South Africa, but at the age of two her family moved to England where Hoppen grew up within an artistic, creative environment: her mother is a dealer in decorative art and her father worked in menswear design, while her brother became a photographer and then a dealer in photographic art.

As a sixteen year old Hoppen was already beginning to design interiors, initially for family friends. She was suddenly asked to design a house for a racing driver, instantly setting her work on a more businesslike footing. 'That was really how the business started,' she says. 'At that age you are just completely fearless, and so doing a million-pound project was fine. By being so natural and fearless you get away with it. But to succeed you also must have a passion for what you are doing, and that has always been there.'

The business has gradually grown, taking on projects not just in Britain but in Ireland, America, France and other parts of Europe. Much of it has been residential work, but Hoppen is now looking at restaurant design and has been working for British Airways, redesigning first-class flight cabins, rather in the manner of Andrée Putman, who caused a stir in the early 1990s with her cabin designs for Air France. There have been a handful of books, Hoppen stores are being developed and her name can now be found on a whole range of products from paints to blinds, rugs, glassware and furniture.

'I do like to do very different things, and the more diverse the projects the happier I am,' says Hoppen, influenced by figures such as architect Mies van der Rohe or, in contemporary design, Christian Liaigre, who have applied their thinking to many different commodities. 'Product design takes every-thing one step further and it's a natural progression because I feel I know the home so well and what people want for their homes.'

There is a sense of adaptability in this approach, with Hoppen trying to create spaces that can be varied, altered and adjusted according to mood, temperament or season. 'I do try to make interiors that are flexible, so you have winter and summer cushions or curtains, runners in different colours for tables. This means the feel of a room can be altered almost instantly; you have to remember that getting bored easily is just part of human nature.'

RIGHT The two suede-covered armchairs in the window bay of the dining room date from the 1930s. Here, as elsewhere, there are rich textural contrasts, with soft suedes and voile curtains juxtaposed with the tin-foil covering for the chimneybreast and the use of stone and wood.

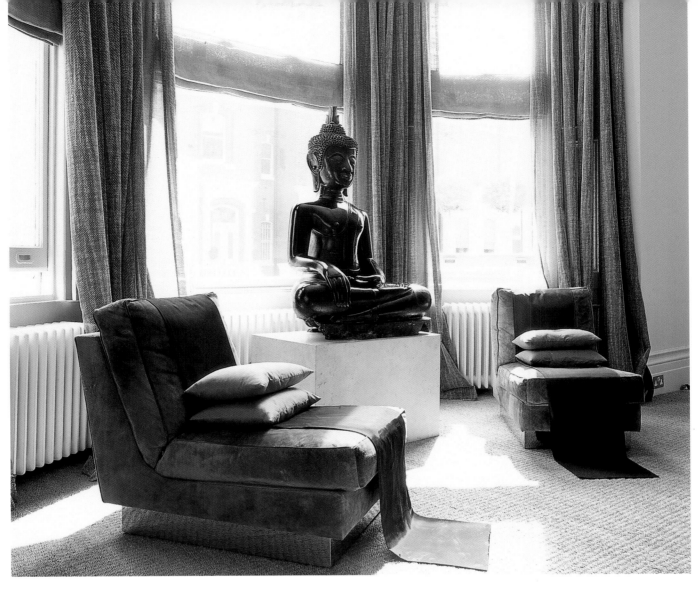

Frédéric Méchiche

MANY INTERIOR DESIGNERS LIKE NOTHING MORE THAN TO BE GIVEN CARTE BLANCHE. CLIENTS WHO HAND OVER A PROJECT AND WALK AWAY TAKE WITH THEM MANY OF THE FRUSTRATIONS THAT OFTEN COMPROMISE CREATIVE FREEDOM. BUT FRÉDÉRIC MÉCHICHE IS THE OPPOSITE: HE SAVOURS THE RELATIONSHIP HE BUILDS WITH HIS CLIENTS AND ENCOURAGES THE DIALOGUE TO BE AS REWARDING AS POSSIBLE. HE NEEDS TO DESIGN FOR REAL PEOPLE, HE SAYS. AND BECAUSE HE ALWAYS WORKS ALONE, CONTACT BECOMES EVEN MORE IMPORTANT. SO, ALTHOUGH HE HAS A CLEARLY CULTIVATED, PARTICULAR STYLE AND A STRONG PHILOSOPHY OF DESIGN, MÉCHICHE IS ONE OF THOSE RARE FEW WHO PROFESSES DISLIKE FOR THE MAGICAL IDEAL OF TOTAL FREEDOM OF EXPRESSION.

It was this strong aversion to absolute liberty that made designing his own apartment especially challenging. 'It was very difficult for me because I had to have a long discussion with myself,' says Méchiche. 'I had to think about how I would use the space day by day, utilizing every corner, because I hate corridors and dead, closed rooms. And because I lived in a loft for many years, I also appreciated the freedom of a life where nothing is hidden, there is no formality. So there is nothing to hide in my home. Everything is visible.'

Indulging his love of the city, the vibrancy of its streets, its constant motion, Méchiche found a space – three adjoining apartments – not far from the Musée Picasso amid the busy lanes of the Marais. He set about completely stripping away and then reorganizing the architecture of these three separate units to form one light, harmonious apartment on two floors with the guiding idea of creating something of the feel of a small Directoire townhouse. He

RIGHT In the entrance hall the floors are eighteenth-century stone and marble, contrasting with the futuristic Olivier Mourge recliner from the mid-1960s and a chair and light from the 1960s and 1970s. As with many of Méchiche's rooms, the hallway is so composed that it looks like a piece of artwork in itself.

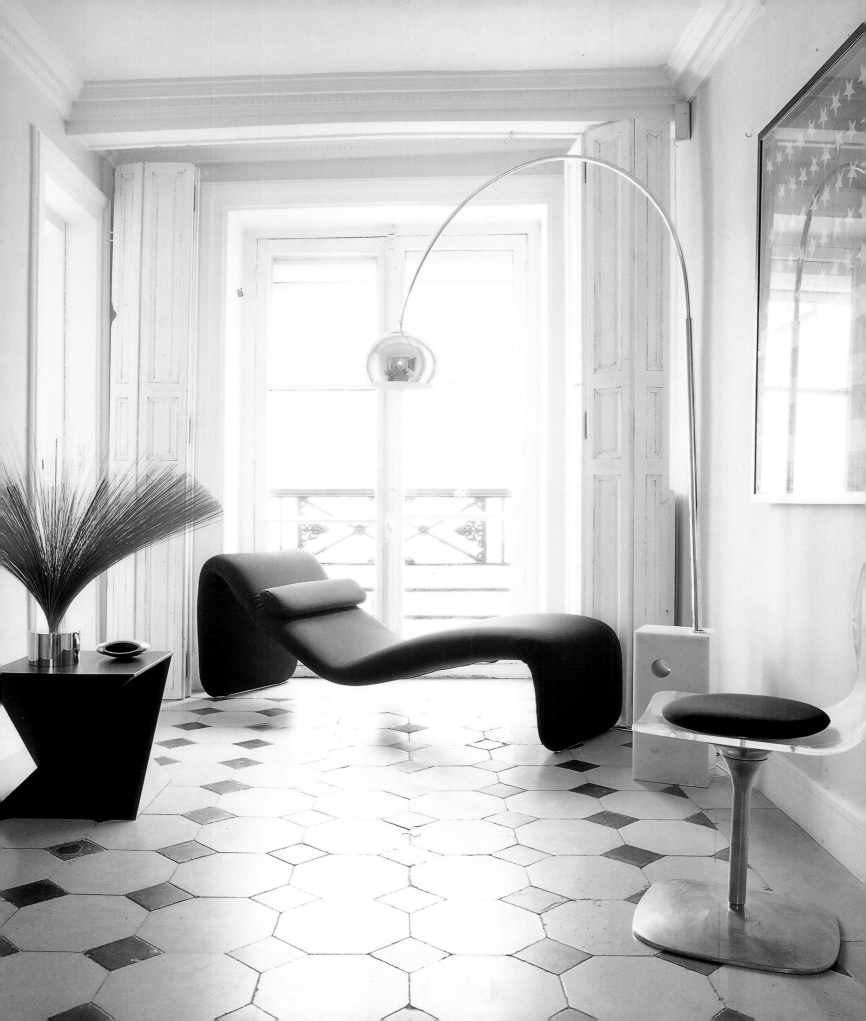

assembled a wealth of wooden panelling from an eighteenth-century postal staging inn, period stone floors, cornicing and mouldings, mirrors and fire-places, and began to bring the disparate pieces of salvage together bit by bit, like a vast jigsaw puzzle.

'I wanted to give the impression that I had just arrived here and truly found it like this,' he says. 'I just added my books, my sculptures, my paint-ings. Even if it's a calculated look, the feeling I wanted was of arriving in an eighteenth-century apartment, painted very simply and with no curtains, no carpets. Very few of the things that people often call "decoration".'

An interior architect with very clear ideas about his own 'rules' of design, of likes and dislikes, of what may or may not go together in a room, Méchiche throws out this word 'decoration' like a curse. He always labours for the impression of a natural environment, a home to feel comfortable and happy with, a room where a piece of art or furniture has a place because it draws an instinctive, positive response. For him 'decoration' implies falsehood and contrivance.

'To feel comfortable in a house, an apartment, you need to have this impression of naturalness. For example, in this apartment there are some extraordinary pieces of art but they are not placed as though they were in a gallery – they are part of my life. If people know what they are, then perfect. If they don't, it's not a problem. All the things that are here are not purely for decoration but because they speak to me.'

Méchiche planned his home around the central axis of the library, a room you constantly have to pass through to reach the sweeping staircase or cross from one room to another. Here the wooden floors, the panelling and Directoire fireplace are complemented by the endless ranks of books on art and design, while into the mix come classic Florence Knoll chairs and a sofa,

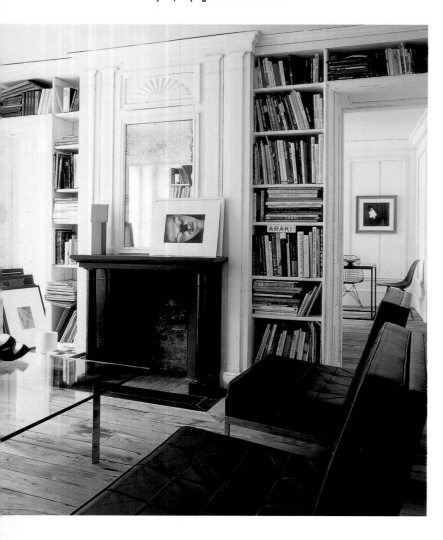

BELOW AND RIGHT The library (below), from which the dramatic staircase leads (right), is the literal heart of this home. Its Directoire fireplace has a mirrored panel above, with a photograph on the mantelpiece by Raoul Haussman. Sofas and armchairs are by Florence Knoll and the glass coffee table by Marcel Breuer. Books on art, architecture and design line every wall and spare inch of space, helping to furnish the room.

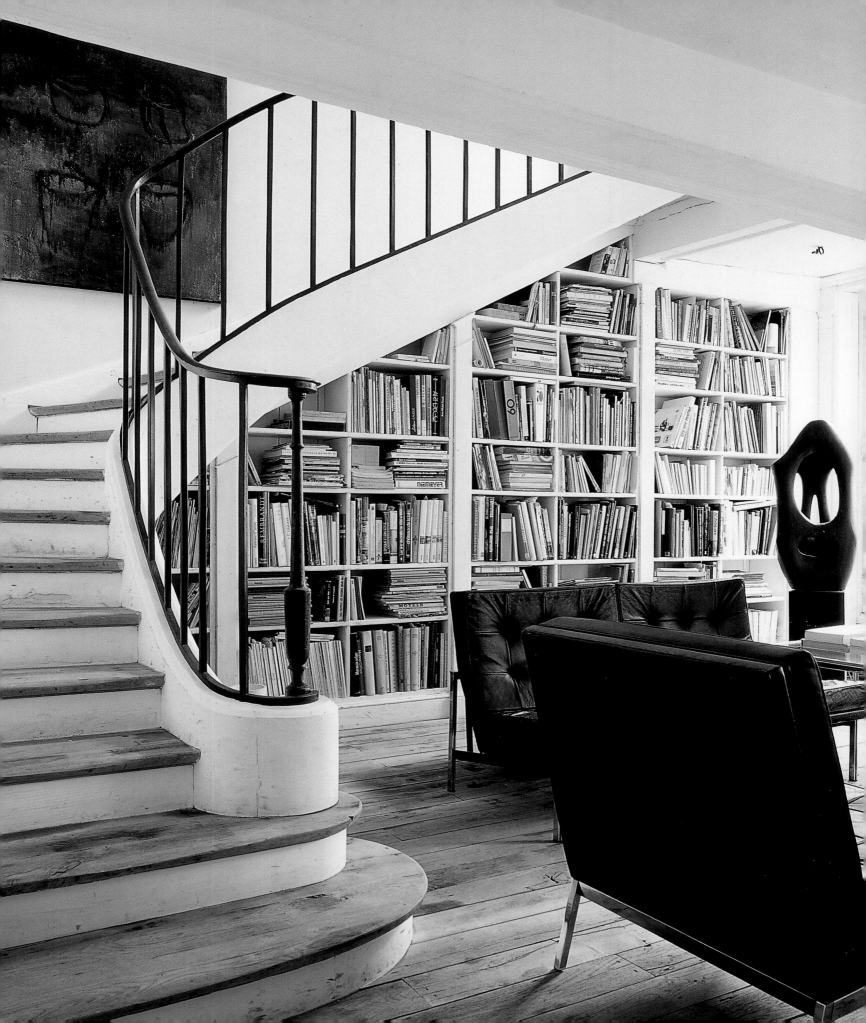

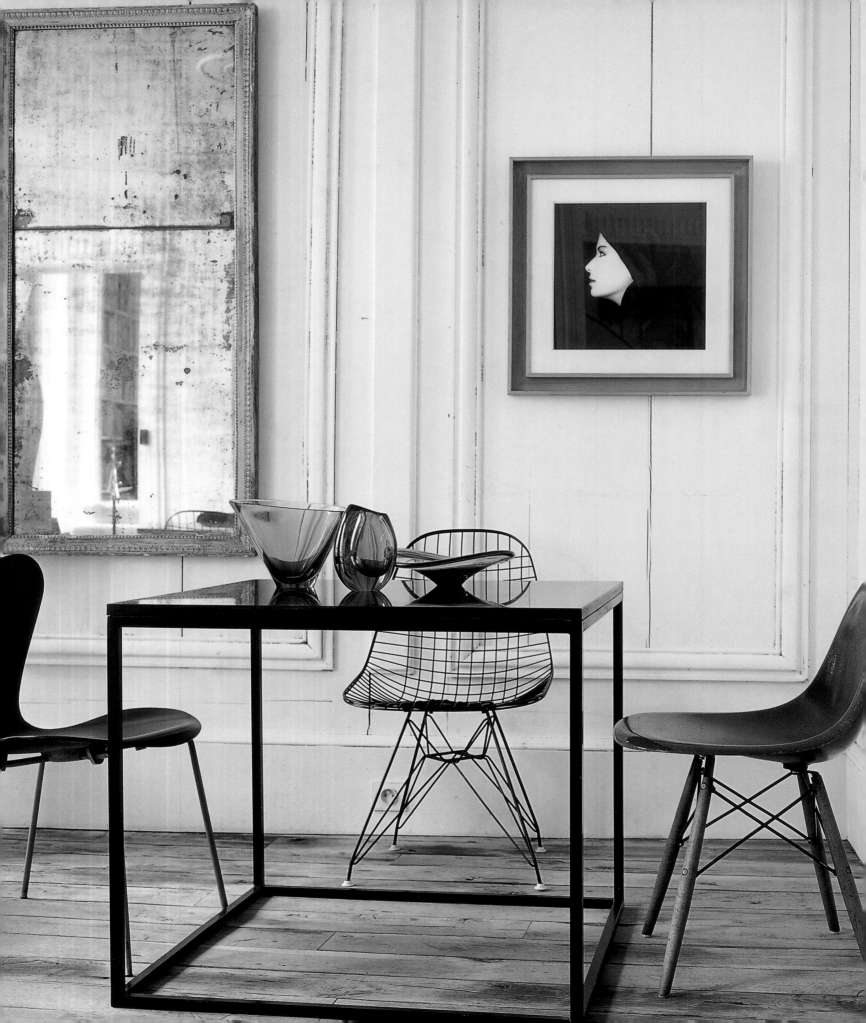

plus a Marcel Breuer glass table. It is a room rich in detail and substance, a purposeful contrast to calmer, more minimal rooms like the main bedroom.

To one side lies a simple white dining room, with mirrors hung on the panelled walls next to black and white images by Robert Mapplethorpe. Four separate, granite-topped dining tables – designed by Méchiche – create a bistro atmosphere, although they can be easily pulled together to form one immense table for entertaining. Double doors lead to the adjoining kitchen, which is designed in sympathy to create a large, open *salle à manger*, but also a glamorous mirror opposite to its white twin, painted black with a tiled floor, zinc-topped wooden island and hanging ceiling lights from the 1950s.

To the other side of the entrance hallway lie another two contrasting rooms: the sparse ivory bedroom, bathed in sunlight from double windows

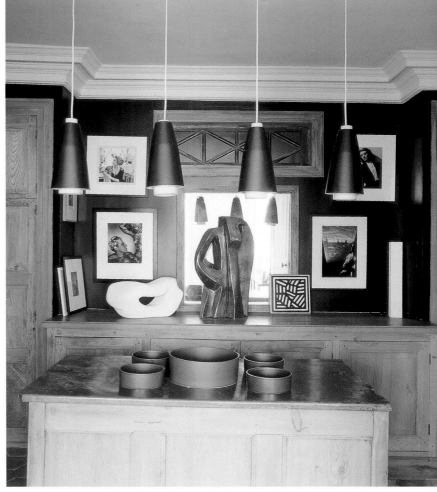

LEFT, ABOVE AND RIGHT The white dining room (left) and black kitchen (right) interconnect and mirror each other. Black and white photographs are in both rooms. The dining room has four tables designed by Méchiche that come together as one dining piece, plus chairs by Arne Jacobson and Charles Eames. Photography in the main salon is by Nan Goldin and Cindy Sherman (above).

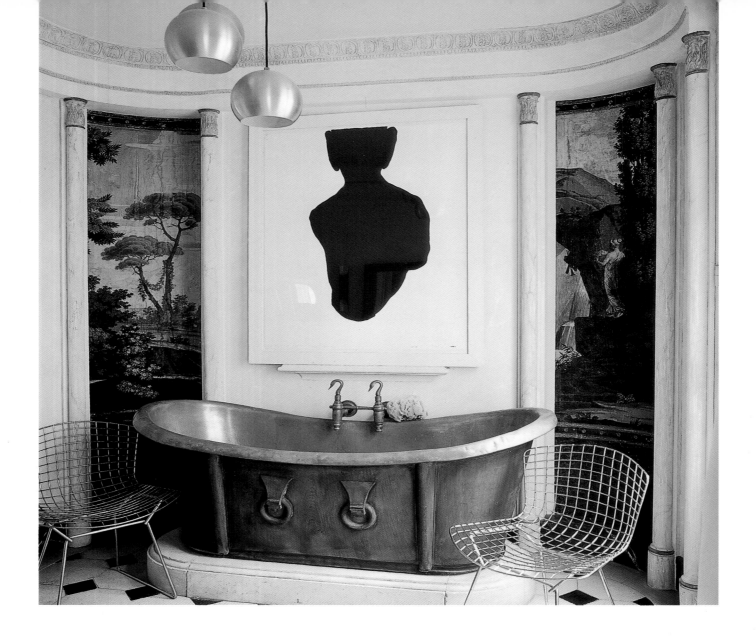

and with just a splash of red in the painting by Jean Pierre Reynaud, and then the bathroom next door on more of an eighteenth-century theme, with painted Directoire panels and period bath and basin.

'I like to have opposition between rooms in a house,' says Méchiche. 'So while I am happy to have a minimal bedroom, I couldn't imagine living in a whole apartment like that. I need to have different kinds of ambience, and you feel more comfortable if you pass from one atmosphere to another.'

Upstairs Méchiche opted for a more open feeling, designing a loft-like sitting room with a semi-separate gym next door. Here the cohesion of style – against the foundation of the familiar white walls and wooden floors – belies the very different origins of elements within the mix. There are period

pieces such as the Louis XVI day bed or the eighteenth-century Italian console table, which blend with twentieth-century classics such as chairs by Charles Eames and Mies van der Rohe. Modern sculptures and paintings by Jean Dubuffet, Joseph Beuys, Pierre Soulages, César and Jean Arp – some positioned on huge hi-fi speakers – stand alongside contemporary images by Nan Goldin or Cindy Sherman, as well as some pieces of African art.

'People think it's enough just to mix anything up,' says Méchiche, 'but I'm sorry, it's not. It's about composition, perspective. In the dining room, for example, I have photographs by Mapplethorpe that are quite classical, but I wouldn't mix them with the sculpture or modern art upstairs. But in the sitting room I do have other kinds of photographs – Cindy Sherman's, for instance, because they embody a different way of thinking that goes with modern art. The Mapplethorpes, however, sit well with images from the 1930s – it's the same classical way of looking at a subject.'

He talks, too, of the importance of a thoughtfully planned-out working structure – a stylistic foundation for the home – which allows flexibility and evolution in the arrangement of art, furniture and books. This should be a basis for living that can last twenty or thirty years into the future, permitting a slow, constant evolution and the indulgence of new choices, fashions and colours.

LEFT AND RIGHT The bathroom (left and above right) and adjoining bedroom (right) are another pair of opposites. The white bedroom, with just a splash of colour in the painting by Jean Pierre Reynaud, contrasts with the opulence of the reclaimed bath, basin and flooring (heated from below) in the bathroom, with painted panels, cornices and mouldings all from the Directoire period.

In his own apartment the emphasis is on shades of black and offwhite or stone – a scheme that has characterized some of his other residential projects – yet his country house in Provence, by contrast, reflects a more rustic and colourful approach. 'It depends on the quality of the light. In the South I can use some colours such as pure white or bright blue that would be terrible in Paris. But often I prefer composite colours – there might be mauve, for instance, but it would also have a little grey, taupe or brown.'

Méchiche was born in Algeria, where he grew up, but came to Paris at the age of seventeen to study interior architecture at the École Camondo. He came from a family of doctors, but medicine was always complemented by a love of art and architecture, and Méchiche knew from a very early age what kind of direction he wanted his life to take.

After graduating from the Camondo he was instantly commissioned to design a vast triplex apartment – complete with gardens and swimming pool – and the success of the project launched his career. There have been hotel

and restaurant projects such as the Dokhans in Paris and Joel Robuchon's restaurant at the Astor, as well as furniture design for his own Parisian gallery and various other furniture companies. But over three decades the work has mostly been private houses and apartments in France, London and America. Méchiche prides himself on the personal touch – there is no buzzing, whirring office filled with planners and managers, but instead he is always responsible for a project from start to finish himself, designing according to his own understanding of lifestyle, location and light.

'I always go around an apartment before I begin,' he says. 'I imagine how it will be to live there and often I spend one day there alone, just looking at everything, the light, the atmosphere. When I start a new project I dream about it during the night, I think of it all the time. I cannot sleep. Each project is like doing my first.'

LEFT AND RIGHT In the sitting room bare wooden floors and the white wall panelling make a neutral canvas for Méchiche's artwork and furniture, which is a mix of period pieces such as the Louis XVI day bed with modern classics such as the Mies van der Rohe 'Barcelona' chairs and the Noguchi glass-topped coffee table.

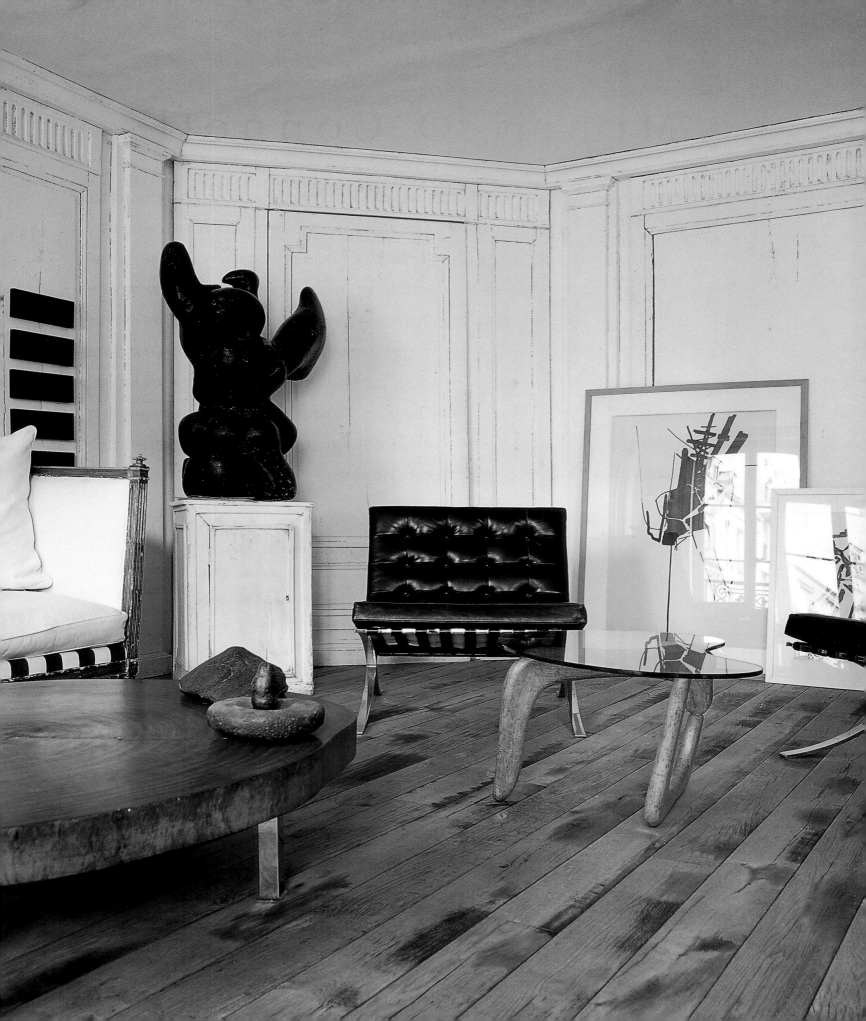

Mimmi O'Connell

THE INFLUENCES ON MIMMI O'CONNELL'S WORK SPRING FROM ALL FOUR CORNERS OF THE GLOBE. SHE HAS LIVED, AT DIFFERENT POINTS OF HER LIFE, IN ITALY, SWITZERLAND, ENGLAND, SOUTH AMERICA AND HONG KONG. SHE HAS LONG BEEN FASCINATED BY JAPANESE DESIGN, ESPECIALLY WORK FROM THE SHOGUN AGE. APART FROM THE PRINCIPLES SET OUT BY PALLADIO, THE IMPORTANT ACHIEVEMENTS OF CONTEMPORARY MINIMALISTS JOHN PAWSON AND CLAUDIO SILVESTRIN OR THE LATE LUIS BARRAGÁN, THE RESPECTED MEXICAN ARCHITECT, HAVE ALSO HELPED TO SHAPE O'CONNELL'S THINKING. ON THE CANVAS OF HER OWN HOME SHE FUSES RICH AND VERY DIFFERENT POINTS OF REFERENCE INTO SOMETHING NEW AND UNIQUE.

'In a way design is about reinventing things that have been done forever,' says O'Connell. 'After all, a Roman house was absolutely perfect. It had everything one wanted – even central heating. I was self-taught simply by looking at things, looking obsessively everywhere I went.'

O'Connell was born in Torino, Italy, but her father was engaged in finance, which meant the family moved often and widely. She went to school in Switzerland, studied political science at the University of Geneva and then took a degree in art and French literature at the Sorbonne, before beginning her career as a designer. Yet Italy has continued to lure O'Connell back again and again; she once owned a farmhouse in Tuscany and now has another home in the region, a converted school, offering an atmosphere of calm escapism.

O'Connell bought La Vecchia Scuola, standing on the edge of a quiet southern Tuscan village, in 1998. A large

LEFT This bedroom mirror was made from a salvaged mansard window, while the table is Indonesian.

RIGHT In the sitting room simplicity and symmetry create an open, ordered and luxe space with Chinese scholarback chairs, an English ottoman and a pair of benches in Ngpo lacquer.

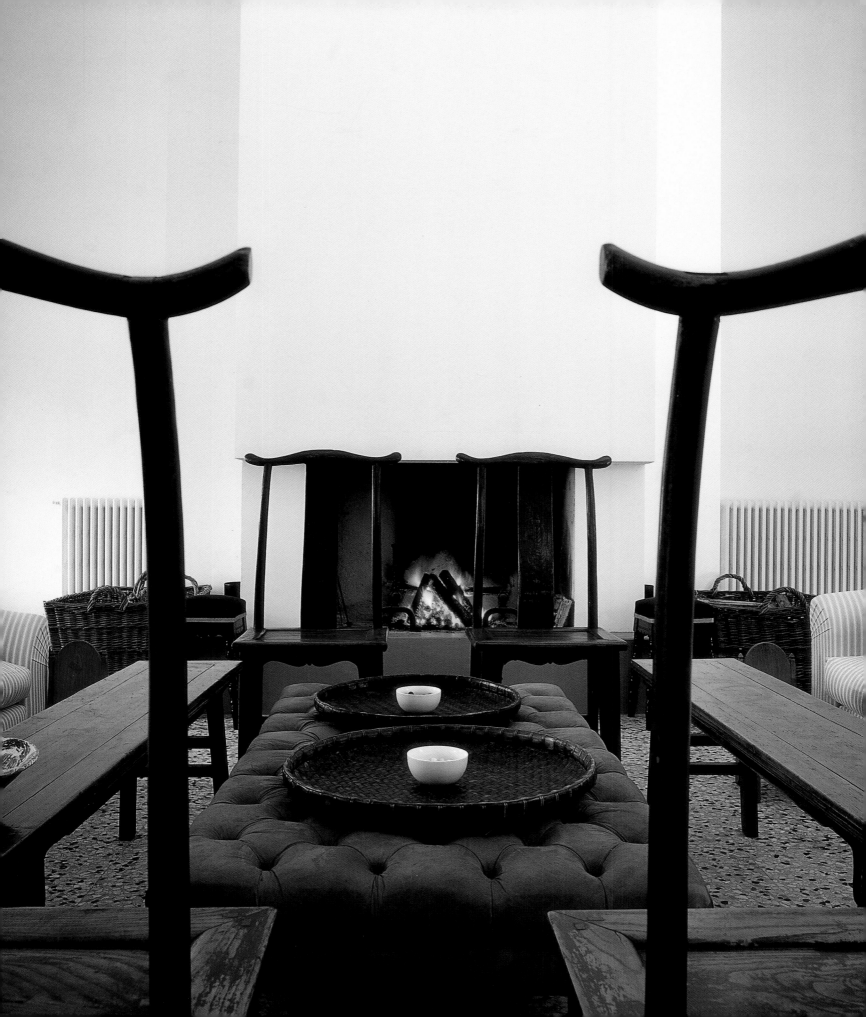

and functional building built in the 1960s, it is anonymous and undramatic when viewed from the street but it offered great potential for creating a sociable living space in one of the most beautiful parts of Italy. The school had been empty for some years and demanded a great deal of work to transform it from institutional space to a welcoming, sophisticated home. So, over a period of two years, O'Connell refashioned the building, reorganizing services, restoring the original terrazzo floors and creating a series of seven bedrooms, each with an en-suite bathroom.

'What I love about La Vecchia Scuola is the neatness,' says O'Connell. 'Because it was built as a school there are no awful little rooms; they needed space for the children so they built a long corridor, which I adore, and then there were six schoolrooms plus a large assembly room, where the living room now is. I created another bedroom out of the teachers' old staff room and each was so big that it could have a bathroom and a large closet.'

As with so much of her work, elements from Asia mix with the cast-iron beds – designed by O'Connell, made by local craftsmen – and other English and American pieces of furniture. In the living room there are some wooden

LEFT In the long hallway, with its restored terrazzo floors, the two benches are Chinese and the mirror from New York. The false doorway at the end is from Lombok, offering the eye an exotic focal point.

RIGHT In this bedroom contemporary designs such as the beds by O'Connell again merge with ethnic pieces, such as the Chinese chairs and trunks.

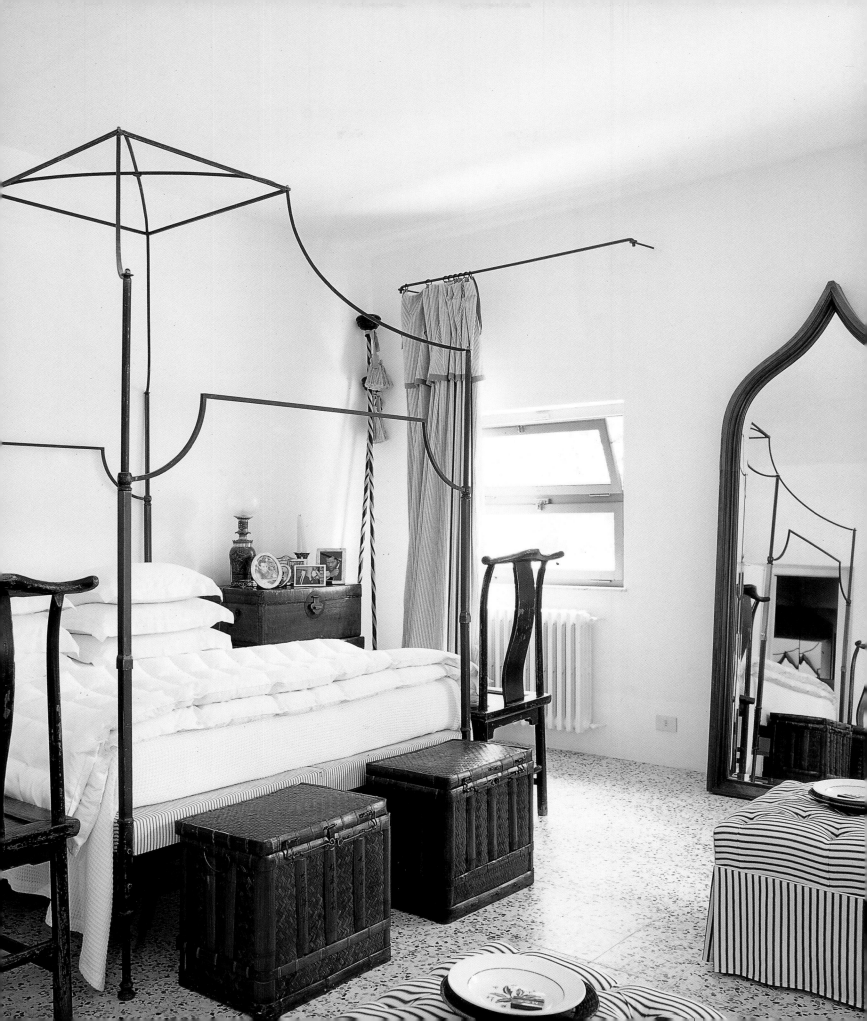

scholarback chairs from Beijing and Chinese lacquered benches, with a pair of vast Indonesian carved horses to one side. At the end of the hallway there is an ornate door from Lombok, leading to nowhere but serving as a focal point. There are Indonesian tables, red Chinese lacquered trunks and a bamboo bed from Bali.

'Bali has been a great influence on my work,' O'Connell says. 'I have been going there for years, since I was young. It's an influence not so much upon the work I do in cities, say London or New York, but upon summer places and homes in the country. Each country has certain things to admire. With Chinese furniture it's mainly peasant furniture that I like, not the imperial look. And I would say that for England, you learn how to sit there. English sofas and armchairs are wonderful – the best in the world.'

Colours have been kept peaceful and restrained, the whites of the walls suited to the Italian light, although in the cloudier atmosphere of a large city such as London she has always favoured at least one red room in her own home and those of her clients. Modest splashes of colour or contrast come from woodwork grain, bedlinen stripes, throws, charcoal and white ticking upholstery, cushions or lacquered furniture. Walls are kept clean and clear, with hardly a canvas or photograph, with the exception of Ben Johnson's painting *Nuts and Bolts* leaning against one wall in the living room.

Composition and scale have been affected by the large, broad dimensions of the rooms in the Old School. There are a few statement pieces – the grand sofas in the living room, made to a design by Jean-Michel Frank, the Gothic mirror in a bedroom – yet O'Connell has been careful not to fill the rooms and so risk destroying the sheer luxury of open space.

'I have a basic little rule that in small rooms you can put in something that is oversized and it can make the room important,' says O'Connell. 'So I tend to put double beds in little bedrooms. But in a big space you can leave it almost empty because the space itself becomes a feature, something divine.'

La Vecchia Scuola represents a more disciplined and judicious approach to design than usual for her, and a more contemporary, pared-down aesthetic. Over recent years her look has edged away from what one might describe as

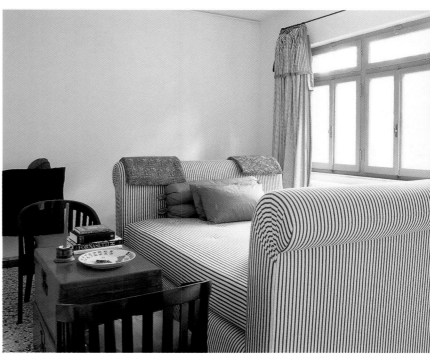

ABOVE, ABOVE RIGHT AND RIGHT Colour and pattern enter the mix largely through the use of fabrics: the reds and yellows of a bed cover; black and white ticking cushions on a Balinese bed and crimson fabrics draped over a bamboo recliner; ruby and scarlet soft furnishings for a ticking day bed, and bright red Chinese lacquered trunks nearby.

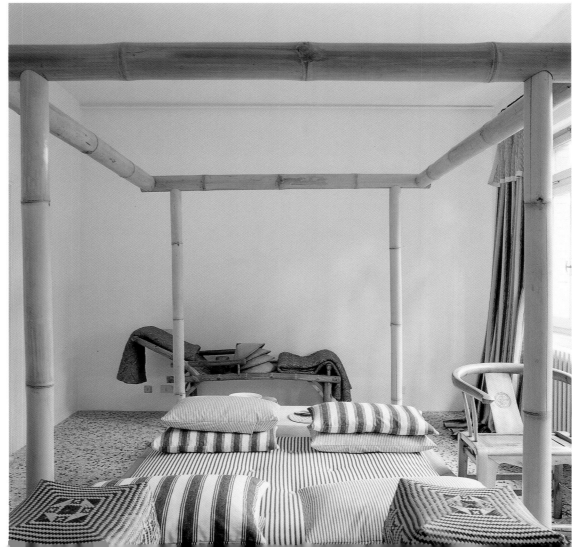

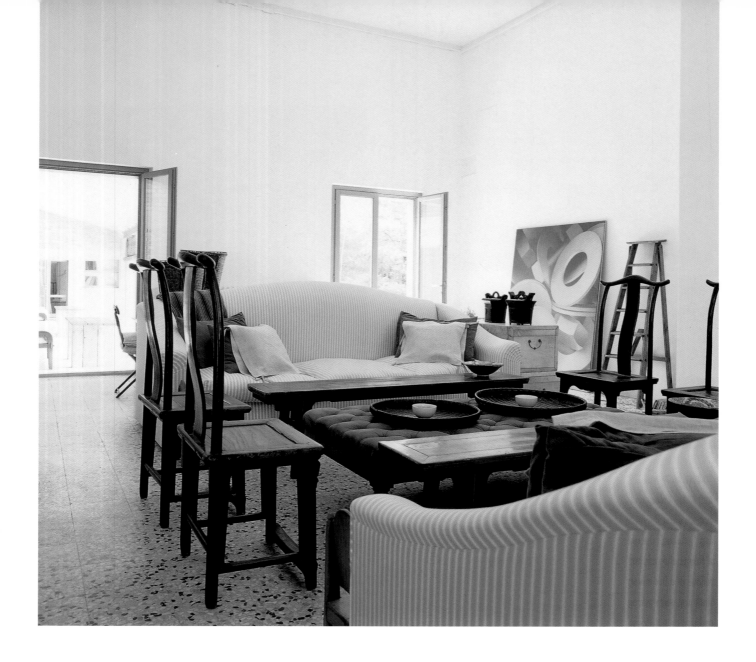

a traditional perspective to one of effective simplicity, bringing her full circle back to the ordered restraint of some of her early projects of twenty or twenty-five years ago. Yet this is not a version of minimalism; comfort and warmth maintain a strong presence, as do texture and a gift for the occasional, innovative surprise such as the circular tole (enamelled sheet metal) mirror made from an old French window.

'I want harmony and order,' says O'Connell. 'In Tuscany I have been able to achieve that and to have exactly what I want: the furniture I want, the space I want, the cosiness I want. I am very happy with the rooms at La Vecchia Scuola. They are representative of my state of mind.'

To the rear of the house lies a large veranda, complete with raw-board dining tables and Javanese benches. It overlooks not just the valleys beyond and below but also the pool, bordered with lanterns and surrounded by teak sunloungers. This is a home that transforms at night into something different, something more exotic and sensual, with candlelight reflected in the water and flickering through the house.

Yet her Italian home represents just one of three bases. O'Connell has lived in London since 1970 and also has a home in South Beach, Miami, while constantly travelling further afield to manage a portfolio of design projects: palaces in Kuwait, townhouses in Belgravia, apartments in Paris, houses in Florida and the Bahamas. Her work has taken her to Ireland, Spain, Germany and Argentina. At the same time her design company, Port of Call, has a London store trading in European and Asian furniture and textiles.

O'Connell will respond to the environment in which she is working, to the home in hand and its architectural style, yet her work has attained an international fusion aesthetic that now matches the breadth of her geographical scope. Even so, there is a refreshing modesty, as well as sophistication, to her perspective. 'Design is becoming more important because people are more design conscious,' she says, 'but it's not that we are necessarily inventing something. We are just helping people to put their homes together.'

LEFT AND RIGHT In the sitting room (left) the french windows are kept bare of curtains, partly to maximize light and partly to create a strong intersection with the veranda outside (right), which is treated as another living room, complete with cushioned benches and plank tables.

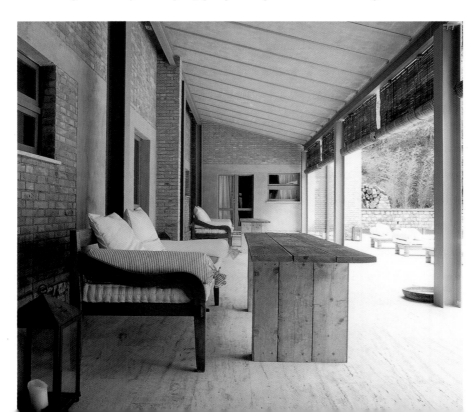

Peter Preller

HAMBURG IS A CITY OF LAND AND WATER. THE GREAT ELBE MEETS ITS SMALLER SIBLING, THE ALSTER, AND – TOGETHER WITH THE SEA ITSELF – THEY FEED A COMPLEX NETWORK OF CANALS AND WATERWAYS, HARBOURS AND BERTHS. THIS IS ONE OF THE GREAT PORTS OF EUROPE, OPEN TO TRADE FROM AROUND THE GLOBE AND TO THE IDEAS AND INNOVATIONS THAT COME WITH TRADING AND TRAVEL, AS WELL AS BRINGING A PARTICULAR MERCANTILE WEALTH TO THE CITY AND FUNDING A SOPHISTICATED ARCHITECTURAL HERITAGE. IT IS NO SURPRISE, THEN, THAT HAMBURG IS A HOME TO ARCHITECTS AND DESIGNERS, AMONG THEM ONE OF GERMANY'S MOST EMINENT INTERIOR DESIGNERS – A STATESMAN OF THE INDUSTRY – PETER PRELLER.

Preller lives in a large section of a house dating from 1906, overlooking the waters of the outer Alster, in one of Hamburg's most picturesque quarters. His main living area stretches across the first floor of the house, taking in the major reception rooms – designed on a grand scale – as well as the old library, which now serves as Preller's main bedroom. He moved here in 1990.

With its high, arching ceilings, pillars, parquet and elaborate cornicing, this was something different from the more modern, sparser environments that Preller has made his own in the past. But he takes an eclectic approach and had no hesitation in introducing contemporary elements, including many of his own furniture designs, into this semi-neoclassical space. 'My style used to be more minimal,' says Preller, 'working with steel and aluminium. But then I started working in wood, marble and many other richer materials. So now my work mixes contemporary ideas and antiques, the old and the new. It's about making contrasts in materials, style, texture.'

RIGHT In the reception room Preller's designs — such as the wall and side tables — blend with a quartet of chairs inspired by Jean-Michel Frank and a black Biedermeier cabinet. The boldness of some of the fabrics is softened by the restrained treatment of floors and paintwork.

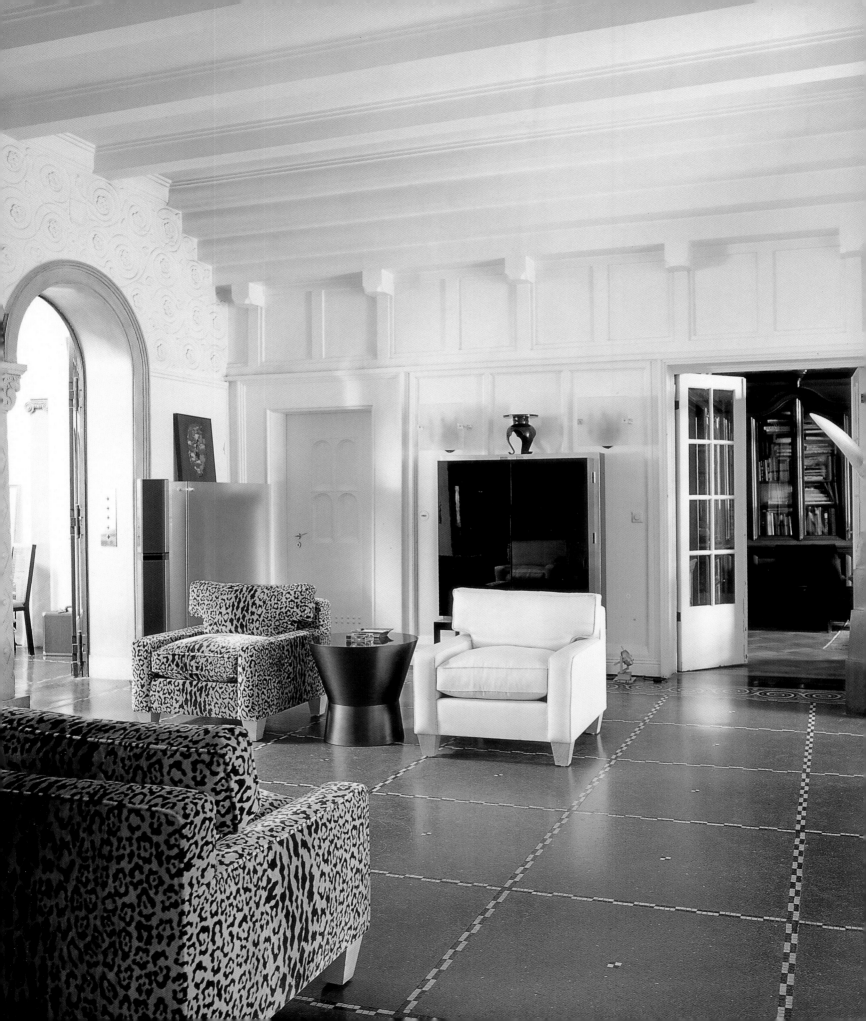

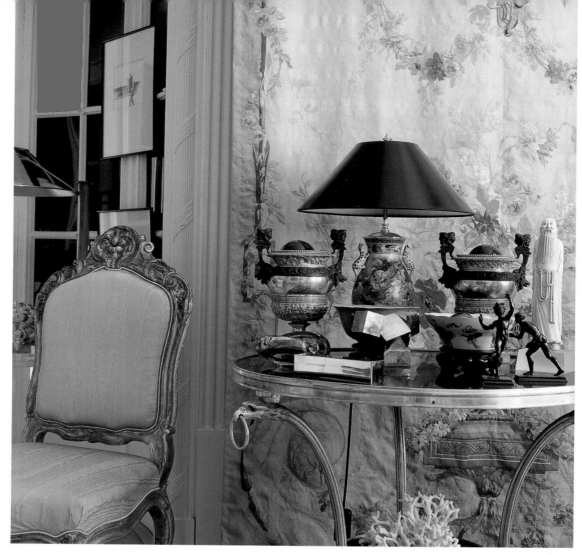

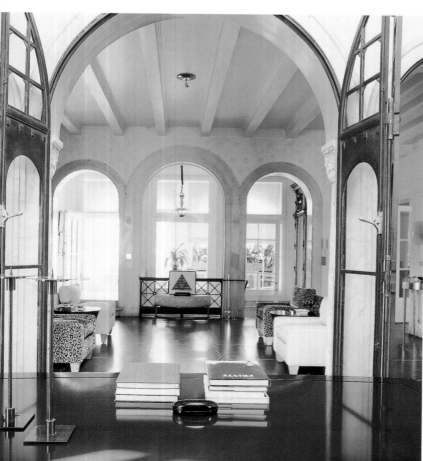

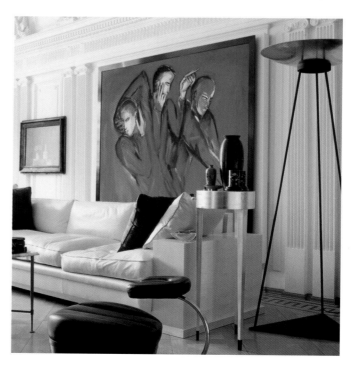

Having walked up the marble stairway from the entrance lobby and into Preller's home, you find yourself in a large reception area with terrazzo floors and a tiered ceiling. It is a sparsely but elegantly furnished zone with a quartet of armchairs in a design inspired by Jean-Michel Frank, two simply covered in white, the others in a bolder leopardskin fabric. This is the hub of the flat, an accessway as well as a functional room, and helps to give the apartment a sense of spacious luxury. Natural light floods into the room from an open arrangement of internal windows – spanning the stairwell – that aligns with a bank of windows to the front of the house, within a slender conservatory-like room overlooking the Alster.

This reception room, simply painted in white, also intersects with Preller's study via a triple-arched opening, supported by elaborately carved stone pillars. The original domed ceiling of the study, lined with geometric ranks of electric bulbs, is complemented by a recessed fountain in one wall, adorned with golden mosaics in classical style. Rich red and green Italian fabrics for the curtains bring intense flashes of colour, while at the centre of the space sits Preller's mahogany desk, hand-made to his own design.

For someone who often works from home, as well as office, the desk becomes a centrepoint and is often awash with sketches and plans, designs for furniture and stacks of books and magazines. Yet at the same time the study can also double as a dining room, served by the kitchen off to one side.

The sitting room is warmed by a rich oak floor, overlaid with a typical fusion of period pieces and contemporary designs. Preller designed the white leather sofa, the armchair opposite and the ottoman, as well as the gold display table and standing lamp nearby. The ornate stucco ceiling and the chandelier are original to the house, reinforced by other elaborate period pieces such as an Aubusson tapestry hanging on one wall or a gilded chair from the 1880s. Touches of a more vibrant shade infiltrate in pieces of modern art such as the red canvas by Meddendorf hanging above the sofa.

'There are many different influences on my work,' says Preller. 'There are designers such as Jean-Michel Frank, Ruhlmann, Chareau and, of course, names from the Bauhaus movement. Museums, too, are important – sculpture

ABOVE LEFT AND BELOW LEFT
In the sitting room the choice of furniture is eclectic, with period and modern pieces, such as the sofa and golden display table by Preller, placed under a painting by Meddendorf.

FAR LEFT A view from Preller's study – across a desk he designed by himself – towards the front of the house. Many original features have been preserved, such as the arched internal windows and doorways and vast glass doors.

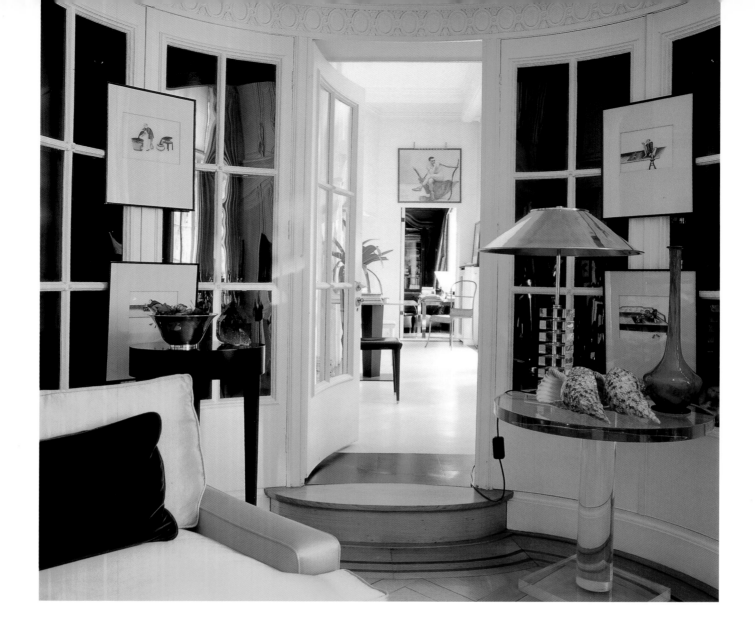

and art. Bavarian churches in baroque or rococo style are influences as well. They all come together in some way or other in my style of design.'

The conservatory-style 'corridor' leads from the sitting room along the front of the house down to Preller's bedroom, which still wears its original mahogany panelling. This is a more indulgent, warmer area, with its red, striped-fabric wall covering complementing the woodwork and soft, tactile materials such as the possum fur for the bedspread and a Chinese carpet to muffle the parquet.

The designer was born in the city, grew up here and studied design at Hamburg's design school. His father ran a joinery and furniture production company and Preller was interested in design from an early age. After he

finished his studies there was a period of travelling around Europe, absorbing influences and ideas from France, Italy, Britain and Spain.

Preller founded his own interior design company in the early 1970s, initially concentrating on commercial projects but gradually becoming more involved in the design of apartments and houses. His fusion style of design has long been in demand among German society figures and fashion designers, such as Wolfgang Joop and Jil Sander. Furniture and lighting design has also become progressively more important, Preller's designs all produced by hand, with an emphasis on fine craftsmanship and materials rather than mass production. Since 1995 he has run a studio in Hamburg selling his designs, as well as making bespoke pieces for individual clients.

Preller's work has shifted and evolved, not so much with the changing tides of fashion but with the changing interests of his mind, the balance of period and contemporary thinking altering subtly over the years. But his style remains familiar, recognisable and popular, displayed with delight in his own arresting home. 'Normally I change my home every five years,' Preller says. 'And often I choose to live with very modern architecture. I like to mix, to change. But somehow this house has been different. Ten years is certainly a long time for me.'

LEFT AND RIGHT Looking right through to the conservatory room (left) – which allows light to spill across the stairway atrium and into the apartment – and to the bedroom beyond (right). The colours and textures of the bedroom are darker, warmer and softer than elsewhere, with the mahogany panelled walls, possum fur bed cover and red striped wall fabric.

Michael Reeves

MICHAEL REEVES HAS HAD TWO CAREERS, TWO LIVES. THE FIRST WAS AS A FASHION DESIGNER, A PERIOD THAT LASTED NEARLY TWENTY YEARS. HE WORKED ACROSS THE BOARD – FROM COLOUR AND FABRIC PROJECTIONS TO DESIGN AND MARKETING – AND APPLIED HIMSELF TO EVERYTHING FROM MENSWEAR TO BALLGOWNS. HE RAN A FASHION CONSULTANCY AND DESIGNED FOR THE MICHAEL REEVES LABEL, BUT SLOWLY THE WORLD OF INTERIOR DESIGN BECAME MORE ALLURING, MORE REWARDING.

'While I was working in fashion I also had my own homes featured in magazines,' says Reeves. 'I was asked by somebody who bought a house from me to make it look just as it was when I was living there. That became my first interiors commission. And the precision that you need to put clothing together I then found was being applied to houses and rooms. Organizing furniture and accessories is like accessorizing a wonderful navy-blue suit – it's the same kind of principle.'

For a time Reeves found himself with a dual role, working on fashion and interiors in tandem. But by 1991 interior design had won and, seeking a new beginning, Reeves went to New York to take on a series of residential projects in America. Ever since then his star has been in the ascendant, as he expanded the design business with a furniture collection and a shop in London (now his permanent base) while also earning an international design award for the originality of his work.

LEFT AND RIGHT The large wenge mirror in the sitting room (right), designed by Reeves, helps to circulate light and seems even to enlarge the space. The display unit is from Ikea, housing a collection of glass and boneware vases. Details are all-important, as in the grouping in the study (left) with an olive-oil storage jar and ceramic antelope, bought in New York.

His style has combined influences not just from the fashion world, but from other periods such as the 1930s, and other continents, especially Asia and Africa. It is an urban look, but also international in character. And it was, in part, the product of a reaction to the constant remarketing of the traditional English country look and its tendency towards overembellishment and unneccessary complexity. 'I just got sick to death of seeing it,' says Reeves. 'Visiting people's homes, I was mentally stripping off the swags and tails and curtains and making something I could live with, something that was more peaceful looking. Really, I did what was pleasing to me, which turned out to be pleasing to others.'

His own London apartment, on the banks of the Thames, offers a refined example of Reeves's eclectic philosophy. He moved here a few weeks before the millennial change, attracted by views across the water and the sight of the river traffic and the herons and cormorants trawling the currents. Its former incarnation was one of Laura Ashley-style femininity. Reeves stripped the flora away to begin again with a sophisticated treatment, building up texture and fabrics on a neutral base, with most of the walls painted – subconsciously – in a shade not dissimilar to that of the Thames flowing by outside.

ABOVE AND BELOW RIGHT Apart from numerous contemporary pieces designed by Reeves himself, other additions add variety and character, as with the French tortoiseshell chest of drawers (above) or the African cane chest and Chinese leather boxes (right).

ABOVE RIGHT In the simply done dining area the dark dining table and chairs from Habitat contrast with the plain white walls.

'My natural feeling is for a neutral palette because I think that creates a sense of tranquillity,' says Reeves. 'Everyone thinks white is tranquil, but I actually find it quite jarring so I never use pure white; it will be a stone colour or a mid-tone. But if you use enough of *any* colour it becomes its own neutral because anything you then impose upon it will stand out. People often think we use just beige or taupe, but there is life after beige and we do use a lot of colour but in a subtle way. We have just done a house in London, for instance, that was themed with aqua, celadon and duck-egg blues.'

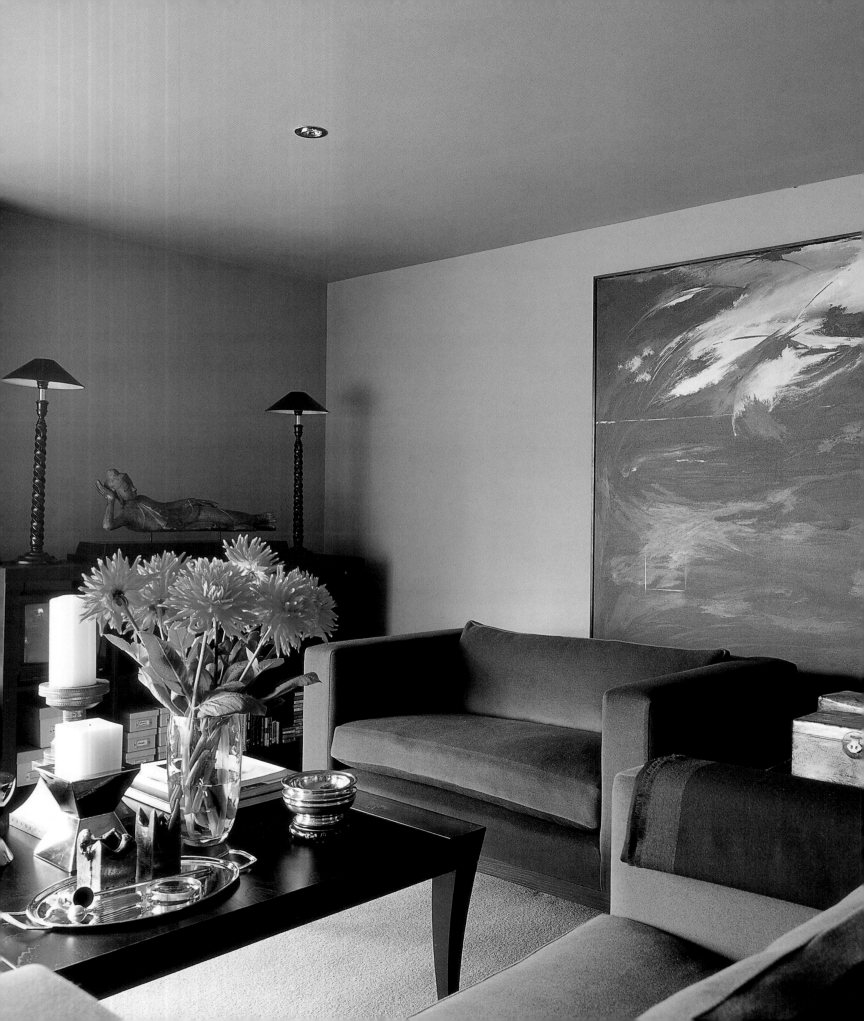

Texture, too, is of great importance in Reeves's work, influenced by the awareness of fabrics and textiles secured in his years in the fashion industry. Knitwear design, especially, helped him in designing rugs and choosing upholstery, while he favours contrasting hard but elegant surfaces such as stone or wood with luxurious elements such as cashmere or satin. In his sitting room you find wenge-stained ash for the coffee table or a decorative tin pilaster juxtaposed with a wool and cashmere mix for the armchairs and soft woollen carpets underfoot.

Much of the furniture in this room was designed by Reeves, forming part of his eponymous collection: the broad, plush armchairs; the chaise-longue with a Deco feel; the coffee table and large mirror, leaning against one wall. Added to the mix are more ethnic or oriental pieces such as the Chinese leather boxes or the African cane chest. And there is the occasional antique, like the ornate French tortoiseshell chest of drawers in Louis XV style.

'I was very pleased to hear someone describing my furniture line as "future classics" because that's precisely what I am aiming at,' says Reeves. 'It has a fashionable element yet I hope that it could translate into a home that might be very contemporary or could work in a more traditional room. But I began designing furniture because I couldn't find what I wanted, even something perfectly simple like an understated nightstand to go by a bed that I could get hold of in different widths. All the sofas were too soft, too high, not pared down enough. I made what I considered to be the ultimate sofa to go with my work, and that was the start of it.'

Large abstract contemporary paintings in the sitting room and hall bring added seasoning to the apartment, especially in the hallway, which is warmed by the reds and crimsons of the canvases. In a small study Reeves can spend time working at home with a view across the river. The main bedroom has been designed as a more intimate, atmospheric space with darker colours – chocolate browns and ebony woodwork – to create an ambience that is ideal for the evening. The screen behind the headboard is made with a plaster finish on canvas, creating a leather-look effect, while Chinese and Indonesian pieces bring drama and character.

LEFT AND ABOVE Reeves advises painting ceilings and walls in the same matt colour for an impression of unity and simplicity (left), while woodwork should be in a satin finish of the same shade. Here the taupe tone is reminiscent of the Thames outside. Paintings add contrast, texture and vibrancy in the sitting room and hallway (above).

In a further bedroom a fourposter bed with a metallic frame conjures the Art Deco age, the period Reeves declares to be the most influential for his work. 'It is the one era that mixes with everything because it's classic but the line of the furniture is simpler and the woods and fabrics used are exquisite,' he says. Jean-Michel Frank is a particular favourite, but the elegant style of contemporary New York designer John Saladino is also much admired. Reeves has a strong architectural interest, too, with a fascination for New York classics such as the Chrysler Building or the Dakota.

The analogy of fashion, in particular the construction of a well-cut suit, applies to the importance Reeves places on formulating a practical, working structure for a home. The form and line must be correct, the pattern laid down before starting on detailing and embellishment. Only once a strong foundation has been established in terms of planning a logically ordered space, with the human traffic flowing correctly, can work begin on the purely visual, aesthetic aspects of a project, whether it is reinventing a period terraced house in London or decorating a Manhattan loft.

'There is a general style running through what I do, the way I group things, gathering up ideas and putting them all together. Even if I do something on an eighteenth-century theme – which I have done on occasion –

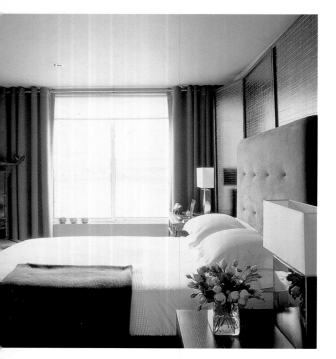

people still say, "That's a Michael Reeves room," and I don't quite know why that is. But the thing is to create a real mix – of modern pieces, antiques and so on – and that's something that a lot of people try to do but often don't do very well.'

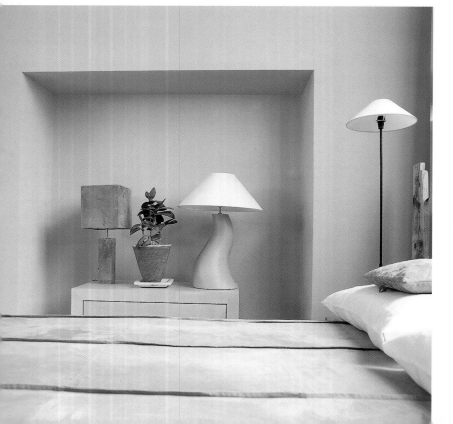

ABOVE LEFT, LEFT AND RIGHT 'Put money into the enduring items,' Reeves has said. 'You can buy a cheap bed, but you can end up spending a fortune at the chiropractor's.' In these two bedrooms, the beds are by Reeves, the colours for fabrics and furniture drawn from nature and the lighting soft and atmospheric.

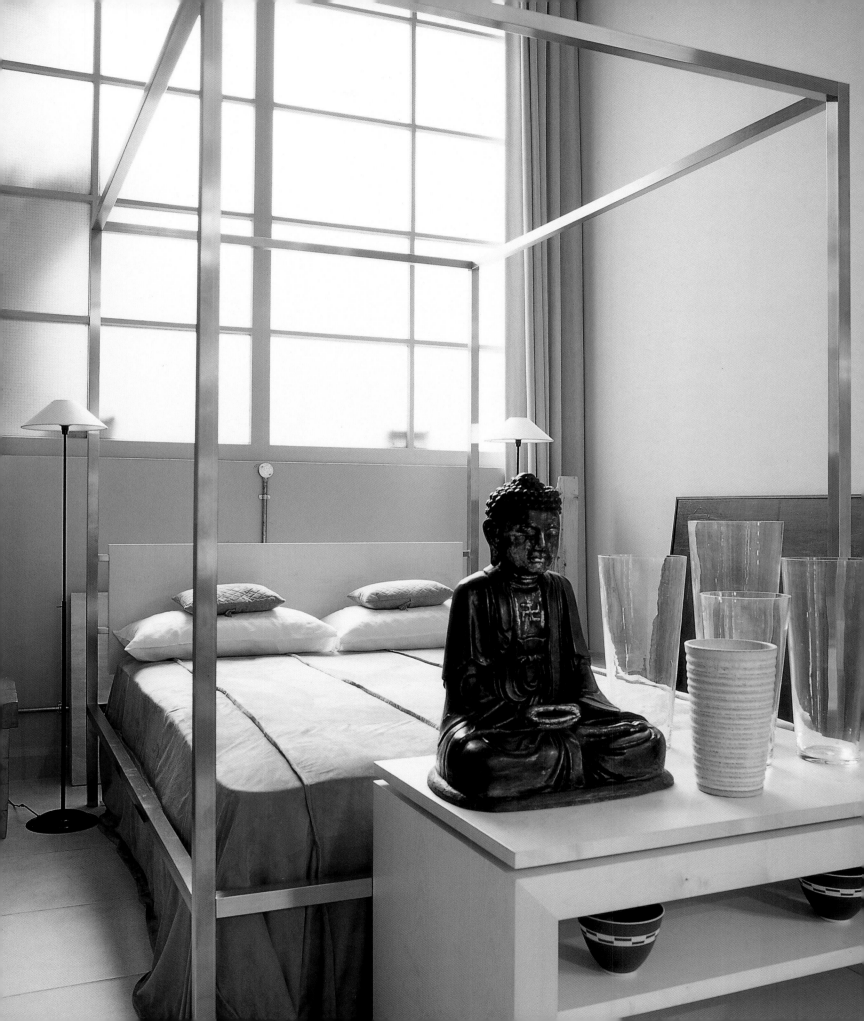

Stephen Ryan

THE FIRST THING YOU SEE AS YOU CLIMB THE STAIRWAY TO STEPHEN RYAN'S APARTMENT IS A PAIR OF VAST TIMBER SAINTS, GAZING DOWN FROM STEEL PLINTHS AND SET AGAINST A MIRRORED WALL. IT IS A STARTLING CONTRAST: THE WORN, CRACKED AND WEATHERED FEATURES OF THESE TWO ANCIENT SEVENTEENTH-CENTURY FIGURES SET AGAINST A GLEAMING BACKDROP WITH ART DECO ECHOES OF THE 1930S. BUT IT SETS THE TONE AT ONCE, NOT JUST FOR RYAN'S HOME BUT FOR AN INSIGHT INTO HIS STYLE, WHICH IS FILLED WITH CONTRADICTIONS AND DRAMA, PLAYFULNESS AND SURPRISES.

'I am basically a contemporary designer, but we sometimes do more traditional work and my style has always used a lot of neoclassical references,' says Ryan. 'It's all in the mix really, that whole notion of juxtaposing a seventeenth- or eighteenth-century piece against a stainless-steel wall.'

It is also a tailored and masculine look, bringing together these diverse, seemingly random elements in a very controlled, meticulous manner. To many, such different choices of periods and materials under one roof might appear a dangerous combination, yet Ryan's apartment is cohesive, ordered and cosmopolitan.

With windows to three sides introducing a good amount of natural light, Ryan felt able to risk using a palette of predominantly dark, elegant colours to tie the maisonette's first-floor, open-plan salon together. So the maple floors were stained black, charcoal fabrics were used to cover some sections of wall and sheets of sleek black glass were used for others.

Yet the heavier tones were balanced by plain white paintwork around the fireplace and for the ceilings, as well as the light-refractive mirrored panels

RIGHT In the main room the maple floors have been stained black, in keeping with the dark surfaces and walls. Yet these darker shades are counterpointed by a number of white walls and by mirrored panels, reflecting natural light. The red armchair and wenge table next to it are from Ryan's shop. The wooden saints — of Mediterranean origin, though once set in a Berkshire country house — overlook everything.

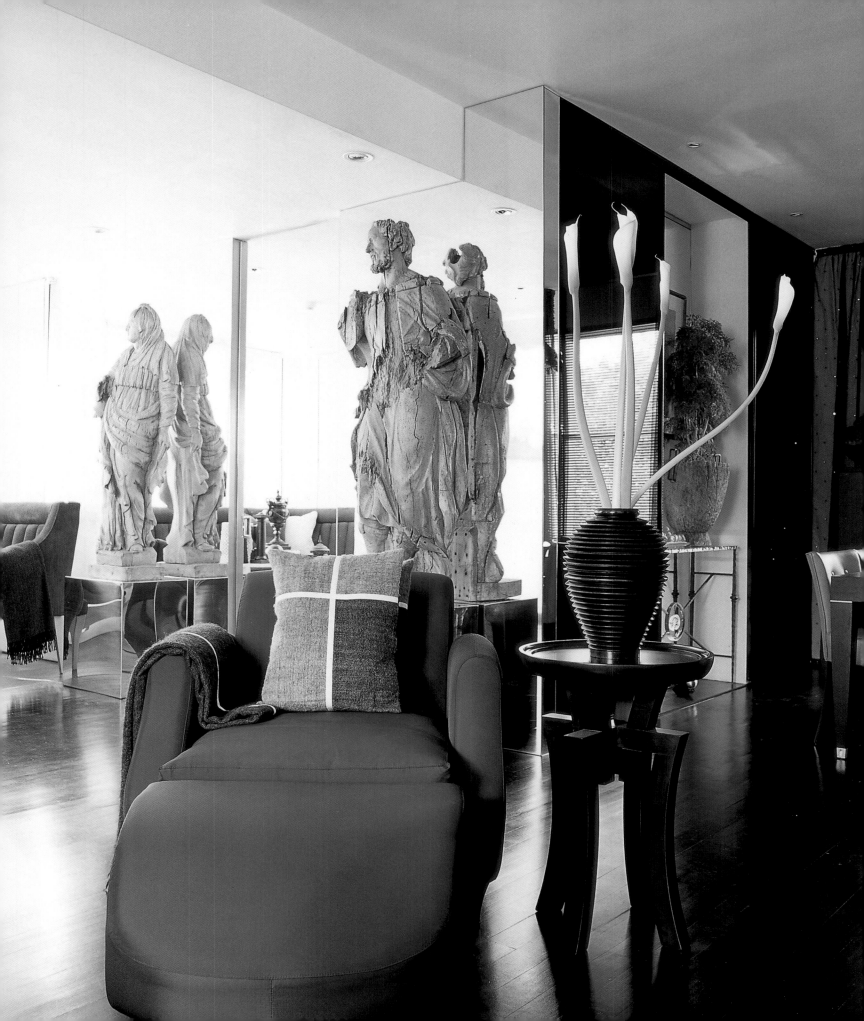

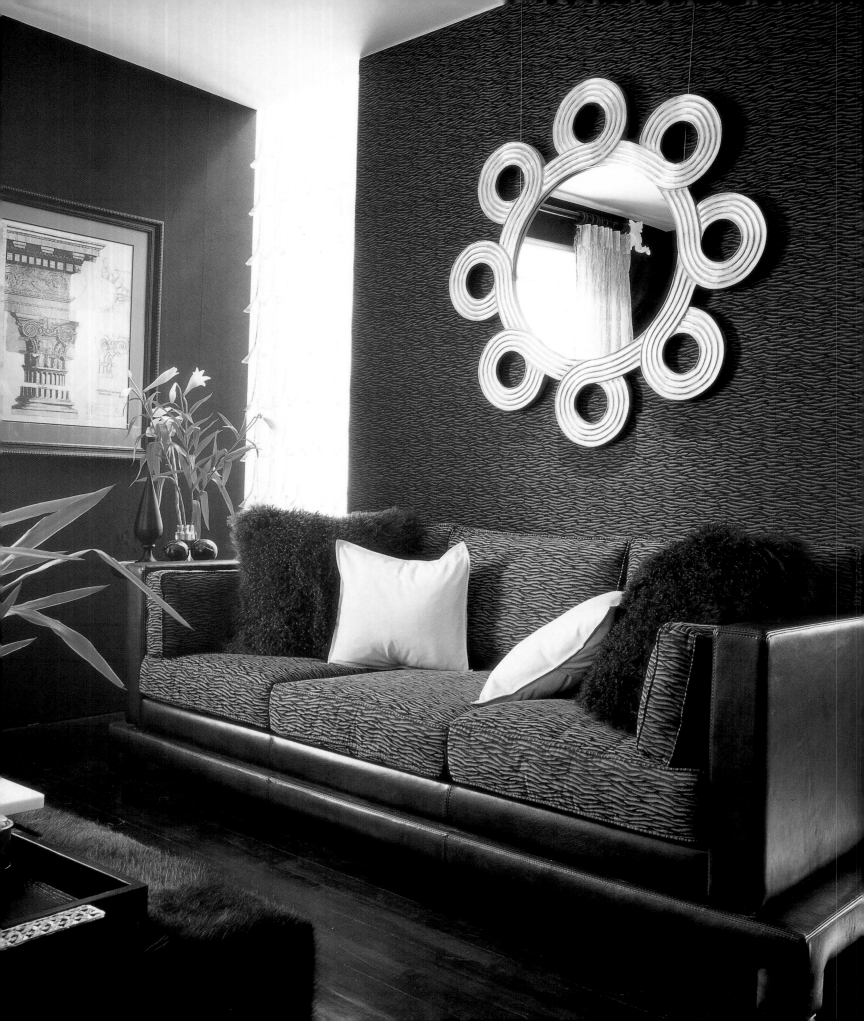

that encourage an illusion of added space while also concealing a doorway into the kitchen, thereby preserving the clean lines and symmetry of the space. Shades of white were also used for a seating area by a bay window towards the top of the stairs, creating a separate reception zone more suited to daytime, while the main seating and dining areas tend to come into their own in the evening, with a careful mix of zoned halogen downlighters – set on dimmer switches – combined with spotlights and the flickering flames of the granite and gravel fireplace.

Despite the apartment being in a period building, any architectural detailing was long gone by the time Ryan arrived in 1999. So there are no cornices, no fire surrounds, no architraves or skirting boards, which allowed more of an emphasis on exuberance and modernity in many other aspects of the style of the apartment. Much of the furniture was designed by Ryan – who has a London store selling his own pieces, plus other selected designs – such as the black sofa in a Pierre Frey fabric or the banquette-style seating by the bay window, covered in a Zoffany cotton chenille.

Yet alongside these relatively muted pieces come more theatrical notes such as the baroque, Italianate gilded chair or a pink calico-covered armchair, also designed by Ryan. Other sourced pieces fit into the blend, including the large 1940s oak cabinet along one wall – suggesting the importance, like the saints, of occasional oversizing for both drama and balance – or the contemporary Italian wenge-look dining table, surrounded by a set of 1940s English chairs, upholstered in a mock-ostrichskin material. This is a room that is typically rich in textural contrasts, with the sleek surfaces of steel and glass or polished wood mixing with ponyhair, leather or lambswool for upholstery as well as for cushions.

LEFT AND BELOW Night and day: darker corners of the large open-plan main room suit evening entertaining, as does the platform sofa by Ryan covered in Pierre Frey 'Ocean' fabric, like the wall behind (left). The mirror is from Ryan's store. The bay window forms a day reception area (below), with banquette-style sofas by Ryan.

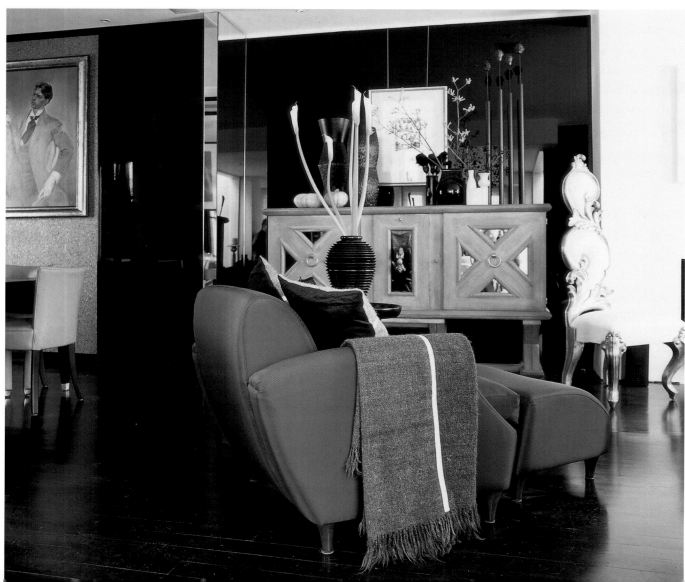

Up the stairway – the two sections of which are divided by a huge slab of suspended plate-glass – the feeling becomes a little more traditional. A designer who has always made the most of transitional spaces like hallways and landings, Ryan has used parchment pillars and ceramics, textured walls, neoclassical architectural drawings and console tables to pave the way from the stairs themselves to the bathroom and a pair of bedrooms. 'We knocked down the existing divisions between the bedrooms and moved the walls around because we wanted to make the second room feel bigger,' says Ryan. 'We also needed to put more storage space in upstairs, as we have in the living room with cupboards hidden behind those black glass walls, because there was just no storage space in the apartment at all when we arrived.'

Both bedrooms are bathed in sunlight from skylights and designed as softer, more indulgent retreats. There are fur throws and leather cushions, raffia-shaded bedside lamps, gaufrage flocked fabric for sliding walls with cupboards behind. The result is a dramatic, comfortable and luxuriant treatment for rooms that began as very modest, attic-style spaces. It testifies to a capacity for invention honed over twenty years of work and the evolution of a hybrid, eclectic approach to design.

Like Michael Reeves and Christian de Falbe, Ryan was originally attracted by the fashion industry, as his father worked in menswear, and as a young child to around the age of eighteen thought he might go in the same direction. But as a teenager Ryan also became more interested in interior design, borrowing David Hicks decorating tomes from the local library even as a fourteen year old and digesting them avidly. Before he was twenty he was being asked by a property developer in Bristol to design flats destined for rental to visiting actors and actresses appearing at the Bristol Old Vic.

But when the same developer asked him to work on a challenging large Victorian house Ryan began to feel he needed a broader frame of reference, so he enrolled at London's Inchbald School of Design in 1979. 'I knew I needed professional training and I also realized that I needed some kind of an entrée into London's interior-design world, which was something of a closed shop at the time,' says Ryan. 'So after Inchbald I went to work for Bill

LEFT Splashes of colour, such as the vibrant pink, calico-covered armchair (below) stand out all the more against the dominant black and white colour code, as do more theatrical flourishes such as the baroque-style chair with its gold-leafed woodwork (far left). At the far end of the room, past the vast 1940s Italian oak cabinet, Ryan has created an atmospheric dining area (left), which is dominated by the wenge-coloured contemporary dining table.

Bennette for three years, where I really learnt the technical and drawing side to interior design. He has a very tailored and precise style that I admired.'

Then in 1985 Ryan was offered a job by David Hicks, who had taken note of his work. From being a design assistant, Ryan suddenly found himself chief designer for a man whom he had admired since he first became interested in interiors, in charge of a twenty-strong creative team and an arbiter of the Hicks house style. 'Obviously there was a Hicks style, yet the client base was changing, people were becoming more design conscious, and so we had to tailor the look a lot more,' says Ryan. 'But Hicks was a great academic, very knowledgeable, and that was influential. So was his love of neoclassicism, Palladianism and symmetry.'

There were eight years at David Hicks in all, juggling projects at home and abroad, including hotels in Japan, Korea and Holland. It was an invaluable experience, a foundation for Ryan's own company, which he founded in 1993. Since then there has been work in England, Greece, Monte Carlo, America and Asia, work that has gradually shifted away from the Anglified neoclassicism favoured by Hicks towards a more tangible modernity, taking in references not just from neoclassicism but from India and Asia, the 1930s and 1940s, France, Italy and America, with the mix tempered and tailored according to his clients' demands.

Ryan suggests that his own apartment represents a low-key treatment in colour compared to the approach he might apply to a more typical commission, although there is a definite strand of calculated glamour there, a characteristic that seems to run through much of his work. 'This is very low key for me,' he says. 'Black and white is something I like for myself, but I do like to inject splashes of colour given the opportunity. I will always remember that when I was at David Hicks, Helena Rubinstein came to David and said that she wanted everything purple, literally everything: purple walls, purple floors, everything. And I thought it was fantastic. Barbara Cartland would have been my perfect client.'

LEFT AND RIGHT Areas such as stairways, halls and landings are always treated as integral spaces by Ryan. Here the stairway (left) is made all the more dramatic by the hanging glass divider. Bedrooms (right) are intimate spaces with a flock fabric for the walls and a fur throw.

Ed Tuttle

FOR ED TUTTLE THERE IS A SOLID LOGIC TO BEING AN AMERICAN IN PARIS. HIS WORK AS AN ARCHITECT AND AN INTERIOR DESIGNER CONSTANTLY TAKES HIM AROUND THE WORLD, WITH PROJECTS IN THE AMERICAS, EUROPE AND ASIA. PARIS, HE DECIDED, WAS IN THE MIDDLE OF THESE CRISSCROSS TRADE ROUTES SO THAT IS WHERE HE HAS BASED HIS BUSINESS AND MADE HIS HOME EVER SINCE THE MID-1970S.

He moved to his current apartment – with partner Christian Monges – in 1980, renovating part of a crumbling *hôtel particulier* in a typically international style, introducing many references from the East while respecting the original character and style of the eighteenth-century building. The parquet floors were intact, cornices and fireplaces were still there and a quartet of vast mirrors in the main salon were also original. Laying a backdrop of celadon-coloured cotton on the walls, Tuttle composed a fusion of self-designed furniture, French and European antiques, modern art, dramatic pieces of salvage and ornaments from Thailand, China and Japan.

This refined fusion style has made Tuttle very much in demand for residential and hotel projects, his work crowned by designs for the international Aman resort chain. Aman has brought him particular acclaim for an approach that combines a sympathetic respect for indigenous architecture, design and culture with modern thinking on comfort and indulgence.

There is Amanpuri in Phuket, Thailand, created as a series of pavilions in the style of a Thai temple, mixing local materials and building methods with a hedonisic, modernist attitude to space, bathing and solace. Tuttle created Amankila, Bali, on top of cliffs staring down onto the Lombok Strait, with a

RIGHT In the study – with its vista down through the main salon and secondary lounge beyond (right) – the desk is nineteenth-century Chinese, with a French chair from the same century. On the cabinet behind the desk stands a segment of Cambodian statuary. The mantelpiece detail (below) highlights a miniature landscape of Tiannaman Square and a pair of nineteenth-century Chinese candlesticks.

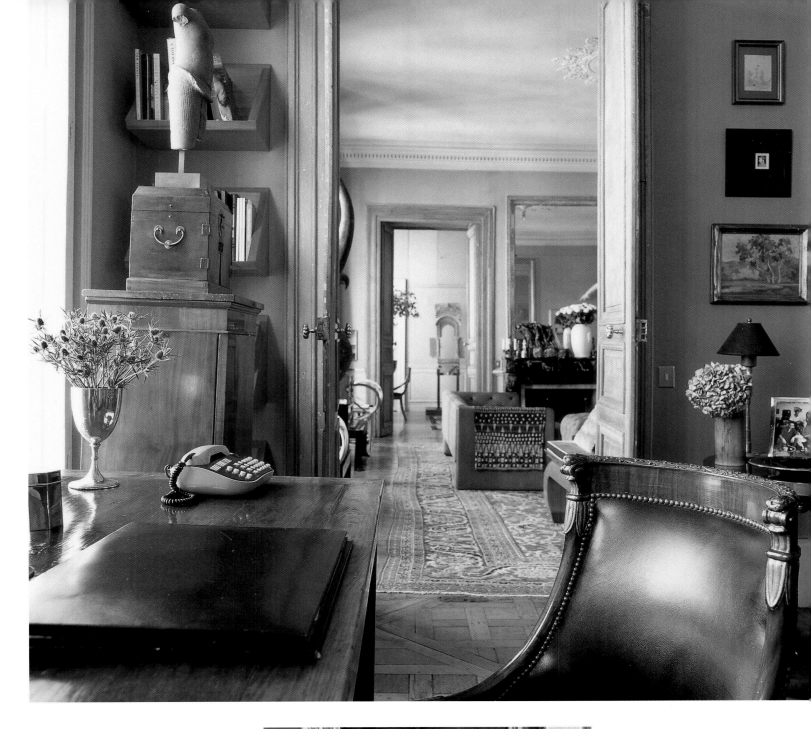

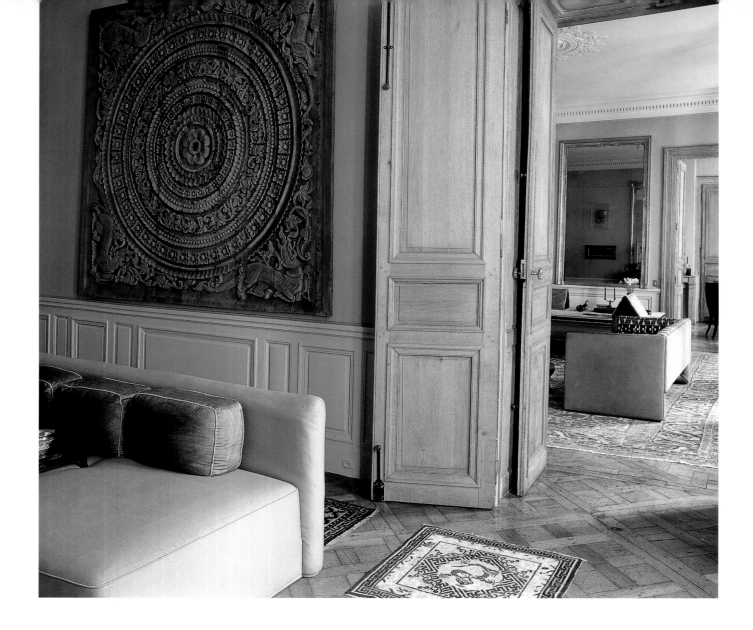

series of terraced, cascading swimming pools and a miniature village made up of individual, thatched, low and open guest lodges. One of the latest Aman resorts – Amanjena in Marrakesh – makes inspired use of Islamic architecture and Moroccan materials and craftsmanship.

'The cultural environment has an enormous amount to do with the attitude of the designs,' says Tuttle. 'I was brought up in the international, modernist style but then realized how important cultural identity had become, because we were stripping the world of it but the more you moved around the more you realized how important the individual culture of a country really was. It's good to keep the architecture clean and beautiful, but why are you there in the first place? So you start extracting things from that culture.'

Tuttle was born in Seattle and grew up on the American West Coast. His great-grandfather and grandfather were architects and this family heritage encouraged him to enroll at the University of Oregon's school of architecture, where he was fully versed in the principles of modernism with icons such as Mies van der Rohe and Frank Lloyd Wright makng their mark on his developing style. By the last year of his studies he was beginning to think not only about architecture but also its relationship to interior design.

'I'm not a graduate of interior design but by the time I finished school I realized that I didn't know that much about it and then it became more important to me. I understood how vital it was to finish the architecture, and that really to understand the space you had to complete it in some way. Furniture design became important to me, too, and I started designing pieces just after I graduated.'

He went to San Francisco to work in the design studio of the Post Street interiors store Gump's, then left for Asia to work on hotel commissions. In 1968 he found himself living in Hong Kong and developing a passion for Asian culture and architecture. 'It was an international life,' says Tuttle. 'Something different from San Francisco, which is a wonderful place in its way. But at a relatively youthful age, being out in Asia and working there was a fascinating experience.'

There was a string of hotel projects through the late 1960s and into the 1970s, in Asia, India and Greece, where he also lived for a time before settling in Paris and setting up his own company, Design Realization, in 1976. Both residential and commercial projects followed: homes for fashion designer Kenzo Takada and painter Brice Marden and then the launch of Aman resorts, founded by Tuttle's friend and collaborator, Adrian Zecha.

'Amanpuri, which opened in 1988, was the first, and very important to me. That was the beginning of trying to do a simple but luxurious resort, something that could

LEFT AND BELOW A view from the smaller lounge (left) — with a Thai ceiling panel fixed to the wall like a piece of art — to the larger. In the main sitting room the sofas and chaises-longues, all covered in leather (below), are Tuttle's own designs. Mirrors and fireplaces are original, colours mainly in the calm spectrum ranging from sand to cream. To the right of the fireplace hang an Egyptian mask and an image by Brice Marden.

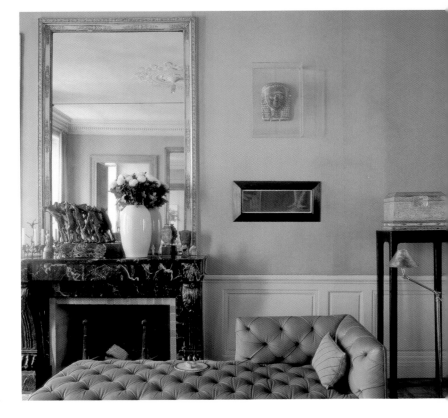

really work on an international basis. It was started not with a commercial mentality but aiming for a very personal, residential feeling. It was a little bit of a dream, but one that seemed to work and it went on from that. I designed Amanpuri and six or so after that.'

His workload combines a majority of new building projects with a number of conversions, blending architecture with interiors. Currently there is work on a new hotel in Paris, created out of five nineteenth-century buildings. In Milan there is a bank being converted for residential use, while home commissions are underway in Honolulu, England, Paris and New York.

'There is a certain classicism involved, but it's very stripped down,' says Tuttle of his style. 'The relationship of proportions is very important and the continuity of materials, with a surprise or two every now and then. But when it comes down to it, it's a matter of what particular style of life you are designing a space for. I do like pure spaces, and if you look at Mies van der Rohe, or Philip Johnson's glass house, that's a form of minimalism that is wonderful. But then you have to live in it. And a style shouldn't just be applied across the board – it's a shame not to appreciate whereabouts you are living. Why live in Hong Kong, New York or Paris without being stimulated by that culture?' Tuttle's Paris apartment manages to bring together many of the principles that play through his work, with a recognition of its

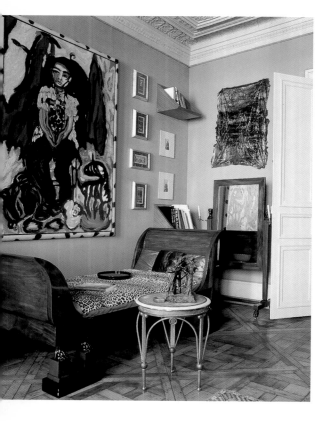

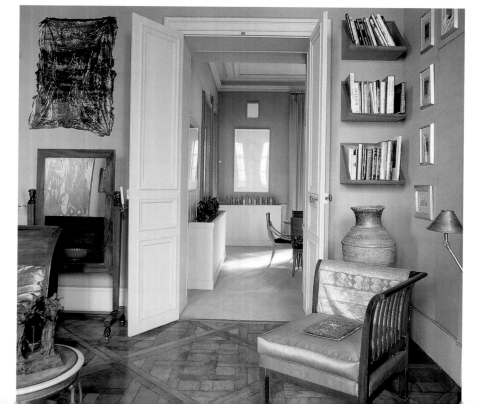

ABOVE LEFT AND LEFT The small circular table in the study (above), in front of a French eighteenth-century day bed, is an early Tuttle design, made in Greece. The study adjoins the dining-reception room (left).

RIGHT The rugs in the sitting room, laid over the original parquet floors, are Ziegler designs from the 1830s. The *chauffeuse* in the middle of the room is French nineteenth century, while the butterfly bentwood chairs are by Tuttle.

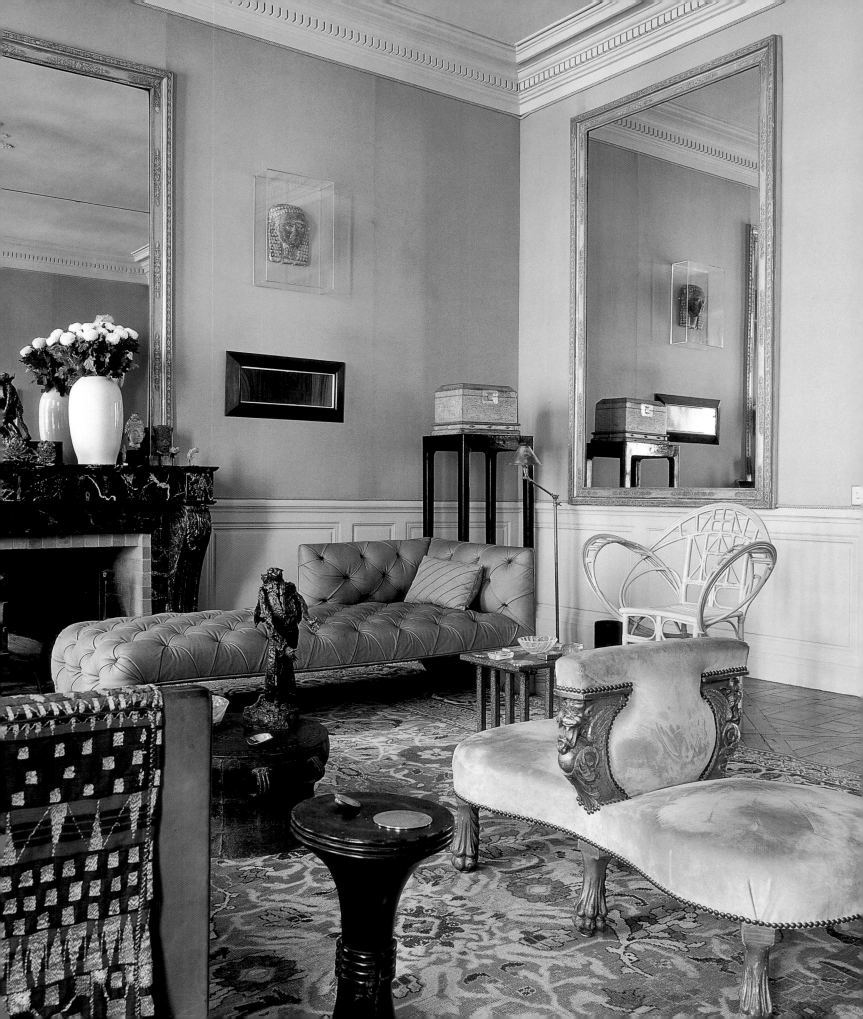

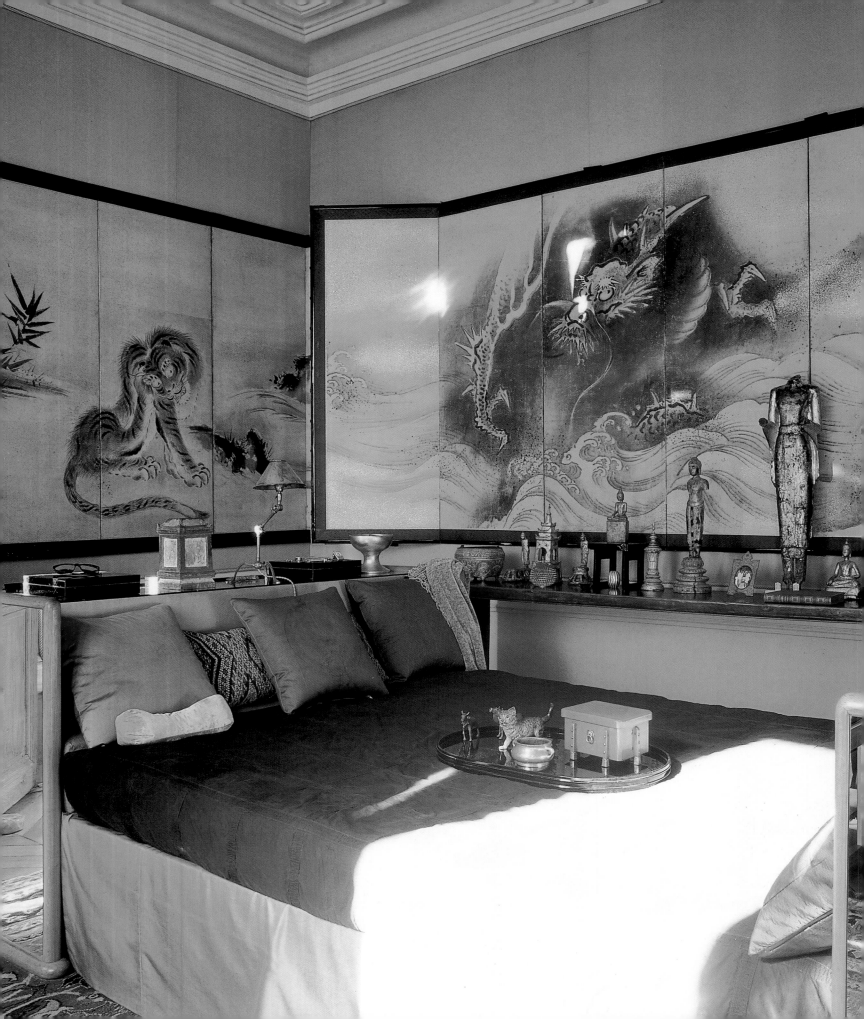

ED TUTTLE

Parisian surroundings, as well as the character of the building, and yet with a significant concentration on comfort and clarity.

The fabric on the walls – as in Jacques Grange's Paris apartment, where a similar shade has been used – creates a calm, neutral background that allows the furniture and artwork to breathe. In the main salon there are a number of pieces – such as the matching pair of chaise-longues and the sofa, all covered in leather – by Tuttle, who now designs occasional pieces of furniture that are commercially produced, as well as many one-off designs for individual clients. They blend with the French nineteenth-century *chauffeuse* at the centre of the room, set on a Ziegler carpet from the 1830s. In the window sits a dramatic gargoyle from a Thai temple – looking rather like a vast, twisted narwal's horn – while to one side is a large low table that is a Tuttle copy of a Chinese Ming design covered in velvet. There are also items of contemporary art: a graphite piece by Brice Marden or a large plaster figure by French artist Roseline Granet.

Other rooms reveal a similar fusion of period, ethnic and contemporary influences. In the study an eighteenth-century cabinet and armchair mix with a Chinese desk, Cambodian statuary and a circular table designed by Tuttle. In a second, more intimate sitting room a vast panel against one wall was once an ornate section in a Thai ceiling, rugs are Chinese and the rosewood desk and chair are nineteenth century. The main bedroom has been designed as a dual-purpose space, doubling as another living room. There are Japanese screens from the seventeenth century, a Chinese cabinet in Ming style and a bed by Tuttle, with built-in storage units.

'I feel it's very personal,' says Tuttle, 'a combination of Christian and myself. Everything is a design statement if you are an architect or a designer, but the apartment wasn't meant as such. It was put together as a home for living in. It was for fun and for pleasure.'

LEFT The screens that dominate the main bedroom are Japanese seventeenth-century pieces, while the ranks of small statues include bronze Buddhas from Thailand. The bed was designed by Tuttle to include built-in storage units.

BELOW In the small salon the desk is of rosewood and the chair beside it is Swedish nineteenth-century. Again the look incorporates pieces from Asia such as the Tibetan rugs.

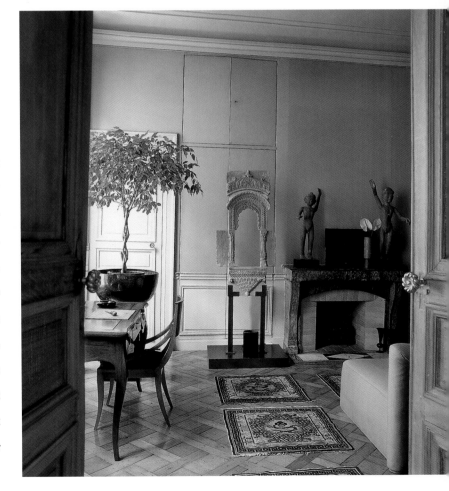

137

Modern

THE MODERN LOOK HAS COME TO INCLUDE PLEASURE AND INDULGENCE, AS WELL AS SIMPLICITY AND CLARITY OF FORM. RICH MATERIALS, MAXIMIZED LIGHT AND HEDONISTIC TEXTURES BRING A RICHNESS INTO THE CONTEMPORARY ARCHITECTURE OF THE HOME, WHERE INDIVIDUALITY AND EXPRESSION ARE WELCOMED AND ENCOURAGED. TECHNOLOGY AND INNOVATIVE, SLEEK ELEMENTS OF GLASS AND STEEL HAVE THEIR PLACE BUT Ñ UNLIKE THE AUSTERITY OF SOME TWENTIETH–CENTURY MODERNIST DESIGNERS AND THEIR MINIMALIST OFFSPRING Ñ THE MORE RELAXED MODERN STYLE OF TODAY IS NOT EXCLUSIVE BUT INCLUSIVE, WELCOMING A MULTITUDE OF IDEAS AND ORIGINAL THOUGHT.

Charles Bateson

FROM THE OUTSIDE CHARLES BATESON'S HOME LOOKS JUST LIKE ANY OF THE OTHER VICTORIAN TERRACED HOUSES RUNNING THE LENGTH OF AN ANONYMOUS, SEDATE LONDON STREET. BUT APPEARANCES CAN BE DECEPTIVE. ON STEPPING THROUGH THE FRONT DOOR YOU FIND YOURSELF ENTERING SOMETHING ALTOGETHER DIFFERENT: A MODERN, CONTEMPORARY SPACE FILLED WITH LIGHT, WARMTH AND SHADES OF GLAMOUR.

Bateson and his wife, Maggie Libura, bought the house in the dying days of the last century, after searching for somewhere that would allow them to start from scratch and create a new home for themselves which would suit them both in terms of style and function. A year's work followed as Bateson updated and redesigned the house, applying a look that mixes elements of 1930s style with up-to-date thinking and home technology.

'The house was completely untouched,' says Bateson. 'All the walls had just one layer of wallpaper stuck onto the bare plaster, so it had never been repapered. There was a Belfast sink in the kitchen and a Belfast sink in the bathroom. We deconstructed the whole house and put it back together again.'

Bateson resisted any temptation simply to take away as many walls as possible to open up the proportions of the rooms. Instead he decided to try for the best of everything: preserving the useful sense of separation between the main rooms while enlarging doorways and rearranging the back of the house to introduce more light. Doors leading from the living room to the family room and from there to the combined kitchen-dining room at the rear were removed, while the openings were extended vertically to maximize a vista from the front to the back of the house.

ABOVE RIGHT A view from the family room through the tall, extended doorway and into the sitting room beyond. The backless day-bed sofa was designed by Bateson and covered in a Scottish bouclé fabric, while the walls are grey-cream.

BELOW RIGHT In the working area of the kitchen the floor, worksurfaces and splashbacks are all blue limestone for unity and simplicity, while the kitchen cabinets are beech. French windows lead out to the decked garden.

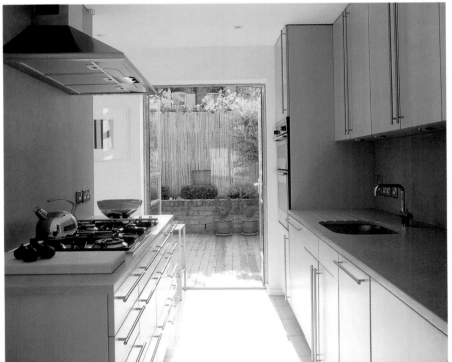

'One of the things you hear people saying all the time is that they want their homes to be light and airy,' says Bateson, 'and one of the reasons people open up rooms so much is that they think they want more space. But when you turn two rooms into one you don't physically get any more space – you get more depth of field because your eye can see further. So they open up everything as much as possible and end up with a football pitch but no structure and very few walls left to put anything against.

'So I think the solution is to keep the integrity of each room while also achieving the depth of field. I don't like the idea of two rooms becoming one but I do like this sense of depth where you can see through to the back garden from the front room through these tall, narrow doorways.'

Bateson resupported the rear of the house to allow him to enlarge the kitchen with a small glass-roofed extension. Here a half-section of slim dividing wall separates kitchen and dining zones while preserving much of the impression of one large room. Two sets of double-glass doors open out onto a decked garden, treated as an integral space, complete with bamboo walls, miniature fountains and sunloungers. The layout here provides an

important sense of flexibility, with the ability to adapt to formal dinners or informal family meals with ease, to create a warm winter room or an integrated indoor-outdoor area in the summer months.

In the kitchen and dining area blue limestone for floor, worksurfaces and splashbacks gives a clean unity to the space and ties in with the stone floors of the hallway. Sandy-coloured carpets in a geometric grid pattern bring the living room and family room together, along with a grey-cream border colour for the walls. In the front room the focus is the fireplace, which Bateson designed in limestone, while in the family lounge the television replaces the fireplace as the focal point, with banks of shelving and cupboards to hide music and video systems.

LEFT AND RIGHT The kitchen diner (right) and the garden (left) have been designed as an integrated space, the twin set of double glass doors providing a soft border between inside and out. In the summer months the two areas become one, with the garden acting as additional living space complete with loungers. In the kitchen itself a monolith wall lightly separates dining and cooking areas.

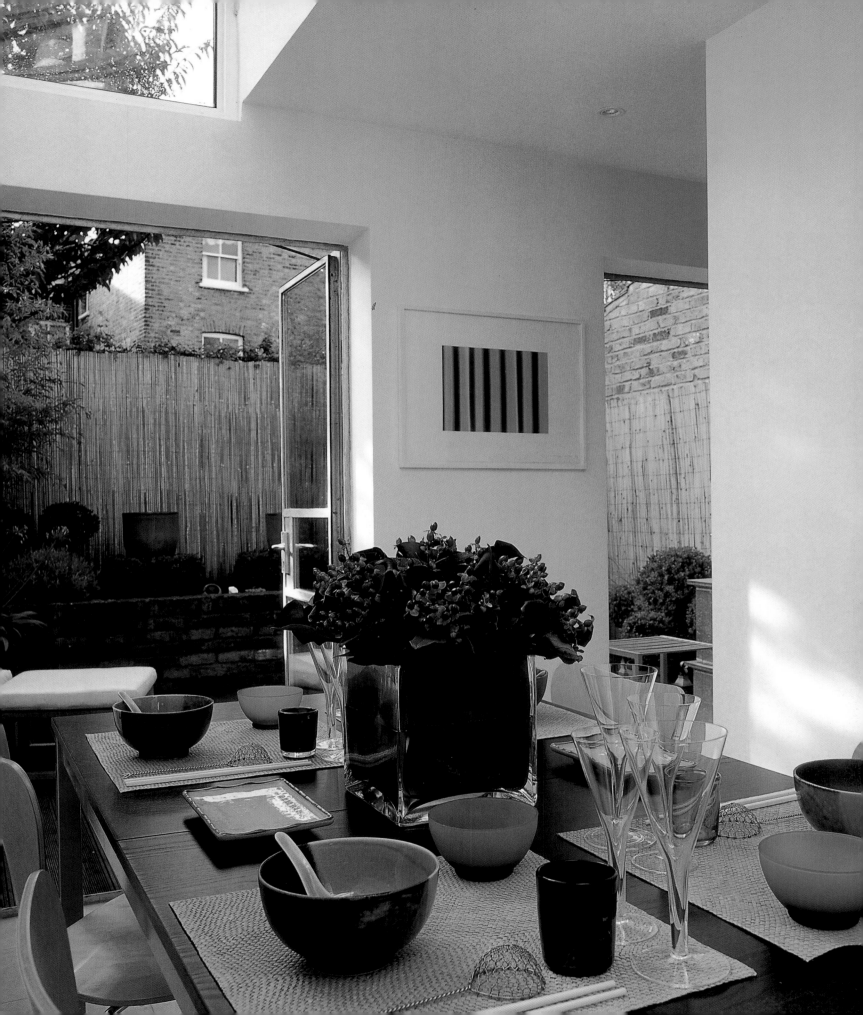

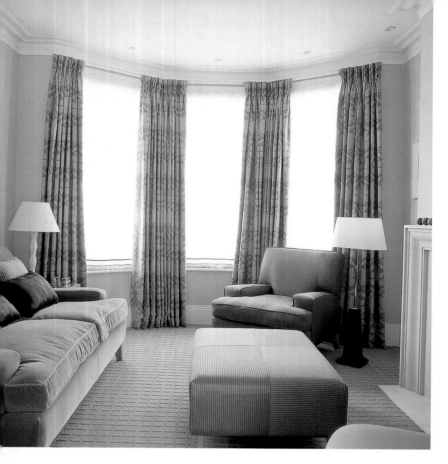
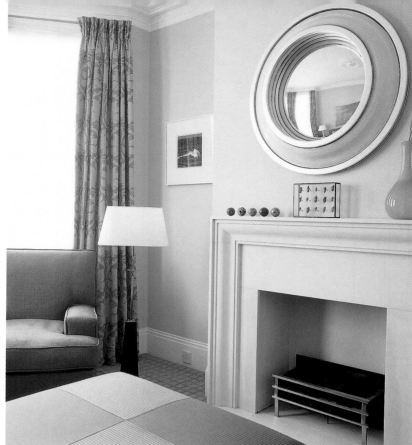
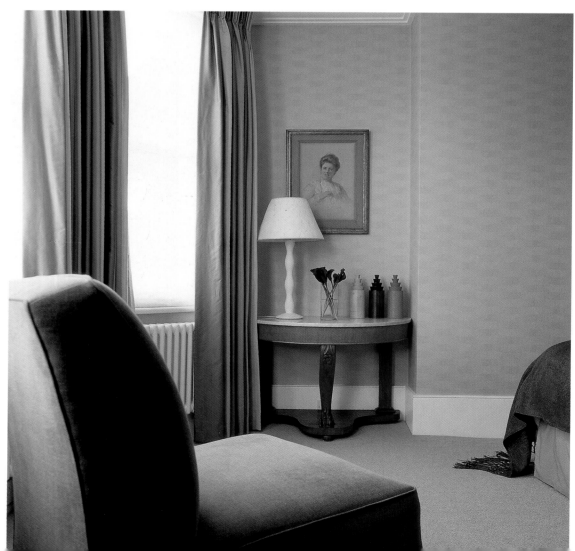

Much of the furniture in the house – including the sofas, armchairs, mirrors and ottomans – is by Bateson, who has formed a furniture company that now produces and markets original pieces designed over the years. Textures are varied, with velvets and raffia, bouclé and silks for upholstery and cushions, emphasizing the importance of comfort and calculated touches of luxury. There is a richness of detail yet it is based on a simple foundation, a statement that partly defines Bateson's approach to interiors. 'I like taking a space and removing everything that's extraneous,' he says, 'and then putting in as much richness as I can without making it cluttered.'

Born in Cheshire, Bateson originally studied fashion and textiles at Winchester School of Art, partly inspired by family friends who worked with fabric designer Zika Ascher. But by the time he left Winchester he found himself losing interest in fashion, but intrigued by other forms of design. He went to work for David Hicks, designing first products then interiors. He stayed for nine years, the experience helping to shape his approach.

'The whole attitude to creative thought, having a basic structure to the way you think but also allowing yourself to be quirky – which was something Hicks was brilliant at doing – was very important to me,' says Bateson. 'And the use of materials, colour, texture. You couldn't help but be influenced by David Hicks if you worked with him.'

Later there were four years at John Stefanidis, where Anthony Collett and interior designer Philip Hooper spent formative years. With Stefanidis came technical lessons, an appreciation of a thorough, organized architectural approach. By the mid-1990s, however, Bateson wanted independence and the opportunity to develop his own way of working.

In 1997 – just months after starting his own company and embarking on his first solo projects – he was invited to participate in the British Interior Design Exhibition at Number One, Cambridge Gate in London's Regent's Park. Bateson joined designers such as Alidad, Stephen Ryan, Christophe Gollut and Victoria Waymouth, each taking a room in the house to showcase their style and individual approach to the proportions of this six-storey Victorian home built in grand Parisian style. Bateson's design for a study was

ABOVE In the main sitting room much of the furniture was designed by Bateson, as were the limestone fireplace and the mirror above (right). Colours are largely neutral with splashes of contrast, such as royal-purple cushions in wool and silk (left).

LEFT Up in the bedroom the look is a touch more traditional with a Knowles & Christou wallpaper. The marble-topped console table and portrait above are family pieces.

both contemporary and opulent, with Mongolian-fleece chairs, leather-hide flooring, glass mosaics and a stone fireplace.

'The one thing that the exhibition forced me to do,' says Bateson, 'was to sit down and think about my style and the direction I was moving in. For a lot of designers it was just a question of doing a room in their established look, but for me it was about clearly crystallizing my style for the first time.'

Bateson steered away from neoclassicism and many aspects of a more traditional English interior design, opting instead to establish a new creative method influenced by pioneering designers of the 1930s and 1940s such as Jean-Michel Frank, André Arbus and Jacques-Emile Ruhlmann. 'The predominantly French decorative movement of that period is what influences me most: my interiors, my furniture, everything. Designers then created rooms that were both modern and beautiful, rich, full of colour, depth and good materials. That's what I like. But I'm not trying to be a purist about it. I'm trying to find the best elements, boil them down and create my own approach.'

Much of Bateson's work is residential; he tends to focus on just one major project – and perhaps two or three smaller jobs – at any one time in order to concentrate his attention and maintain standards. His style adapts to town or country, and he has also designed showrooms for fabric and furniture designers such as Bruno Triplet, Jean Monro and Christopher Norman.

RIGHT In the bedroom detailing such as the 1930s-style cornicing is new, and the dramatic headboard and the bedside tables are by Bateson. Vibrant shades for bedlinen and cushions impart a feminine element.

LEFT Limestone floors in the hallway create a seamless connection to the kitchen beyond. The mirror leaning against one wall is designed by Bateson.

His own home perfectly reflects his love of reinvention, his recognition that patterns of living laid down by the Georgians and Victorians may be out of date but modernity does not have to mean minimalism or lack of comfort. 'I am very happy with what we have here,' he says. 'It's just a bay-fronted terraced house, and Victorian terraced houses as they were built are not that useful for how people want to live now. But people who come here can see the sense behind the way we have redone it. Every room has a focus.'

MODERN

Thomas Sandell

RIGHT ACROSS SCANDINAVIA THERE IS A STRONG TRADITION OF INTERDISCIPLINARY DESIGN. PAST MASTERS SUCH AS EERO SAARINEN, GUNNAR ASPLUND, BRUNO MATHSSON, ARNE JACOBSON AND POUL HENNINGSEN WORKED NOT SIMPLY AS ARCHITECTS AND INTERIOR ARCHITECTS BUT ALSO AS INTERNATIONALLY RECOGNIZED FURNITURE AND PRODUCT DESIGNERS. TODAY A NEW GENERATION OF NORDIC DESIGNERS IS EMERGING AND TALL AMONG THEM STANDS THOMAS SANDELL.

In a relatively short period of time Sandell has established an international regard for himself and for his work, designing furniture for companies such as B&B Italia and Cappellini, as well as mass-market products for Ikea. His company, Sandell Sandberg (encompassing a graphic design and advertising arm run by Ulf Sandberg), has undertaken architectural and interior projects in London, Boston, Moscow, New York, Bologna and Munich. And in Sandell's home city of Stockholm, Sweden, he has been responsible for the interiors of major institutions such as the Swedish Parliament building, the Museum of Modern Art and the Swedish Museum of Architecture.

'There is this tradition among architects in Sweden to do everything,' says Sandell. 'And that's the way I like to think about design. Perhaps the best-known example is Alvar Aalto. He is a big influence, in the way he worked across so many disciplines and the way he transformed international style with a kind of Scandinavian humanism in his work. I'm trying to follow a similar way of working: to add something different in terms of design rather than just doing the same kind of work you might see in Italy or Germany.'

RIGHT The many windows and glass bricks of the penthouse apartment betray its past as a 1930s studio for textile designer Ingegerd Thorsman. Sandell's scheme has preserved the light, white and airy nature of the main room with its bleached floorboards and white walls. The sofa and wicker chair in the corner were designed by Sandell for Ikea, the table for B&B Italia.

148

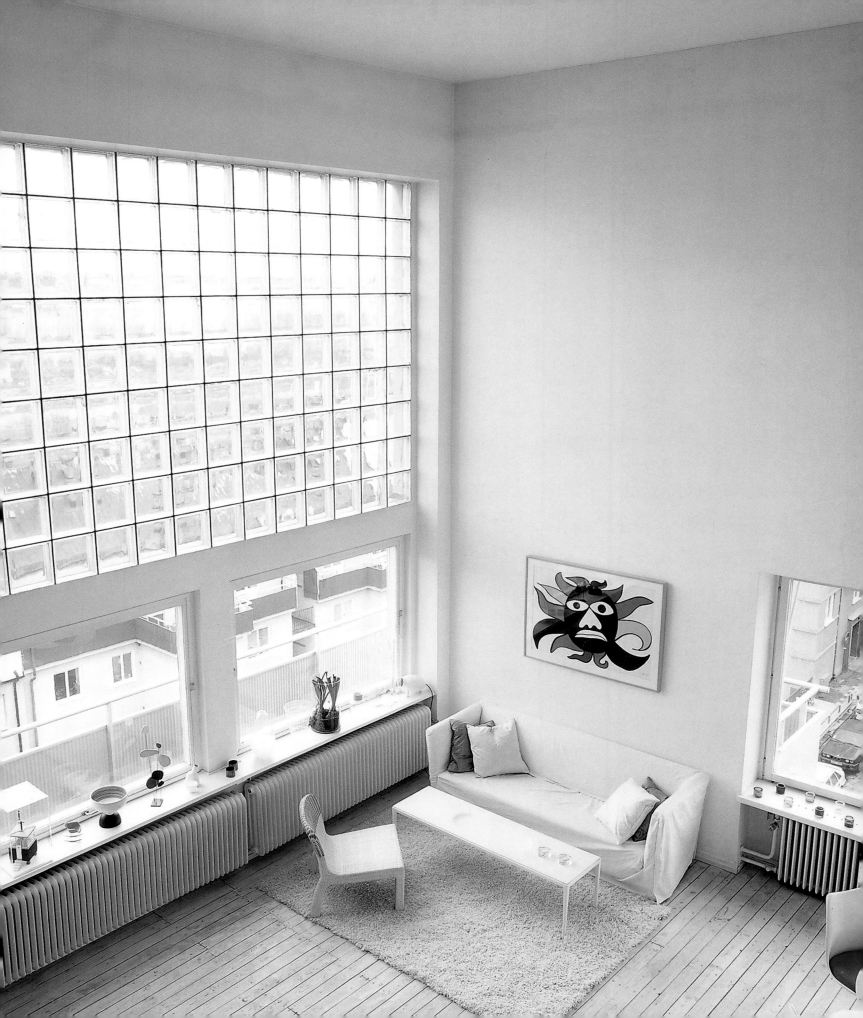

Like Aalto, Sandell was born in Finland, but to a Swedish father and a Swedish-speaking mother. The family moved to Sweden when Sandell was young. He showed little interest in design and art as a child and it was only when he spent a few years in the Swedish marines, doing his military service, that architect and interior design began to intrigue him.

'I quite liked the military and was even considering it full time. But I also had two good friends in the marines who were planning to go to architectural school and were also very good at sketching, painting. We would all go off into the countryside together with some wine, sketching, playing the part of artists. So we all tried to get into architectural school together. But I was the only one who was accepted.'

When Sandell finally left college in 1985 he was taken on by his professor, the respected Swedish architect Jan Henriksson. The five years Sandell spent with Henriksson's practice – a young team, filled with friends – were like being in an architectural graduate school, a solid apprenticeship but also one with responsibility and a close working relationship with Henriksson himself.

When Sandell set up on his own in 1990 he took on a strong mixture of architectural and interiors projects, including shops and restaurants as well as collaborations with Jonas Bohlin and Love Arbén, both well-known Swedish designers and architects. Around the same time he moved into furniture design, almost by mistake. He was working on a restaurant project – Tranan – and mistakenly ordered a counter twice from two different carpenters and so asked one to make a pair of cupboards instead, to Sandell's own design.

'I used a Dalecarlian horse – a carved, wooden, colourful horse like a child's toy – and I cut it in half and stuck it on the front of the cupboard,' says Sandell. 'These horses are almost symbolic of Sweden and some people thought this was a terrible thing to do, like burning the national flag. So I suddenly got a lot of media attention and everybody wanted to buy one of these cupboards. I did a limited edition, had an exhibition and sold every piece. I thought if it's this easy to design furniture I'll carry on.'

Since then Sandell's designs have become increasingly sophisticated. His furniture, like Aalto's, is often in natural materials such as wood or wicker to

RIGHT The dining area, in one corner of the studio room, features 'Tulip' dining table and chairs by Eero Saarinen and a large lamp by Castiglioni (above left). Under the gallery (below), where the ceiling height is lower, there is a less exposed seating area, with sofas by Piero Lissoni and a coffee table and rug by Sandell (above right). The cowhide bench-top against one wall was designed by Sandell for B&B Italia and the photograph above it is by Magnus Reed.

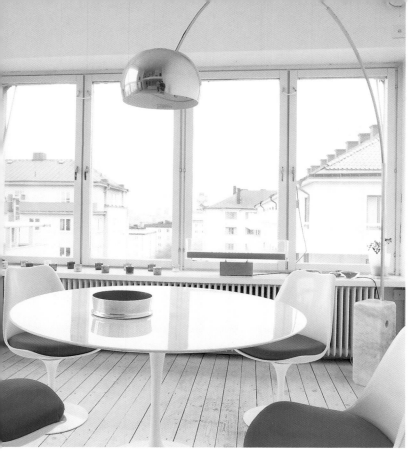

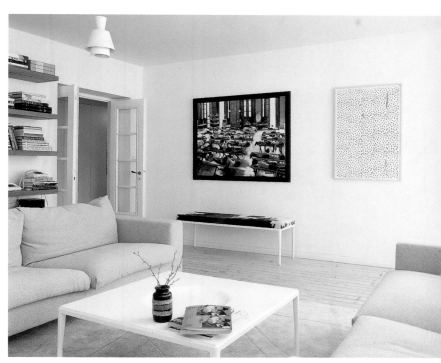

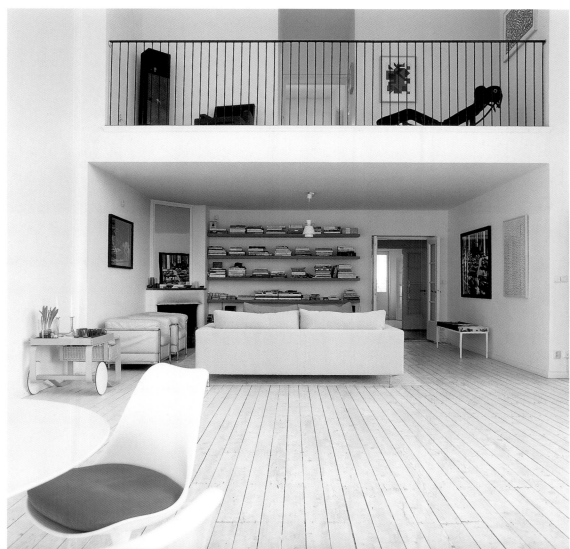

help soften the modern lines of the design and make them more friendly to home and hand than steel or aluminium. His interiors and architecture follow similar principles of Scandinavian humanism, trying to bring a gentle edge to contemporary ideas. Natural and local materials are used wherever possible, the colour tones of materials and paintwork tend to be light and airy, and in many of his house projects Sandell creates a link between inside and out. Sometimes these natural elements are juxtaposed with man-made materials – wood with concrete, stone with steel – for textural contrast.

At the same time, the more homely, wholesome influence of traditional Swedish design – including Carl Larsson's pervasive nineteenth-century approach to Scandinavian style – lies in the background. 'I certainly don't try to copy that traditional look, but you always have it somewhere in your mind because you see those kinds of things when you are growing up. It comes in as an influence so naturally you don't even think about it.'

Sandell's own home, which he shares with his wife, Anna Holtblad, a fashion designer, is a penthouse apartment in central Stockholm. Dating from the 1930s, the flat used to belong to the textile designer Ingegerd Thorsman, and the main living room – with its banks of windows and glass bricks to maximize the light – was once her studio, famous in its day. Sandell moved into the apartment in the autumn of 2000, respecting the original layout and features while making the space both into a more practical and elegant home, through the addition of storage cupboards for the bedroom and elsewhere plus a mixture of furniture that blends Sandell's own designs for B&B Italia and Ikea with twentieth-century classics such as the circular dining table and chairs by Saarinen or the tea trolley by Aalto to one side of the living room and a pair of chairs by Le Corbusier.

Materials such as the cowhide for a Sandell-B&B Italia bench or the leather of the Le Corbusier chairs softens the plain white base of the walls and the bleached floorboards in the living room, while the photographs and paintings by Nan Goldin, Alexander Calder and Magnus Reed provide contrast and splashes of colour. Elsewhere in the flat Sandell's designs mix with others by Jonas Bohlin, Asplund and Aalto. Sandell has further plans for the kitchen and terraces that border the apartment, yet it has already become a dramatic space, bathed in sunlight from all directions, with the studio room bringing resonance through its restrained choice of furniture and artwork.

Other projects have made more use of colour – a motif of coloured dots decorates the walls of Sandell's rooms at the Birger Jarl Hotel in Stockholm for example – while other buildings have a more rustic quality. Yet whether the project is contemporary modernism or a restoration of a period building, all of Sandell's work brings a unique slant to new Scandinavian style.

LEFT In the dining room the marble-topped table is a one-off design by Sandell, with dining chairs by Alvar Aalto. The clock – a nod to more traditional Swedish style – is eighteenth-century Swedish and is from Anna Holtblad's family.

ABOVE The two chairs in the hallway are by Jonas Bohlin, another well-known contemporary designer based in Stockholm and an occasional collaborator with Sandell.

Jonathan Reed

THERE IS A TRULY INTERNATIONAL FLAVOUR TO JONATHAN REED'S WORK. HE HAS TAKEN ON PROJECTS IN LONDON, NEW YORK, ITALY AND GERMANY AND HAS WORKED FOR ICONIC CLIENTS SUCH AS DAVID BOWIE. HIS STYLE SUBTLY BLENDS FLAVOURS FROM EUROPE, ASIA AND THE AMERICAS IN A VERY MODERN, COHESIVE AESTHETIC. YET THE ROOTS OF HIS WORK LIE IN A PAROCHIAL ENGLISH CHILDHOOD, A RURAL BACKGROUND IN YORKSHIRE IN THE FAMILY HOME ON THE YORKSHIRE MOORS, NEAR WHITBY.

'It was a very rural, farming background,' he says. 'As a kid I would go to school and then go out onto the moors and start rounding up sheep. All of my extended family are farmers, my sister is a farmer, but I have a mad inventor father who is a great resolver of problems. He has designed some of the world's largest cranes, worked on things I barely understand. If anything, it's that side of my upbringing that has rubbed off because that drives what I do – solving problems and coming up with creative solutions.'

The colours of the moors – greys, greens, soft earthy browns and heather purples – play through Reed's look. His love of open, communal kitchens and living spaces was partly born of a love of traditional Yorkshire farmhouse kitchens where the dining table and cooking range usually share the same space. But from very early on he was also playing with convention and setting off in new directions.

LEFT AND RIGHT Fire-surrounds are in brushed steel, the bespoke mirror above the one seen here having a contrasting rust-effect jesso finish (right). Colours are natural, masculine and earthy. The leather sofa in the foreground is from the 1960s and was rescued from a friend's garage, while the ottoman was designed by Reed. The bowl on the dining table (left) is contemporary French, in painted composite.

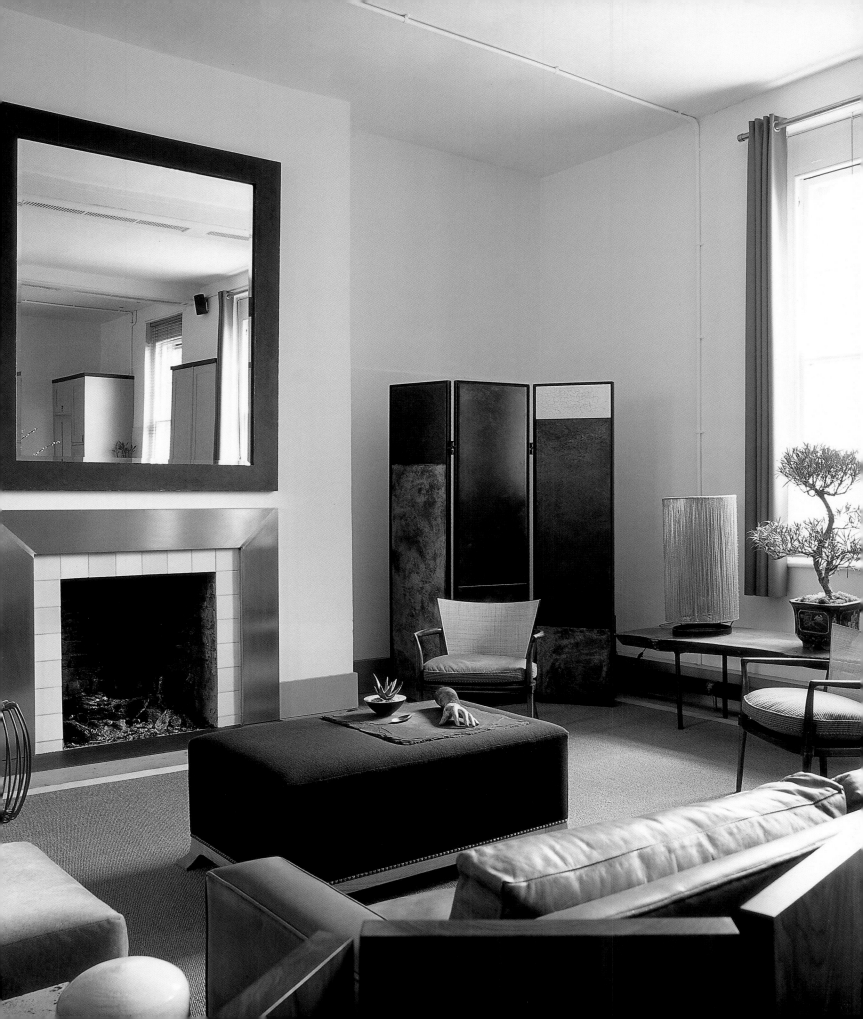

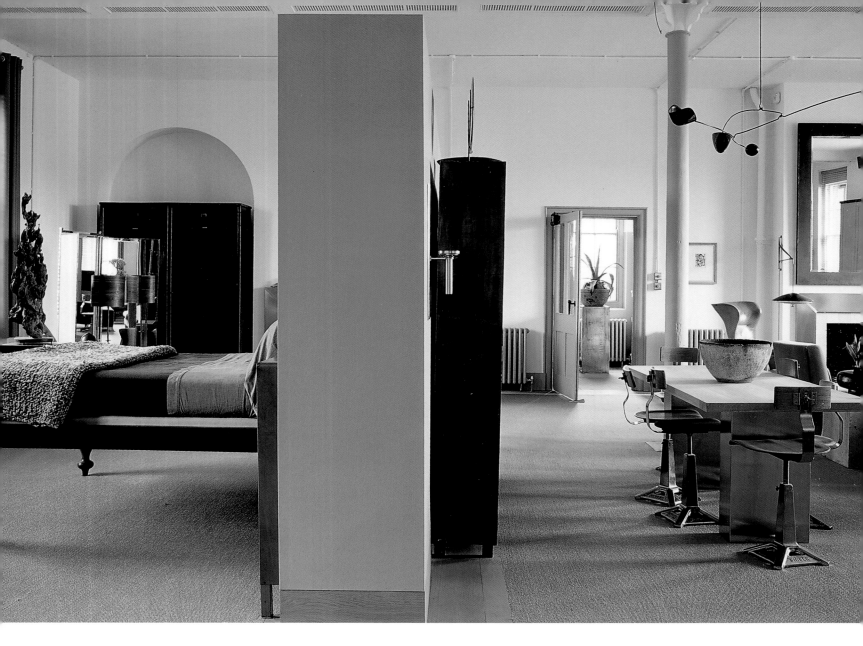

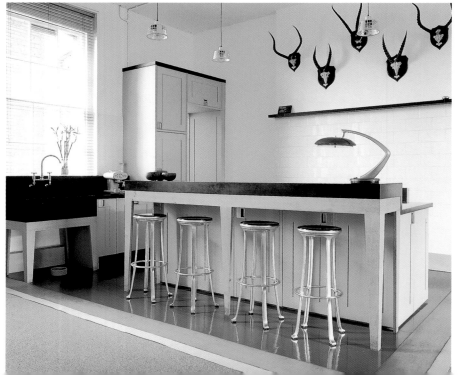

He began a degree in physiology at King's College, London, with the aim of becoming a vet or a doctor, but at the same time became involved in dealing antiques. 'I was running around in a Morris Minor and going off to auctions, cramming the car with things and selling them. It did extremely well and funded my studies – and fuelled an addiction to Yohji Yamamoto.'

Reed earned his degree but by his last year at university was already working for the fashion house Hackett, well known for its take on quintessential English style. He would work on sourcing traditionally made products such as hand-stitched leather gloves or hand-filled hairbrushes, finding himself back in Yorkshire and in other rural parts of the country talking to craftspeople and workshop designers. At the same time he was also freelancing for a Japanese company, sourcing designs in Asia.

Later Reed was appointed creative director at Hackett, working on store and product design. There came work, too, with Ralph Lauren, working on store designs in Paris and helping in the development of Lauren home-furnishings stores. All the time he was gradually building upon an instinctive understanding of design and architecture, proportion and scale. Through Ralph Lauren he met the interior designer Ann Boyd and together they formed a business partnership that took Reed wholeheartedly into the world of interior design.

'We started the company and didn't really know exactly what we were going to do, but we felt confident that we had something to sell because we had all this experience. We ended up working for Nicole Fahri, Asprey and other retail names, and at the same time we started doing residential work.'

Since the launch of Reed Creative Services in 1997, the work has shifted more and more towards residential projects. There have been projects in Ireland and Denmark, lofts in Manhattan, apartments in London and Italy, plus an Italian villa. Over the years Reed's style has become increasingly distinctive: masculine, ordered, restrained and rich in texture, with fine materials and craftmanship. There are occasional touches of humour and extravagance and – despite the controlled, precise, practical quality – there is also a definite emphasis on comfort and indulgence.

LEFT The three-quarter-height partition separates sleeping space to one side and dining area to the other (above). The dining table, in oak and steel, was made to Reed's design while the bed is nineteenth-century Burmese. The kitchen area (below), in one corner of the open plan space, is partly delineated by its island unit in oak with a Corian countertop.

'I'm not really a colour freak because I believe in the strength of materials,' says Reed. 'We achieve strength through amazing floor finishes, wall finishes, woodwork. If you have all of that going on, you don't need a house full of bright colours. Also, the neutral shades that we use – be they yellow, green or whatever – are still colours in themselves and they allow the form of the furniture to be expressed much better.'

A lot of the furniture used in Reed's projects is bespoke, but with some designs now becoming more commercially available. The bespoke ethos and the idea of avoiding repetition are key to Reed's design philosophy. Lights and light switches, doors and door handles are often individually designed and made to suit. There is also a strong architectural dimension to the work and an insistence upon being involved to as great a degree as is possible in every aspect of a home's form and function.

The most prominent influences on Reed's outlook – apart from eminent American interior designer Albert Hadley – are architects who have stretched across the borders of their profession and become involved in interiors, in furniture design, in every dimension of a living space. 'I love the Arts and Crafts movement – as well as medieval architecture or post-war American design – and Sir Edwin Lutyens and Charles Voysey especially were both true architect-designers involved in every aspect of a project. In the twentieth century someone like Eero Saarinen would design a house, have the carpets woven, have the the curtains made up. That's the equivalent of what we do.'

Reed's own Chelsea apartment offers a typically sophisticated version of his approach to design. It ranges over the second floor of a Victorian block that has been through various incarnations, serving as a hospital, a work-house and for a time as Chelsea's town hall; Judy Garland graced its front steps on her wedding day. Reed moved into the building after it had been empty for fifteen years, enticed by the prospect of such generous floor space – he has around 4,500 square feet in total – located in the thriving heart of designer London.

Reed decided against dividing up this precious space into a series of smaller rooms and opted instead to 'zone' the living space, with areas for

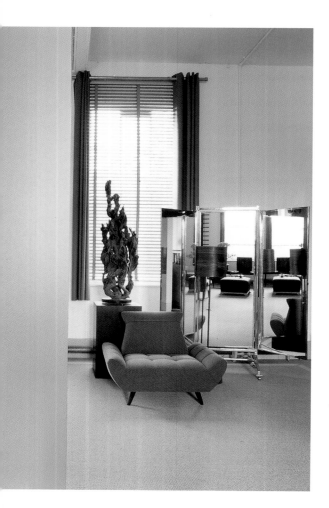

ABOVE AND RIGHT There are strong echoes of the 1920s and 1930s in pieces such as the low mirrored screen, while the chair in front of the sculptural Japanese cedar root is a 1950s custom-made piece from Los Angeles (above). In the main seating area the armless mohair chair is Reed's design; textures constantly juxtapose the soft and harsh, the natural and the man-made (right).

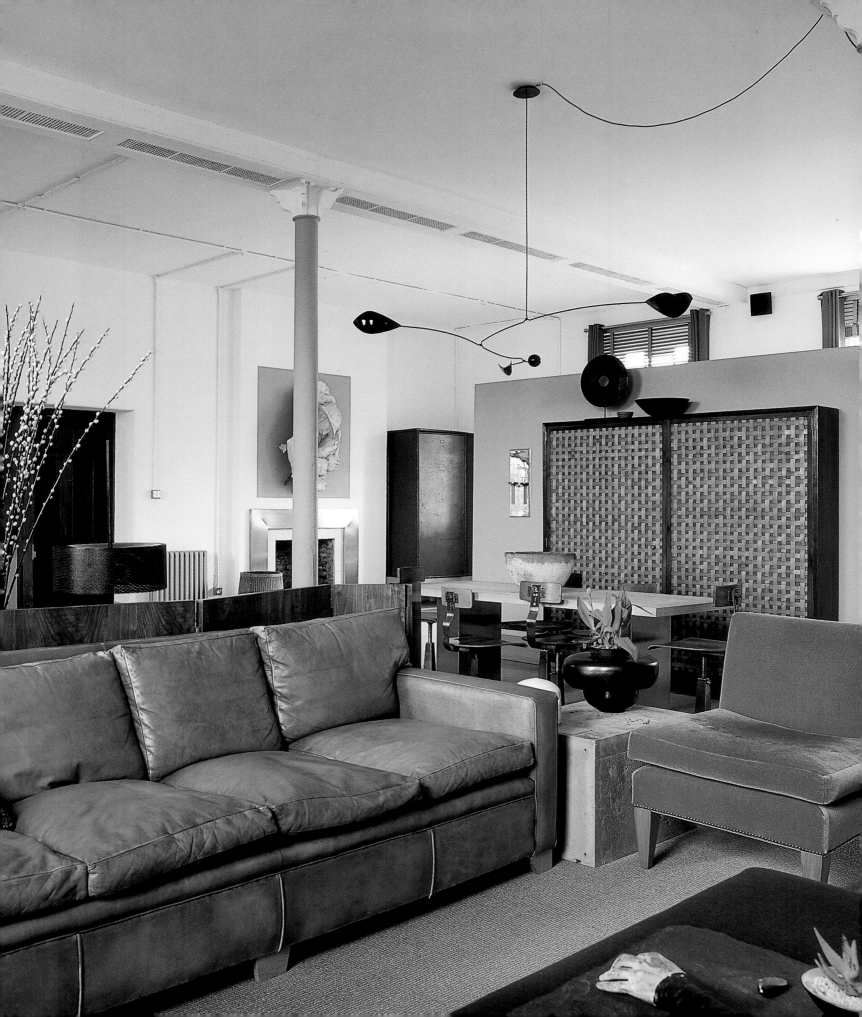

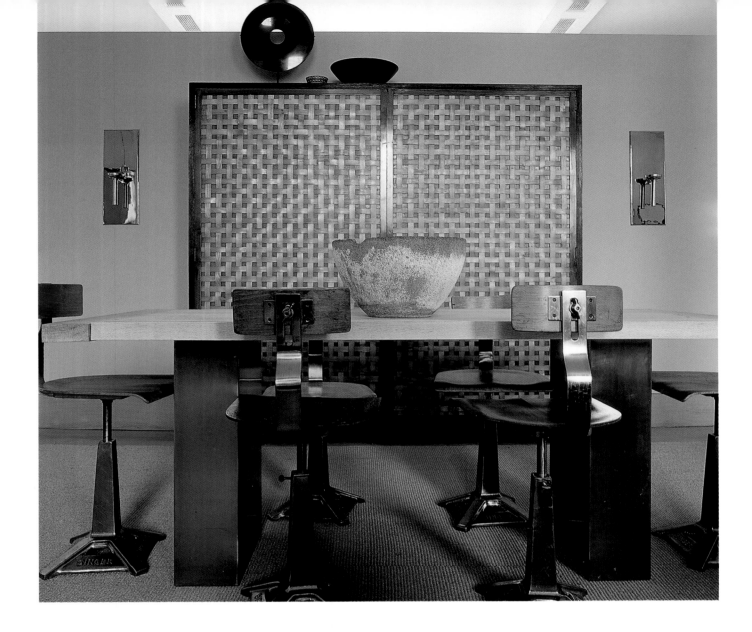

cooking, relaxing and sleeping; only the bathroom was kept separate, set in what was once a hospital scrubbing-up room off one corner of the apartment. Original features of the semi-industrial space were respected, such as the four fireplaces that would have served to heat the wards in Victorian times and are now finished with steel fire-surrounds.

In one corner, near the entrance to the bathroom, Reed designed a kitchen with a large working island, sink units and oak cupboards with Corian countertops. A three-quarter-height screen wall to the side of the room partly conceals a sleeping area, with a nineteenth-century Burmese bed and bedside cabinets formed from 1950s steel utility furniture. Any divisions are slight, preserving the proportions of the apartment and allowing light through.

'I didn't want to divide what must be one of the rarest spaces in west London,' says Reed. 'To chop it up would have been a travesty. So any separation is almost invisible. It was never my intention just to create an environment that was representative of my work, rather to create an apartment that was comfortable.'

Fitting in with Reed's ambition to break down some of the traditional spatial divisions within the home, the apartment has an informal sociability. The bespoke dining table in oak and steel is exposed, adjoining both a comfort seating area and the kitchen zone. Colours are muted with browns and greens prominent against white walls and sisal carpeting, set into an oak border. The blend of furniture is both eclectic and cohesive, representing Reed's own designs (the ottomans, nickel sconces, mirrors), twentieth-century classics (such as the 1940s Danish leather wing chairs by Fritz Henningsen or a Scandinavian seat from the 1940s in steel, canvas and leather) and more eccentric finds such as the pair of Ministry of Defence filing cabinets that serve as wardrobes or the droplights in the kitchen area, salvaged from a Manchester library. Yet having perfected this version of loft style, an apartment in architect Richard Rogers's Montevetro building in London is now tempting him, offering a new challenge and fresh possibilities.

LEFT The dining chairs once stood alongside Singer sewing machines in a workshop. The cabinet behind the table is French, 1920s, with pearwood woven doors. The nickel wall sconces to either side are by Reed.

RIGHT A brown leather wing chair, from the 1940s, is by Danish designer Fritz Henningsen. The curves of such pieces help to soften the linear quality of the space itself.

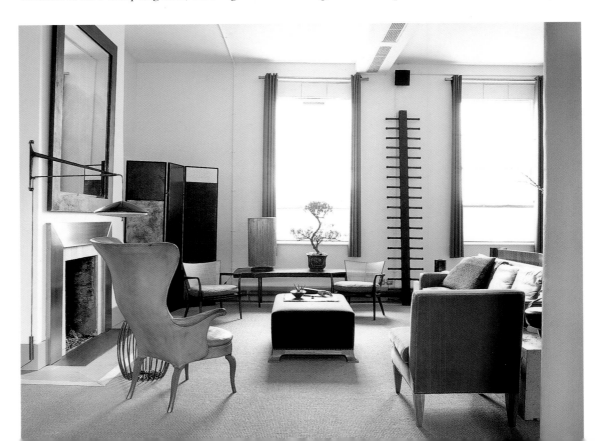

Nico Rensch

AS AN ARCHITECT AND INTERIOR DESIGNER, NICO RENSCH HAS EARNED HIMSELF A COMPELLING REPUTATION FOR UNCLUTTERED, COSMOPOLITAN, CULTIVATED AND MOSTLY URBAN LIVING SPACES. SO IN ENGLAND YOU WOULD EXPECT TO FIND HIM LIVING IN CLERKENWELL, ISLINGTON, SHOREDITCH OR SOME OTHER DESIGNER ENCLAVE OF ITS CAPITAL, LONDON. IN FACT HE HAS CHOSEN TO ESCAPE TO THE COUNTRYSIDE AND HAS ADOPTED THE RURAL IDYLL.

'We actually moved five times in six years,' says Rensch, who was born in Germany but settled in England in the mid-1980s. 'That's an architect's syndrome: find an old house, do it up, sell it and move on. But this is it, this is home.' Rensch is talking of his Victorian family house, settled into the Sussex landscape – complete with paddocks, stables and four Hanoverian horses – and home to the designer and his office, his wife Jane and their two children. Outwardly it is a classic, well-proportioned English country house, yet the interiors are something different. There is nothing in the way of traditional swags and tails, chintz and flocked wallpapers. Rensch's treatment is modern, contemporary and verging on the minimal, while still respecting the original proportions and layout of the house.

'This house is a good example of how I don't speak just one architectural language,' says Rensch, 'and I would not do a Victorian house in the city in the same way as a place like this. But it does have the thread of sophisticated simplicity that runs through a lot of my work, and I do always look for high-quality craftsmanship and natural materials.'

Rensch and his family bought their home in the spring of 1999. The house had been long neglected and was in need of a total refurbishment, with a

RIGHT The Victorian contemporary look for the secondary living or family room; here, as elsewhere downstairs, the floors are in simple Spanish limestone and the walls painted a uniform white. The sofa is a reclaimed, recovered classic English piece. The artwork is by Hardy Rensch, Nico's father.

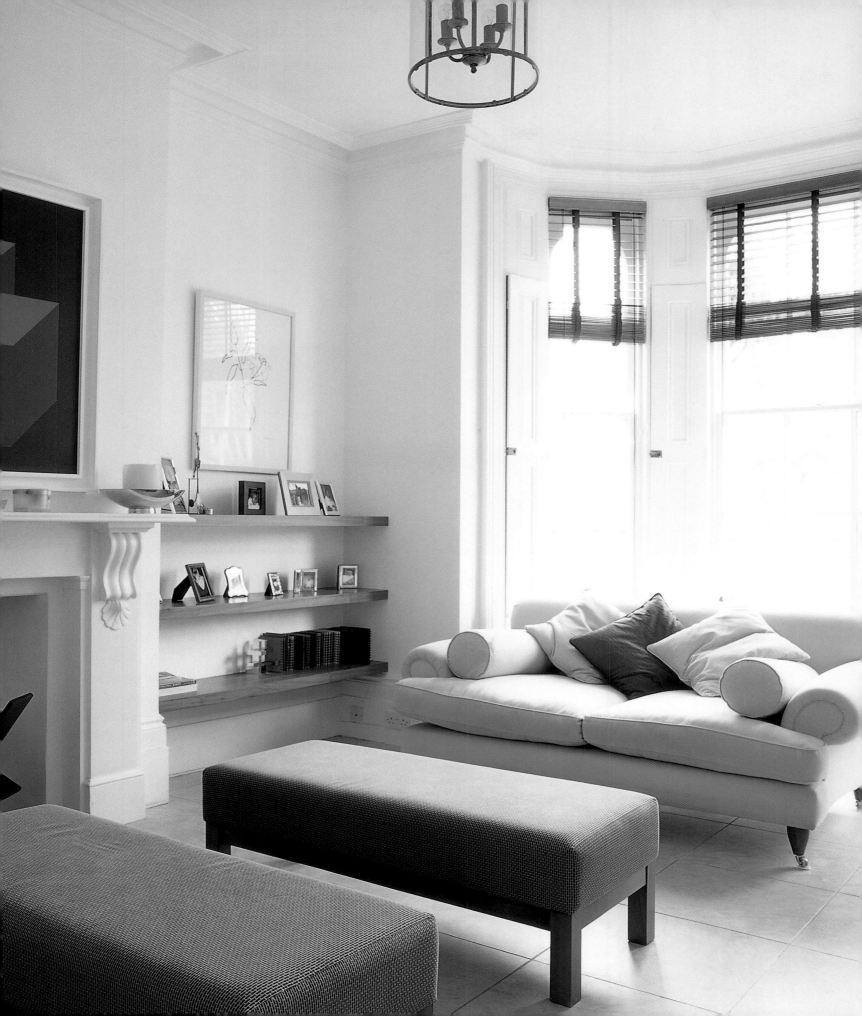

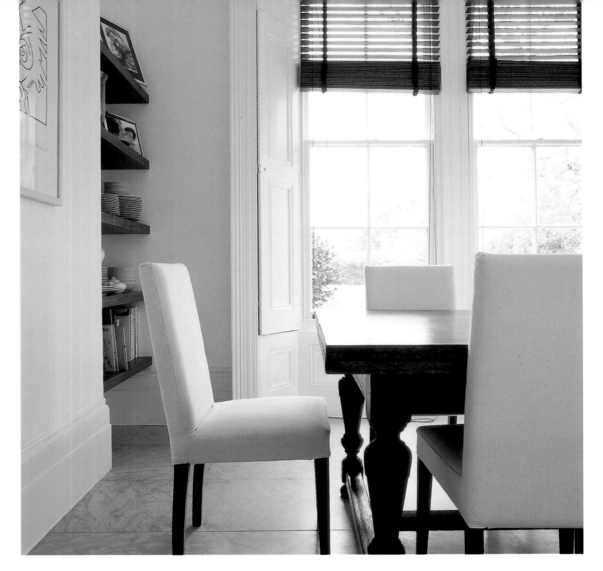

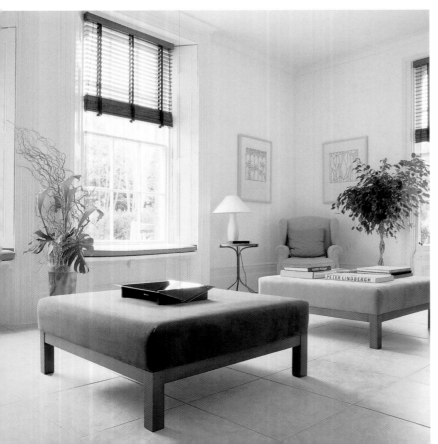

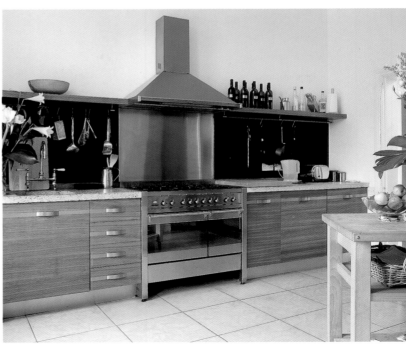

team of a dozen builders working solidly on site for six months, gradually realizing the obvious potential of the space. Fireplaces, shutters, simple cornices and many other features were preserved, while downstairs a floor of Spanish limestone warmed by underfloor heating was introduced throughout, creating a cohesion uniting the many different rooms.

There were just two small structural changes: a door to the living room was moved and an entranceway was made between the kitchen and outbuildings, to make a children's dining area and den. As the changes were carved out it became apparent that both involved reinstating original doorways from when the house was first built. Upstairs the major innovation was to create three extra bathrooms, as well as remodelling the existing one, to serve all of the six bedrooms.

ABOVE LEFT AND FAR LEFT Window treatments are kept simple and light throughout, as in the dining room and main sitting room. The dining table (above) once graced an artist's studio and was covered in paint, but was salvaged and repolished. The large ottomans are upholstered in a synthetic suede (far left).

LEFT The kitchen was designed by Rensch, using American walnut veneers and stainless-steel handles for units, a concrete countertop and black linoleum for the splashback.

'We live surrounded by space here and so there was really no need to start putting rooms together,' says Rensch. 'Because this was designed in the 1870s as a family house, rooms were created for a specific purpose with good proportions, so it was easy to say, yes, this is the dining room, the living room, the kitchen. It is quite the opposite of what happens with a lot of my work in London and other cities, where space is limited and I work to create multifunctional rooms.'

As with so many of Rensch's residential projects, the house is painted a uniform white, allowing the architectural detailing to breathe, reducing the visual clutter and allowing the furnishings and artwork to shine. Synthetic suedes and endearing fabrics in neutral tones help to soften the environment, making for a calm, composed atmosphere.

Much of the artwork in the house is by Hardy Rensch, Nico's father. An artist of the constructivist school, he is also an influential architect and his work has played a powerful role in stimulating his children's career paths. Hardy Rensch pioneered new building systems for houses – using simple aluminium sections, fitted together like a jigsaw – and later on began to develop assembly furniture on similar principles.

'I grew up in hexagonal-system houses that even today would be far ahead of their time,' says Rensch, 'and most definitely my father was a big

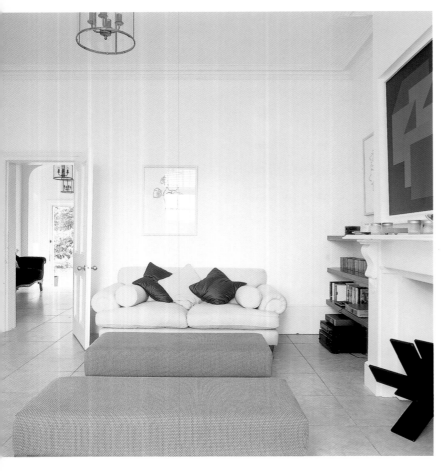

influence. But I realized quite early on that the world wasn't really ready for what he created and developed. I learnt that people are not always ready for progress, and I made my approach to architecture and interior design more reality bound.'

Rensch was born in Frankfurt and lived in Germany until he was thirteen, when the family moved to Switzerland. Surrounded by an extended family of architects and artists, for a time the young Nico tried to fight against the presiding spirit by working in a bank and then reading law in Munich. But before long he was studying at the École d'Architecture in Geneva, where his professors included the renowned Swiss architect Mario Botta. He worked for two years in Zurich, but then came the move to London and another change of direction, partly prompted by the unending prospect of the theoretical strain that would always accompany the architect's relationship with his client.

ABOVE AND RIGHT The hallway is a simply realized focal area, large enough to function as an extra living room with its Beidermeer sofa, upholstered in black linen (right), offering both contrast and comfort within its subdued surroundings. All the major living rooms (above) filter off from here, where, as elsewhere, clean lines are preserved by an absence of radiators thanks to the device of underfloor heating.

In 1984 he opened a fine arts gallery in Bruton Street, specializing in constructivist art from the Bauhaus period. But seven years later he went back to architecture, mostly remodelling period houses in contemporary style, maximizing space and light and introducing his own version of 'sophisticated simplicity'. Frustrated by the hardship of sourcing reliable craftsmen for every job, in 1991 he formed his own company, Architeam which acts as an umbrella for a regular group of builders and joiners as well as forming a partnership with his sister, Josephine Barabarino.

Rensch's work has taken him not just back to Germany – where Architeam runs an office in Munich – but to Singapore, Spain and elsewhere. In England the majority of the work remains residential although in Germany there have been large commercial projects such as a theatre and restaurants at Neuschwanstein, the famous Ludwig II fairytale castle in the Bavarian Alps. Hardy Rensch is now also part of the company and, as a family triumvirate,

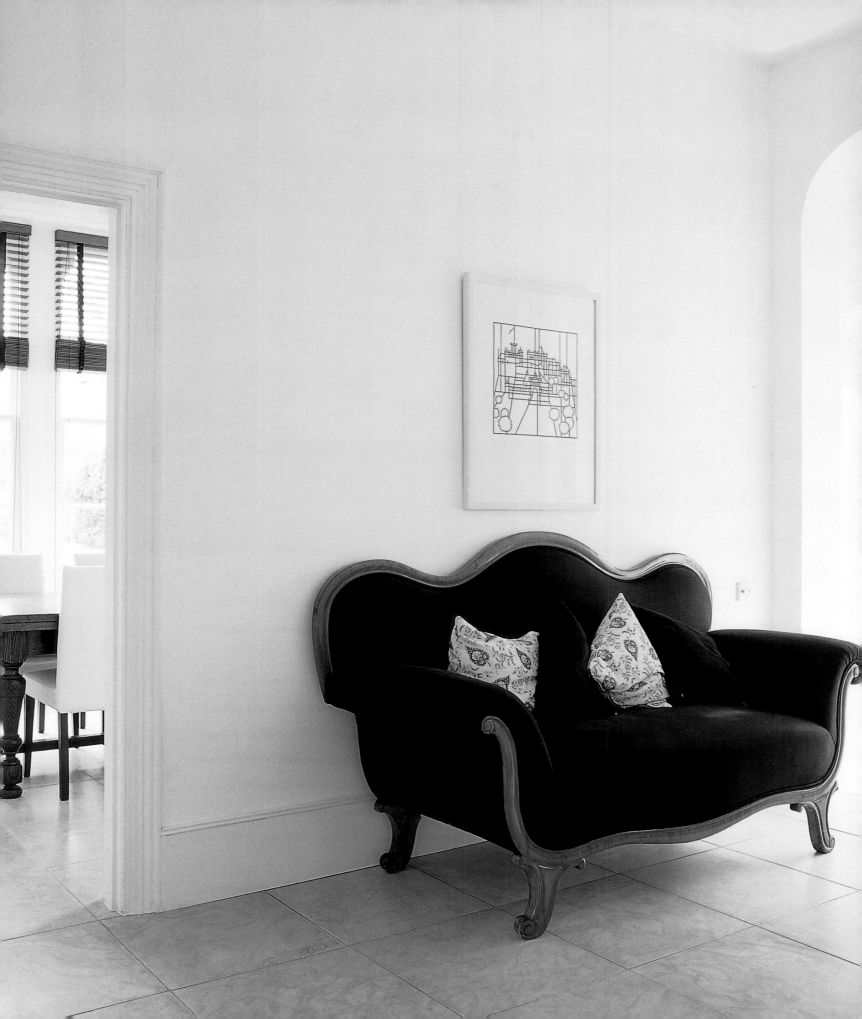

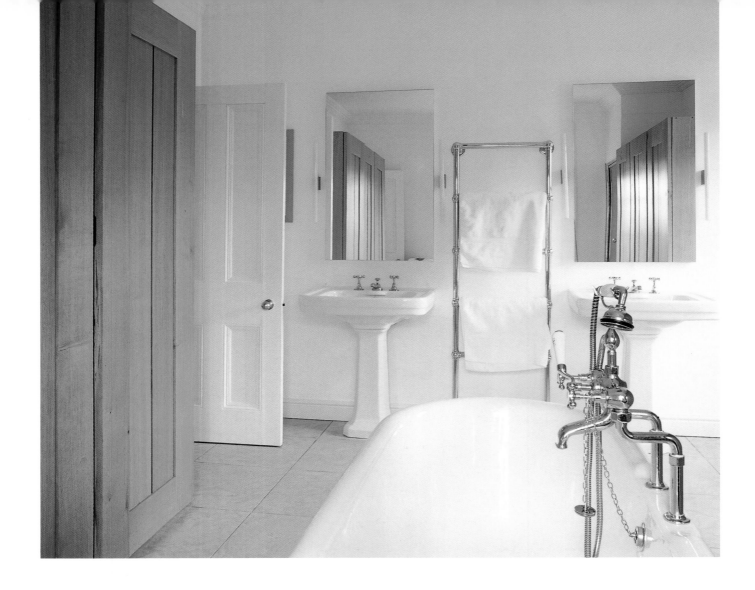

Architeam has been developing a new range of furniture, using a systematic framework for the basis of their designs, as well as varying finishes according to season and fashions.

Apart from his regular trips to London and also to Germany, Rensch himself works largely from home, although many of his ideas and plans are formulated unconventionally, sketched out in his mind or on a scrap of paper and then translated into reality by others in the Architeam fold. His influences include not just Le Corbusier, Mies van der Rohe and Frank Lloyd Wright, but Louis Barragán, Australian architect Glenn Murcutt, David Chipperfield and Claudio Silvestrin, although he sees his work as far less strict, less formal than the harsh minimalism of Silvestrin or John Pawson.

'Unlike many other minimalists I like to use a lot of strong, expressive materials: stone, wood and glass. It is also extremely important to create a

certain warmth within this limited language, which is something I hear people appreciating a lot because they may like the ideals of minimalism but they are frightened of its severity.'

Simplicity comes through reducing the overdemanding detailing and embellishment in the home – such as excessive mouldings, skirting boards and architraves – while increasing proportions where claustrophobia rules, by taking down walls and reorganizing room layouts. This gives the feeling of more space, less visual information, making an apartment, a house, seem uncluttered, tranquil and relaxing. These are principles Rensch tries to carry through Architeam's work, residential and commercial, at the same time as being sympathetic to the character of a location.

'A few years ago we had a house we were working on in Scotland, in East Lothian, by the sea. It was an old house and I started doing oak-panelled rooms, walnut libraries, although always with quite simple detailing. But it certainly wasn't minimalist, because the house just couldn't digest it. You can't create totally contrived shrines of design. It's rewarding to create a family house and to see it really working. My own house is about just that.'

LEFT AND RIGHT This bathroom (left) – adjoining the master bedroom – is treated as a primary room, not a secondary one. It is a living room, dressing room and bathing area with vast storage cupboards in English oak for clothing and shoes. The bedroom (right) is extremely simple and light, dominated by the bed designed by Rensch.

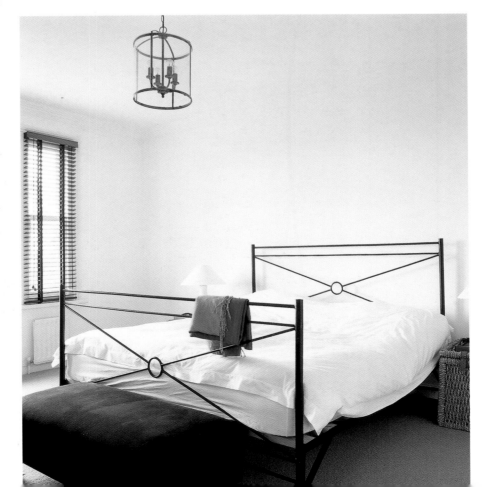

Andrée Putman

ENCOURAGED BY HER MOTHER INTO A WORLD OF MUSIC, ANDRÉE PUTMAN ONCE THOUGHT SHE MIGHT BECOME A COMPOSER. BUT AS SHE WAS COLLECTING AN AWARD FOR HARMONY AND COMPOSITION FROM THE PARIS CONSERVATOIRE ONE OF THE JUDGES TOLD HER THAT TO BE A SERIOUS COMPOSER WOULD COST HER TEN YEARS OF ISOLATION AND QUIET LABOUR. IT SOUNDED LIKE A PRISON SENTENCE, SO PUTMAN RENOUNCED A CAREER IN MUSIC FOR A NEW VOCATION. YET SHE HAS BECOME A COMPOSER OF A DIFFERENT KIND THROUGH A LIFE IN DESIGN. HER POSITION IN FRENCH INTERIOR DESIGN IS NOW UNRIVALLED: SHE IS ITS GRAND DAME, YET IS STILL REGARDED AS AN INNOVATOR AND A PIONEER.

Her own home reflects her avant-garde philosophy. It is an elegant example of loft living, yet when Putman designed the apartment in the mid-1970s there was no such thing as loft style in France. It was a shock to those who saw it. 'At the time I received condolences,' says Putman.'"Poor Andrée," people said to me, "when do you plan to have a real home?" I designed the apartment too early to be respected for having made a good decision. Now this style is so fashionable in Paris that if it was not such an effort I would move.'

The apartment is housed in a former printing workshop dating back to the 1890s. Putman had lived in an adjoining building since 1960 and had her eye on the semi-industrial space for many years before moving in. Respecting the dimensions and openness of the original floorplan, the windows and supporting columns were kept as they were, but large skylights were added to improve the flow of natural light, while a floor of poured concrete with added resin for a sheen effect was laid down.

RIGHT The workshop past of Putman's apartment was not effaced in the design for her home. The floor has a utilitarian poured-concrete surface, with resin for a vibrant sheen, while original pillars and windows have been preserved.

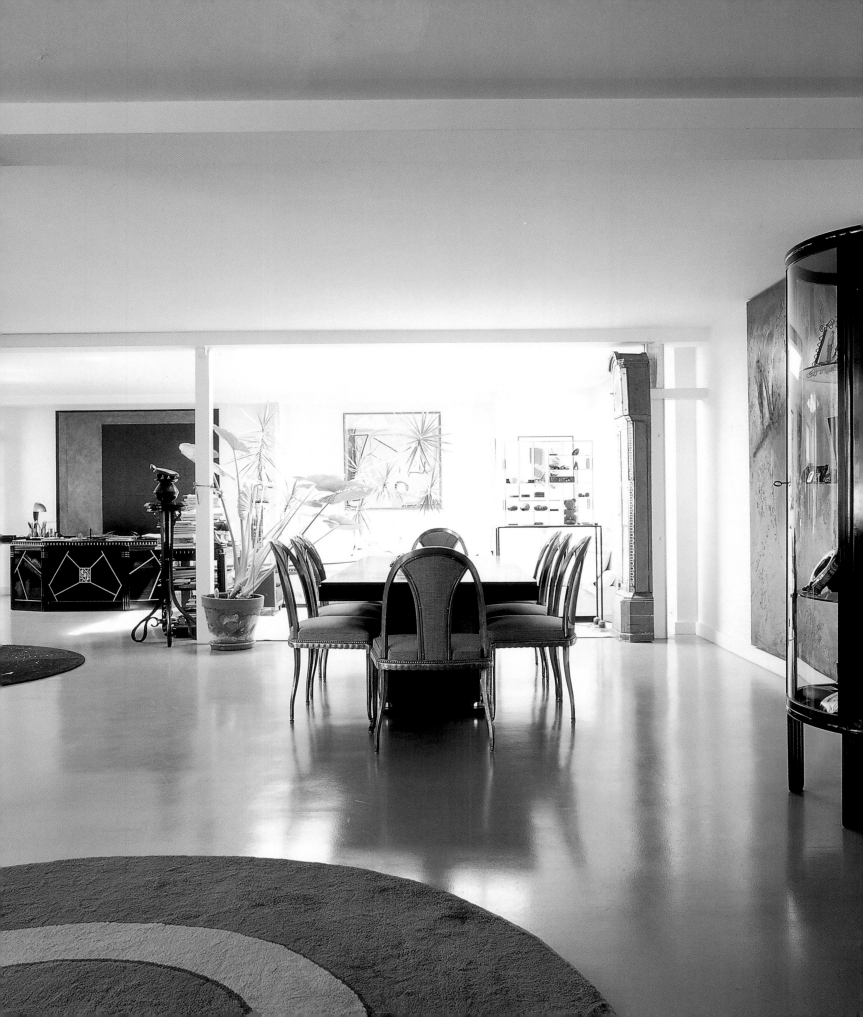

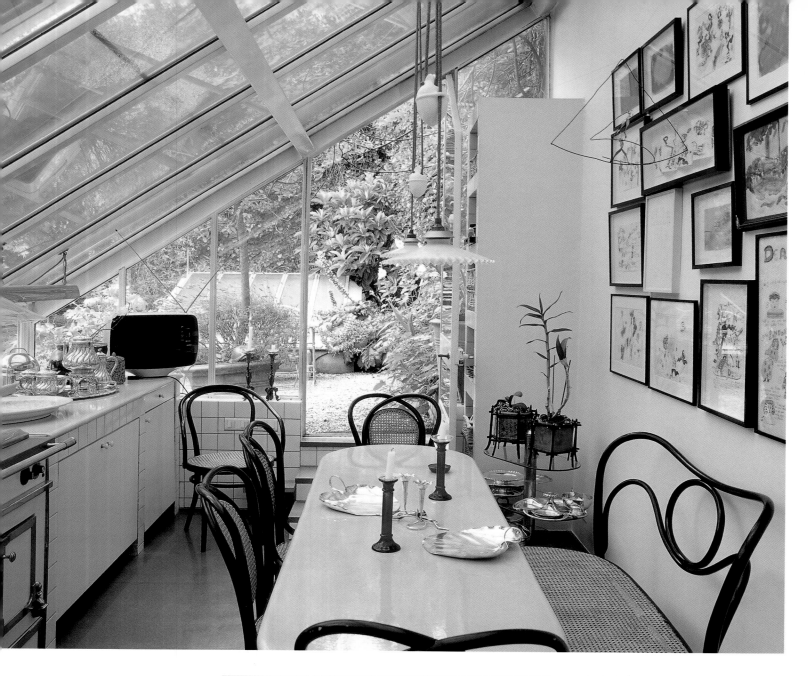

ABOVE The kitchen is housed in a glass room constructed on top of the main apartment, with a roof garden alongside. The table is made of enamelled lava stone.

RIGHT AND LEFT The main relaxation area is in one corner of the main studio room, delineated by a natural-weave rug underfoot and skylight above (right). The standing case with a patchwork of clear and coloured glass (left), designed by Putman, helps form the lightest of divisions from the dining area while also holding a personal treasure trove of *objets trouvés*.

A white tiled bathroom was made in one corner, but otherwise the main living space was preserved as a large open unit with areas for dining and working, plus a bedroom that was divided off as a more private space by screens of hanging gauze. Upstairs, at roof level, Putman designed a glass-house kitchen looking out onto a terraced garden, with views across the chimney pots and gables of Paris.

With this blank canvas Putman was able to organize an eclectic collection of objects, furniture and art. Every piece has a story to tell: the pair of carved wooden armchairs by the windows were designed for Sarah Bernhardt, to be used in a play she was to star in; the beautiful grandfather clock was something Putman had periodically chased around the antiques shops of Paris until a grateful client presented it to her as a gift; the ornate chest of drawers to one side, with a small collection of golden objects on its surface, belonged to Putman's grandmother, and as a teenager Putman once demanded that it be removed from her bedroom.

'I like the relationship between objects more than the things themselves,' says Putman. 'I like the way they exist together, because that's unique. But if it's not sincere, if it's not something you have chosen to do, it doesn't work. Sometimes I look at my home and think there are just too many things going on, but many of these pieces bring back a memory every time I look at them – a private joke or a story that comes to mind.'

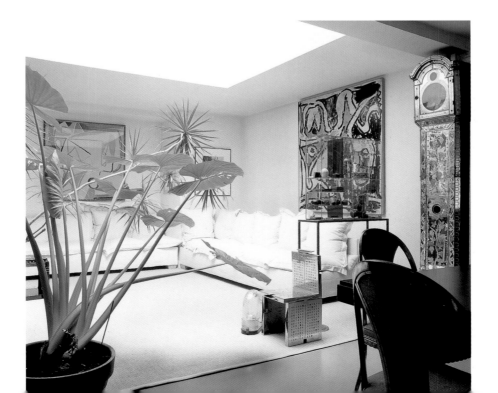

Periods and styles mix, although there are a number of pieces from the 1930s: the black lacquered desk and coffee tables; the Jacques-Emile Ruhlmann dining chairs and the Deco dining table by Paul Dupré-Lafon. There is also a striking collection of modern art, with pieces by Bram van Velde, Lucio Fontana, Julian Schnabel, Max Ernst and others. But despite the eclecticism, the overall feeling manages to be both contemporary and time-less at one and the same time.

The same can be said of much of Putman's work – the hotels, the houses and apartments, the stores and showrooms, the furniture and ceramics. Again and again there is this ability to create the contemporary classic. Many projects of the 1970s and 1980s still look as fresh and successful as they did when they first transferred from the drawing board to reality. Morgans Hotel in New York, which Putman worked on in the early 1980s, not only helped spur on the movement towards modern designer hotels untainted by old-world aristocratic snobbery, but still retains its seminal glamour.

'If you are asked to design a hotel that will be different, that will break all the rules, you will have a sense of which rules you want to break. Perhaps, through intuition and a little thought, you get a feeling for what people want

ABOVE AND RIGHT The ornate chest of drawers (above) once belonged to Putman's grandmother, its surface now busy with a glit-tering assembly of gold pots by Jean-Pierre Reynaud, golden eggs by Lucio Fontana and an Egyptian tomb dog inherited from Putman's grandmother (right).

RIGHT The pair of wooden armchairs, designed for Sarah Bernhardt, were once reserved by Yves Saint Laurent. Putman had to wait six months for the vendor finally to allow Putman to buy the unclaimed treasures.

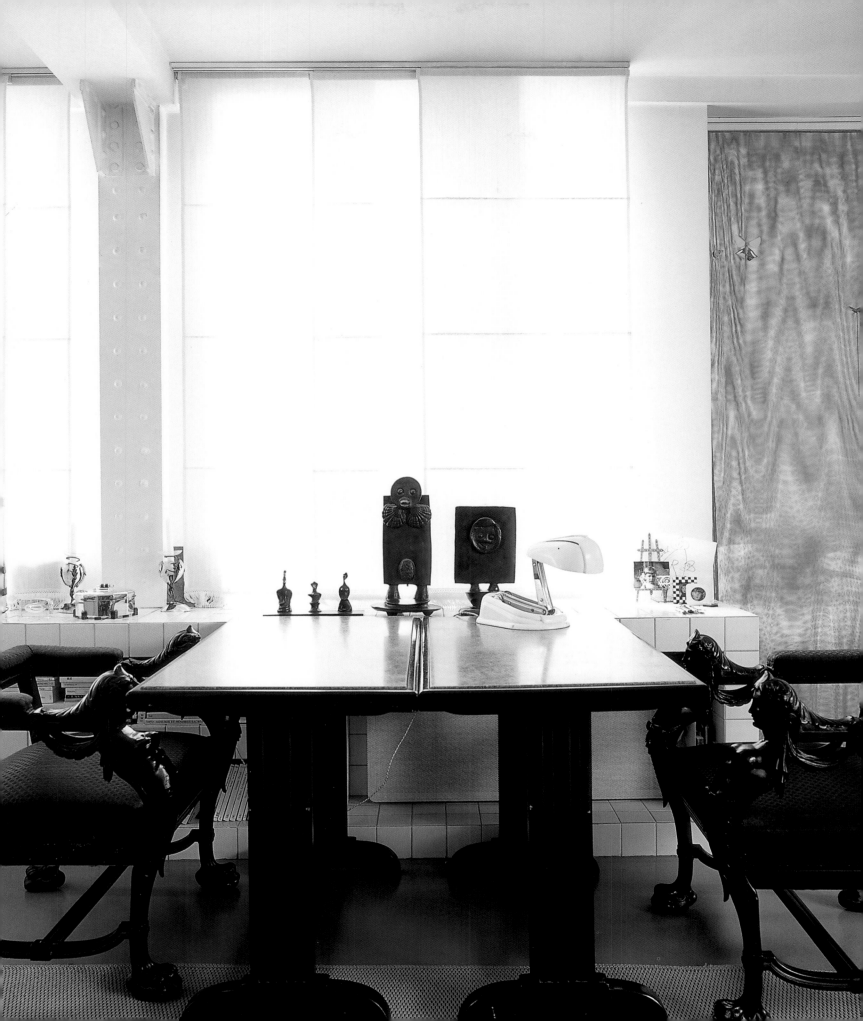

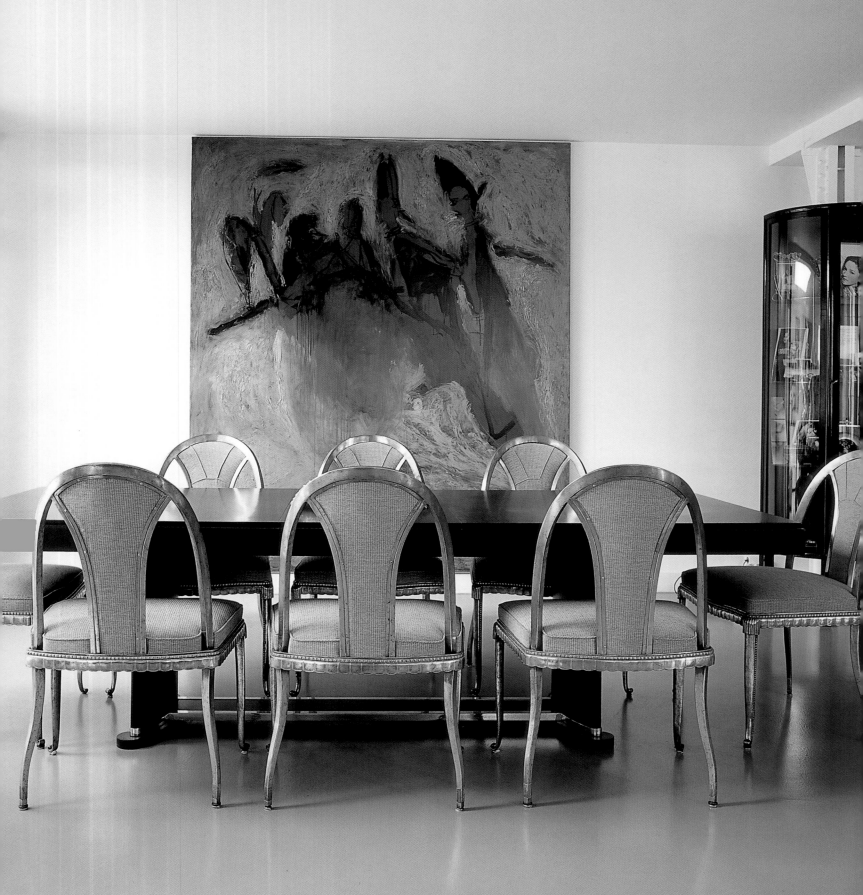

to experience tomorrow and what are the traces of dust and boredom with the past that you never want to see again, what is simply habit.'

Morgans was the first of a number of major hotel projects where Putman's prescience – her ability to predict not only what people would want and enjoy, but also to confer a style that would not date within a few years – came to the fore. In Putman-designed hotels such as the Saint James Club in Paris, the Wasserturm in Cologne or Le Lac Hotel at the foot of Mount Fuji in Japan there is a cohesive modernity that appears to draw upon the example of the great modernists as well as the refined and adventurous spirit of the 1920s and 1930s, while fused within the mix there is also an element of futurism. Intimate spaces such as bedrooms and bathrooms are reinvented as places of indulgence and escapism rather than functional, utilitarian zones.

'There is a saying that hotels are "a home away from home",' says Putman. 'But to me nothing is more absurd than that, because the only charm that belongs to a hotel is that it brings you a kind of amusement that is completely different from the way you live at home. It is like saying a geisha should be like a wife. But that is not what a geisha is for.'

LEFT The Deco dining table was designed by Paul Dupré-Lafon, while the dining chairs are by Ruhlmann and date from the 1930s.

RIGHT The black lacquered desk matches two other small tables in the apartment, all designed by Jeanne Lanvin in the 1930s.

Disparate influences are brought together through their connections in colour, texture and patina, and this is done with a precise eye for detail. Decisions tend to be taken instinctively rather than according to a clear body of overall principles. 'Of course, there is never any set recipe for anything that I do,' says Putman. 'I don't try to explain what I am doing. My work comes completely from instinct, but I am sincere in my decisions and the reasons why I like something, why something has to be placed here and not there.'

There is also a love of simplicity and restraint. This was part of the initial attraction of her home, the quality of a large space – a blank page – that could be used in as many ways as imagination allowed. Owning a substantial collection of artwork also demanded a neutral backdrop that avoided a fight between the paintings and their setting. This love of emptiness dates back to her childhood, when her family – her mother a musician, her father a writer and thinker, both of them unconventional – summered in Dijon.

'We lived in one of the most beautiful places one can imagine; an abbey dating from the twelfth century, the Abbaye Fontenay in Burgundy. We had these very strange summers there for twenty years and when we were children we just couldn't believe that this place could be occupied by people like us, a family. The monks were still there somewhere in our minds, walking the cloisters. Now I realize that the abbey gave me a passion for emptiness – I loved the idea of seeing beauty in something that seemed empty or absent.'

When Putman was starting a career in design in Paris – immersing herself in a cultural scene of writers and painters, Picasso, Samuel Beckett, Ionesco – her apartment in Place St-Germain-des-Prés exhibited this same quality of restraint, allowing the beauty of carefully selected pieces to shine through. 'I just had one or two pieces in my room: a Miro poster, a Barcelona chair by Mies van der Rohe, but for a young girl at the time it was extremely daring. I was shocking for my milieu and thought to be annoying and problematic.'

In those early years she worked for magazines, advising on interiors and furniture, before helping to reinvent radically the products offered by French homeware store, Prisunic. There were other ventures, and a house that she designed for herself and her family in the South of France. 'That was very important to me because without realizing it I was starting to propose a new way to live. But again, it was shocking then: "Oh, you think you are modern but you are also nostalgic," people said, as they could not categorize me.'

In 1978 she launched her company Ecart, a furniture showroom that championed designers such as Eileen Gray and Pierre Chareau, and at the same time also began designing homes for friends and associates. Since then Putman's work has expanded in many directions: designing the sets for Peter

RIGHT Natural light pours into the loft from banks of windows (above) and the added skylights, as well as pouring down the stairway from the glass kitchen above (right). The quality of light is key to appreciating Putman's collection of twentieth century artwork, which includes a tortoise by Max Ernst (far right).

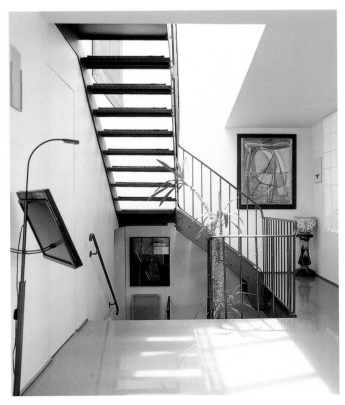

Greenaway's film *The Pillow Book* was very important to her, as were her ideas for the Bordeaux museum Le Centre d'Arts Plastiques Contemporains. Apart from designing furniture herself – plus work on ranges of ceramics, rugs and glassware – in the month when we spoke there was a vast house project in Tel Aviv, a Nile hotel boat, work for the Guggenheim in New York, a London loft for an art collector, a new Parisian hotel and more besides, not to mention fielding many other requests for the Putman touch.

'We do have very faithful clients and I can do more with people I know well because you can then help them create their houses – you have to do it with them. In 1981 I designed Jack Lang's office – he was the new Minister of Culture. Nineteen years later he became a minister again – of education – and he called me up, saying, "Please Andrée, come and do my office because I can hardly work. I am in such a sad place. I need you immediately."'

Putman is always in demand – she has in a sense become iconic, just as Madeleine Castaing or Jean-Michel Frank were iconic. But she is also above fashion; she carefully stays beyond ephemeral trends as they sway back and forth. 'A word I find unbearable is *tendance*. People say "it's a *tendance*", meaning a hyped trend of today. This is to me a nightmare. I start to be almost mean when I hear people describe me in this way, because I am the opposite. This cuts me off from a fashionable world, but it is good for me.'

LEFT AND RIGHT Putman calls her lightly recessed bedroom 'the room', veiled by lengths of hanging gauze (left). The bathroom is a separate room to one side of the studio (right), illuminated by internal and external windows and tiled from floor to ceiling.

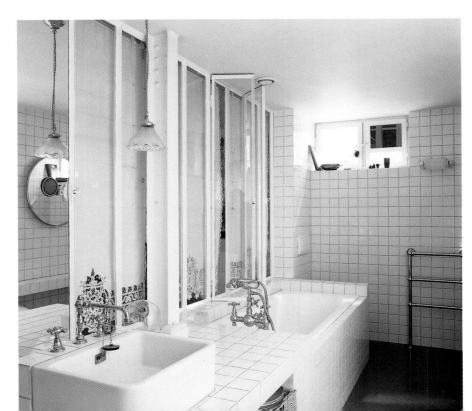

Anne Maria Jagdfeld

IT MAY WELL TAKE THE WORK OF GENERATIONS TO UNDO THE DIVISIONS THAT POLITICS, HISTORY AND GEOGRAPHY ONCE IMPOSED ON BERLIN. IT IS A CITY IN TRANSITION, SHIFTING SLOWLY TOWARDS REBIRTH AS A GREAT COSMOPOLITAN CAPITAL AND EVERYWHERE PLANS ARE BEING MADE, BUILDINGS ARE RISING UP, BYWAYS AND VISTAS BEING REMODELLED AND INNOVATIONS DRAFTED BY COUNTLESS DESIGNERS AND ARCHITECTS.

Amid this dramatic reinvention of the city, Berlin-Mitte – the historic heart of Berlin – is slowly coming back to life, and so, too, is Friedrichstrasse, one of the premier shopping streets of the pre-1939 era. Here you will find Quartier 206, a new and gleaming department store, founded by Anne Maria Jadgfeld and her husband, Anno August Jagdfeld, a property developer and investment banker. It was the Quartier 206 building – with its mixture of retail space, offices and apartments – that helped to invigorate Anne Maria Jadgfeld's career not just as an entrepreneur, a store-owner and a businesswoman but as an interior designer.

'We had to get some of the memory back of the old centre of Berlin and create a building that is joyful, that you want to be inside, so people would really want to come,' says Jagdfeld. 'I developed the department store but I also worked on the interior-design control of the whole building, and that's how I started.'

Quartier 206 was conceived in the early 1990s and since then Jagdfeld's design company – amj design – has

LEFT AND RIGHT The translucent calf-skin parchment screens, which move across on tracks to veil the banks of windows to one side of the main room (left), create privacy and atmosphere while still allowing soft yellow light to filter through (right). They also look dramatic and beautiful, drawing the eye with their echoes of the 1930s and Japanese shoji screens.

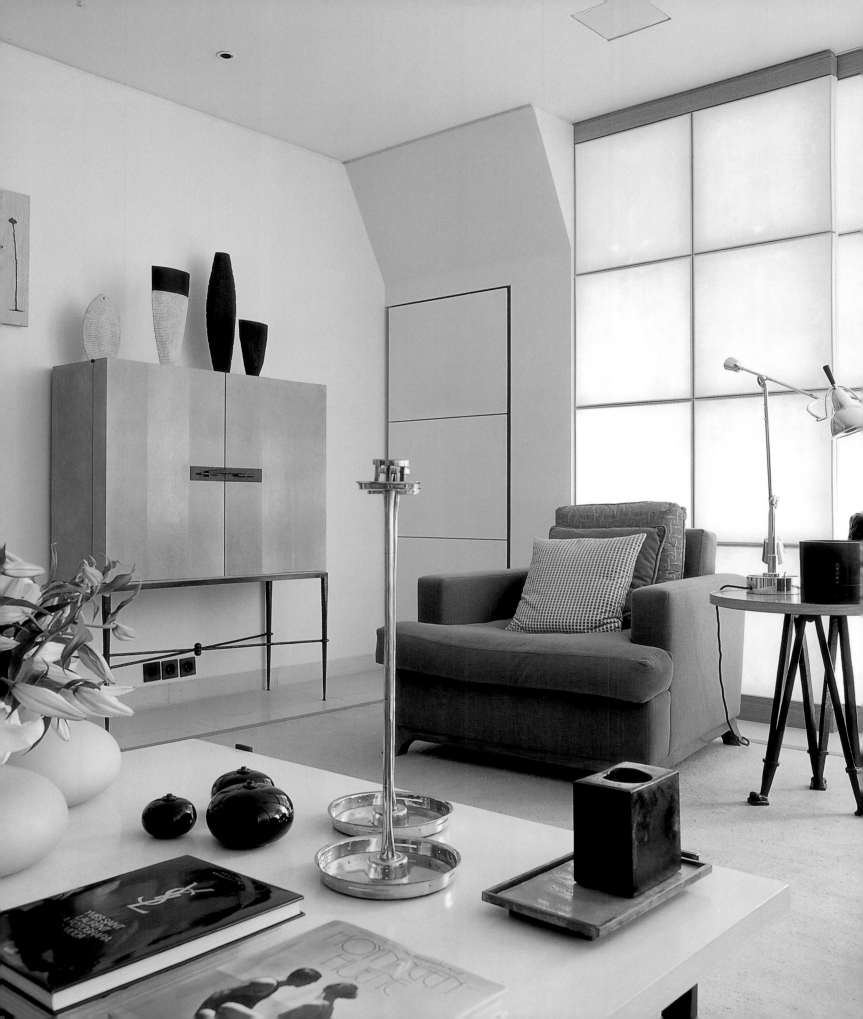

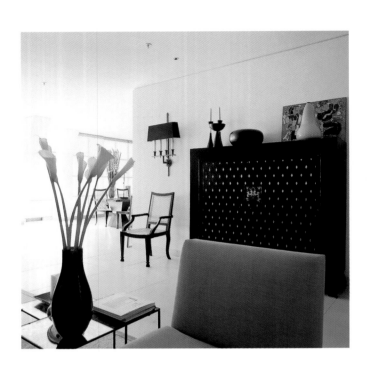

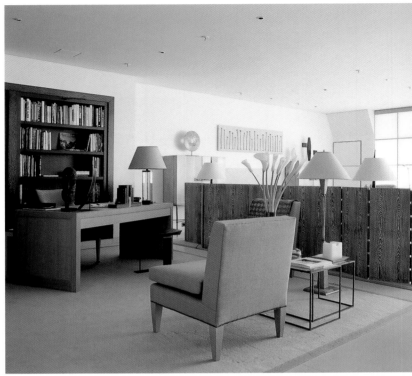

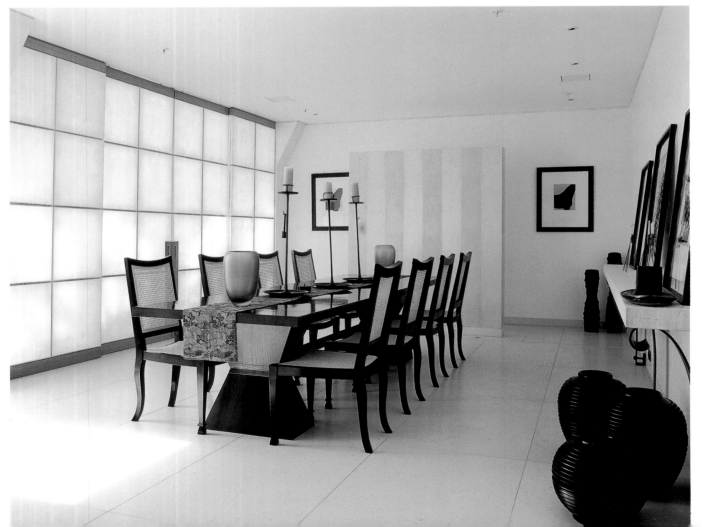

taken on projects not only in Berlin, but across Germany and further afield. Jagdfeld, with her family, has homes in Germany, Thailand and, of late, Marrakesh. But it is her apartment on the upper floors of the Quartier 206 building, a step away from the offices of her studio, that she chooses to present as an example of her sophisticated, eclectic approach to interiors.

'I wanted something very calm and relaxing,' says Jagdfeld, 'something that was both timeless and modern. I am here on my own a lot and have many things to do in a day, so I wanted a place where I could really relax.'

Jagdfeld planned the duplex so as to preserve as spacious a feeling as possible for the main living areas, creating an open-plan sitting room with separate zones for dining and study, with a library area to one side. Upstairs the bedrooms and bathrooms have an attic air, with their large banks of windows and french windows leading onto a small roof garden. Having planned the structure of the apartment and prioritised the desire for space and light, she began collaborating with Ann Boyd and Jonathan Reed on detailing, and called in technicians to create a high-tech environment, with piped music throughout and computer-controlled lighting.

In the main loft-style room Jagdfeld was anxious to avoid blocking out the wealth of natural light with heavy curtains against the row of windows across one side, while still wanting to mask them for an evening ambience. The solution was a sequence of sliding translucent panels made with calf leather, which act like Japanese shoji screens and become a striking feature in themselves, also contributing echoes of the 1920s and 1930s. Limestone flooring was chosen, but with two large rugs to one end to delineate the seating and study areas lightly. The open double-doorway to the kitchen, beyond the dining table, was concealed by a three-quarter-height monolith with a stucco covering laid in an angular formation to give the visual illusion of a stripe. Again this practical element of the room's design is striking at the same time because of its simple beauty.

The choice of furniture mixes pieces by amj design – a number of them, such as the pair of cabinets against the far wall, the sofa or the low screen that separates seating area and study, inspired by Jean-Michel Frank – with

LEFT The main living room is one large L-shaped space with lightly demarcated zones for dining, study and relaxation. The pale limestone floor and simply painted white walls tie the whole area together, but divisions are subtly made – as with the low screen between sitting and study areas, both of which are in their turn softly delineated with natural-weave rugs. The three-quarter-height monolith beyond the dining table hides the doorway to the kitchen.

other contemporary choices and twentieth-century elements such as a classic Eileen Gray chrome and glass table or the large black and gold French cabinet from the 1940s, which stands by the doorway to the entrance hall.

Added to the mix are many decorative objects from Africa and the East: the Japanese temple lights on the dining table, African masks and sculptures on tables and desks, black-and-white photographs of Tahiti and the South China Seas. 'I do travel a lot,' says Jagdfeld, 'and as you travel you develop a more global style, a more cosmopolitan outlook. We have a large collection of Asian art in our house in Thailand and a few pieces here, as well as some African. I like to mix a little bit of everything.'

Colours throughout are largely neutral to sustain the tranquillity of the home, but the apartment is rich in texture of all kinds and glories in the quality of materials and craftsmanship. There are the hard, smooth surfaces of stone and richly grained wood, but in the hallway, for instance, half of the granite floor flags are scored and grooved to create a chequerboard effect. Gentler touches come with the natural-weave rugs, the soft cottons and velvets for upholstery and cushions. At the top of the stairs you are faced with a leather-panelled wall, juxtaposed with the hard stone floors, while in the main bedroom carpets are soft underfoot and the bed draped with a luxurious fur throw.

'An apartment or a house should be a sensual experience,' Jagdfeld says, 'and everything should not be too obvious. You should be able to touch and feel, to enjoy a beautiful fabric or a wall or wood finish that is just so wonderfully done. That's very important. It's important to make things sing in the apartment; if everywhere is the same it gets too boring.'

LEFT AND RIGHT The neutrality of the colours in the apartment provides the perfect backdrop to artwork and sculptures, including many pieces from the Far East such as the Japanese temple lights on the dining table, with dining chairs by J. Robert Scott. Textural contrast is also important, with the strong lines of the space juxtaposed with soft suedes and linens for upholstery.

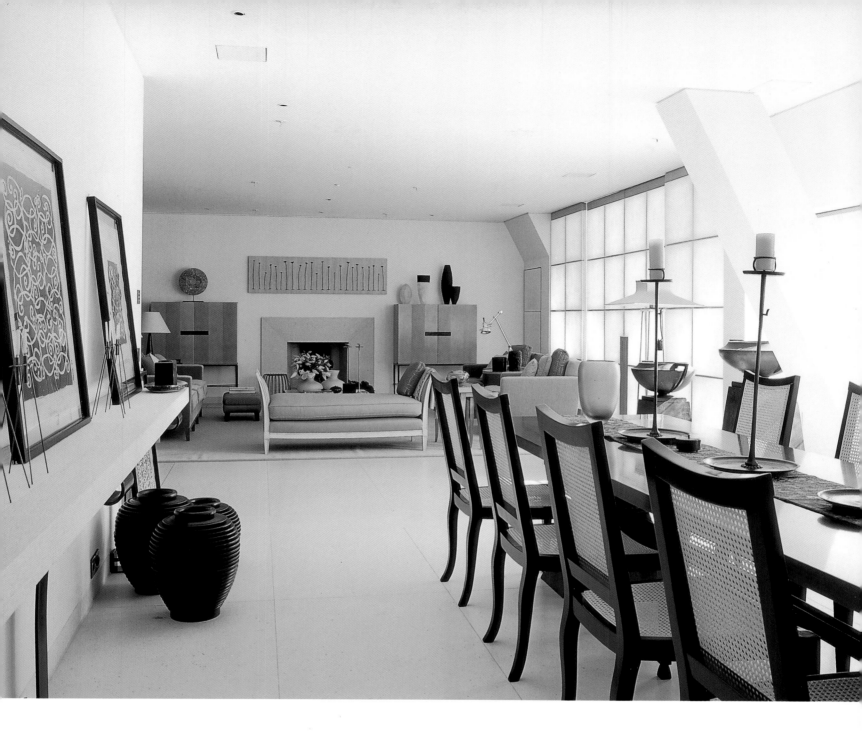

The bathroom, too, combines textural contrast with a wet-room effect: the antique English bath stands on a marble base but around it there is limestone – both smooth and indented for a corduroy effect – as well as sealed stucco for walls and floors. Upstairs the walls are rich with examples of Jagdfeld's collection of twentieth-century and contemporary photography, including images by Horst, Robert Mapplethorpe, Steve Klein, Cecil Beaton, August Sander and Karl Blossfeldt.

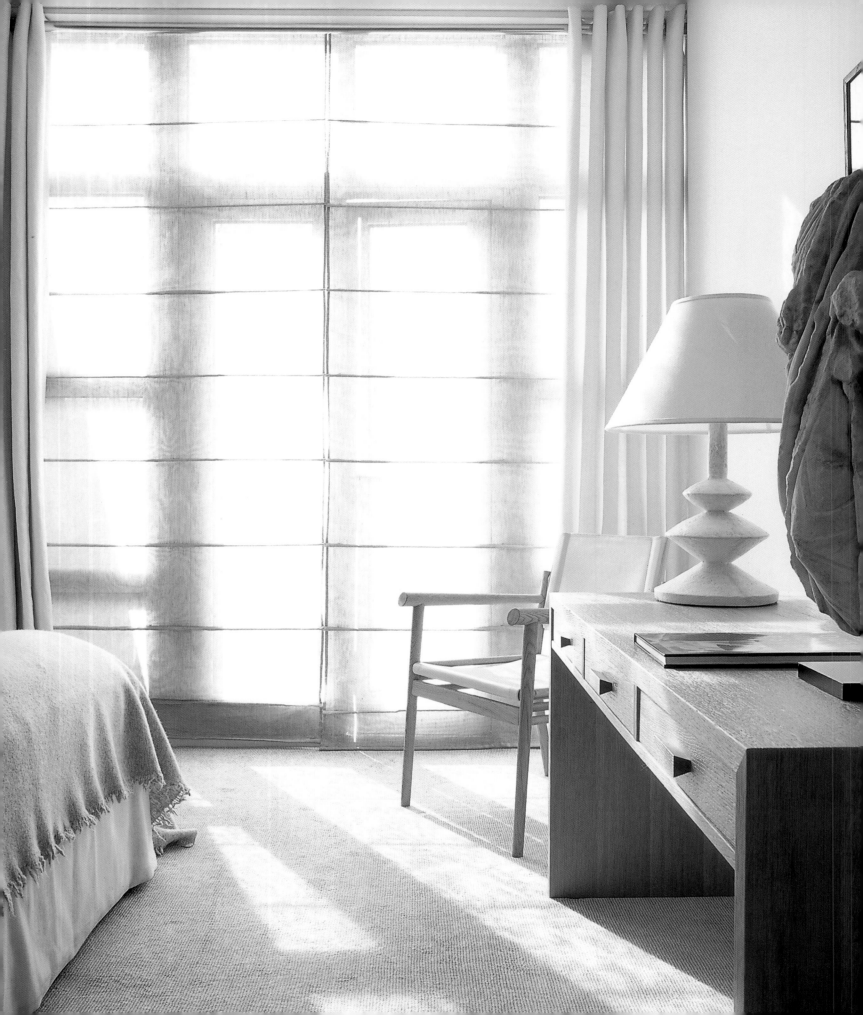

The apartment was finished in 1997. Since then Jagdfeld's interior-design work has steadily increased. Perhaps her most high-profile project to date is restoring the interiors of the Japanese Embassy in Berlin, which dates from the 1940s and is being given a mix of 1940s and contemporary styles. But there is also work on extending The Adlon, one of Berlin's premier hotels, plus other restaurant, hotel and apartment projects in the city. Then there is a long-running commitment to redevelop the Baltic coastal resort of Heiligendamm, a complex of houses and a hotel dating back to the 1790s.

Jagdfeld's interest in design stretches back to when she was a child: 'I never played with dolls,' she says. 'I was always building houses with Lego and shoe boxes. I did want to be a ballet dancer at one point – I studied classical ballet for seven years – but then I had an accident, had to stop and went on to do a degree in architecture.'

Influences include Jean-Michel Frank, Jacques-Emile Ruhlmann, Pierre Chareau, Frank Lloyd Wright and many architects and designers of the Bauhaus era. The apartment suggests her love of Deco, of the 1930s, but it is also deeply modern, elegantly contemporary. And together with the rest of Quartier 206 it forms one of the many building blocks in the creation of the new Berlin, an enterprise in which Jagdfeld and her family have established themselves as major players.

LEFT In the guest bedroom the curtains are lined linen paired with translucent blinds, to keep the mood light and airy. Neoclassical touches such as the Romanesque torso on the desk convey the stylistic frame of reference.

RIGHT In the hall the floor is a chequered arrangement of granite while the centre table is made of English slate. The African mask was found in Paris.

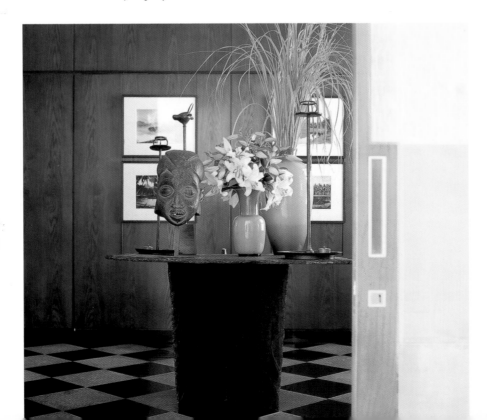

Index

Figures in *italics* refer to captions
and illustrations.

Aalto, Alvar 148, 150, *152*, 153, *153*
Aaron, Didier 65, 66
Abbaye Fontenay, Burgundy 178
Adjani, Isabelle 65
Adlon, Berlin 189
Air France 88
Albers, Josef 53
Alidad 14–21, 145
Aman 130–2, 133–4
amj design 185
Arbén, Love 150
Arbus, André 62, 146
Architeam 166, 169
architects 10, 27, 44, *86*, 148,
 158, 165–6
Architectural Association 44
Arp, Jean 97
Art Deco 62, 66, *74*, 75, *75*, 76, 119,
 120, 174, *176*, *177*, 189
Arts and Crafts 25, 28, 158
Asplund, Gunnar 148, 153
Asprey 157
Astor, New York 98
Aubusson 111
Avenue, Paris 53

B&B Italia 148, *148*, *149*, *150*,
 151, 153
Baechler, Donald 43
Baldwin, Billy 11
Banier, François-Marie 62, *67*
Barabarino, Josephine 166
Barragán, Luis 100, 168
Bateson, Charles 43, 140–7
Bath & Racquets Club, London 28
Bauhaus 10, 111, 166, 189
Beaton, Cecil *42*, *43*, 62, *62*, 187
Beckett, Samuel 178
Benette, Bill 127–8
Bérard, Christian 62, *64*, 65
Bernhardt, Sarah 173, *174*
Beuys, Joseph 97
Biedermeier *108*, *109*
Birger Jarl, Stockholm 153
Blenheim, Oxfordshire 54
Blossfeldt, Karl 187
Bohlin, Jonas 150, *152*, 153, *153*
Boiceau, Ernest 62, *67*
Bonaparte, Napoleon 58
Botta, Mario 166
Boulard 54, *55*
Bowie, David 154
Boyd, Ann 157, 185

Brazier-Jones, Mark 85
Brethy pottery 22
Breuer, Marcel 10, *92*, 95
British Interior Design Exhibition
 1997 145
Brunei, Sultan of 53
Bunuel, Luis 65
Burne-Jones, Sir Edward 19, 62,
 64, 65
Buscot Park, Oxfordshire 19

Calder, Alexander 153
Camberwell School of Arts 75
Cappellini 148
Caroline of Monaco 65
Cartland, Barbara 129
Castaing, Madeleine 11, 66, *67*, 181
Castiglioni 150, *151*
Centre d'Arts Plastiques
Contemporain, Bordeaux 181
Champ de Bataille, Normandy 48–59
Champion, David 28
Chareau, Pierre 9–10, 66, 111,
 178, 189
Charles, Caroline 75
Chateau de Clagny *49*
Chatsworth, Derbyshire 54
Chipperfield, David 168
Christie's 28
Club Gascon, London 30
Colefax & Fowler 37
Colette 7, 60, *61*, *62*, 66
Collett, Anthony *6*, 22–9, 145
Coper, Hans 75
Corian *156*, *157*, 160
Costes, Jean-Louis 50
Coutts 72

Dalecarlian wooden horses 150
Danube, New York 53
de Falbe, Christian 13, 30–9, 127
Delanois *54*, *55*
Design Realization 133
Dokhans, Paris 98
Douglas brothers *47*
du Plantier, Marc *67*
Dubrueil, André *46*
Dubuffet, Jean 97

Eames, Charles *94*, *95*, 97
Ecart 178
Ecole Boulle 65
Ecole Camondo 65, 98
Ecole d'Architecture 166
Ecole des Métiers d'Art 53
English Gothic 18, 19, *102*, *103*, 104

Ernst, Max 174, *178*, *179*
feng shui 82
Fontana, Lucio 53, 174, *174*
Fortuny 20, 28, *47*
Fouquet, Paris 53
Frank, Jean-Michel 9–10, 62, 65, 104,
 108, *109*, 111, 120, 146, 181,
 185, 189
Frey, Pierre 125
Fung, Stephen *86*, *87*
Fusion style 9, 79
 Hoppen, Kelly 7, *11*, 80–9
 Méchiche, Frédéric 7, 33, 90–9
 O'Connell, Mimmi *7*, 9, 100–7
 Preller, Peter 108–13
 Reeves, Michael 114–21, 127
 Ryan, Stephen 43, 122–9, 145
 Tuttle, Ed 9, 130–7

Garcia, Jacques 13, 48–59
Garland, Judy 158
Giacometti, Alberto 62, *64*, 65
Gilbert and George 22, *26*, *27*
Gill, David *30*, *31*
Goldin, Nan 97, 153
Gollut, Christophe 30, 145
Grande Armée, Paris 53
Granet, Roseline 137
Grange, Jacques 7, 33, 60–7, 137
Gray, Eileen 178, 186
Greenaway, Peter 178–81
Guggenheim, New York 181
Gump's 133

Habitat *116*, *117*
Hackett 157
Hadley, A;bert 158
Halliday, Johnny 65
Hampton, Mark 43
Hardouin-Mansart, Jules *see* Mansart
Haussman, Raoul *92*
Henningsen, Fritz 161, *161*
Henningsen, Poul 148
Henriksson, Jan 150
Hicks, Ashley and Allegra 7–9, 40–7
Hicks, David 11, 43–6, 127, 128,
 129, 145
Hicks, Lady Pamela 43
Hockney, David 62
Holtblad, Anna 153
Hooper, Phillip 145
Hope, Thomas 77
Hoppen, Kelly 7, *11*, 80–9
Hornsey College of Art 27
Hôtel Costes, Paris 50, 54
hotels 28, 50–3, 98, 130–2, 133–4,

153,
 174, 177, 181, 189
Ikea *114*, *115*, 148, *148*, *149*, 153
Inchbald School of Design 127
Ionesco, Eugène 178
Iribe, Paul 62

Jacobson, Arne *84*, *85*, *94*, *95*, 148
Jagdfeld, Anna Maria *8*, 9, 182–9
Jantar Mantar *44*, 46
Japanese Embassy, Berlin 189
Jardin des Tuileries, Paris 60
John Widdicomb Company 65
Johnson, Ben 104
Johnson, Philip 134
Jones, Edward 27
Joop, Wolfgang 113

Kapoor, Anish *42*
Kent, William 76
Klein, Steve 187
Klein, Yves 53
knitwear business 37, 119
Knoll, Florence 92, *92*
Knowles & Christou *144*, *145*

Lac, Mount Fuji 177
Ladurée, Paris 53
Lafon, Dupré 174, *176*, *177*
Lang, Jack 181
Lanvin, Jean *177*
Larsson, Carl 153
Lauren, Ralph 157
Le Corbusier, Charles-Edouard
 Jeanneret 10, 153, 168
Ledoux *50*
Leighton, Lord 62
Lemercier, Jacques 60
Liaigre, Christian 80, *81*, 82, *84*,
 85, 88
Libura, Maggie 140
Lissoni, Pierre 150, *151*
Lloyd's building, London 65
Lombok *102*, 104
Louis XIII 60
Louis XIV 65
Louis XV 58, 119
Louis XVI 66, 97, *98*, *99*
Louvre, Paris 60, 65
Ludwig II of Bavaria 166
Lutyens, Edwin 158

Mallet-Stevens, Robert 65
Mansart, Jules Hardouin 53–4, 58
Mapplethorpe, Robert 95, 187
Marden, Brice 133, *134*, 137

Mathieu, Antoine *54, 55*
Mathsson, Bruno 148
Méchiche, Frédéric 7, 33, 90–9
Meddendorf *110*, 111
Met de Penninghen 53
Mies van der Rohe, Ludwig 10, 88, 97, *98, 99*, 133, 134, 168, 178
Minimalism 100, 134, 168–9
Minshaw, John 9, *10*, 68–77
Miró, Joan 178
Modern style 9, 139
 Bateson, Charles 43, 140–7
 Jagdfeld, Anna Maria *8, 9*, 182–9
 Putman, Andrée *8, 9*, 88, 170–81
 Reed, Jonathan *8, 9*, 154–61, 185
 Rensch, Nico 162–9
 Sandell, Thomas 148–53
Modernism 10–11, 133
Momo's, London 30
Monges, Christian 130
Monro, Jean 146
Moorcroft pottery 22, 23
Morgans, New York 174, 177
Mountbatten, Lady Edwina *42, 43*
Mountbatten, Lord Louis 43
Mourge, Olivier *90, 91*
Murcutt, Glenn 168
Musée de la Vie Romantique, Paris 53
Museum of Modern Art, Stockholm 148

Neuschwanstein, Bavaria 166
New Classic style 9, 13
 Alidad 14–21, 145
 Collett, Anthony *6*, 22–9, 145
 de Falbe, Christian 13, 30–9, 127
 Garcia, Jacques 13, 48–59
 Grange, Jacques 7, 33, 60–7, 137
 Hicks, Ashley and Allegra

7–9, 40–7
 Minshaw, John 9, *10*, 68–77
Nicole Farhi 157
Noailles, Marie-Laure de 65–6
Noguchi, Isamu *98, 99*
Noll, Alexandre 62
Norman, Christopher 146

O'Connell, Mimmi 7, 9, 100–7
O'Keefe, Ghaban 30
Oregon, University of 133
Ormond, Julia 30
Osbert 65

Palais-Royal, Paris 60, 62, *63*
Palladian influence 33, 100, 128
Parliament building, Stockholm 148
Parthenon 40
Pawson, John 100, 168
Penn, Irving 60, 62, *62*
Picasso, Pablo 62, *62, 63, 64, 65*, 178
Picasso, Paloma 65
Pompadour, Madame de 65
Port of Call 107
Preller, Peter 108–13
Prisunic 178
Putman, Andrée *8, 9*, 88, 170–81

Quartier 206, Berlin 182–5, 189

Reed, Jonathan *8, 9*, 154–61, 185
Reed, Magnus *150, 151*, 153
Reeves, Michael 114–21, 127
Rensch, Hardy *162, 163*, 165–6
Rensch, Nico 162–9
restaurants 28, 30, 53, 88, 98, 150, 166
Reynaud, Jean Pierre 96, *97*, 174, *174*

Rie, Lucy 75
Riva, London 30
Robuchon, Joel 98
Rogers, Richard 28, 161
Rothschilds 65
Royal College of Art 27
Royal Opera House, London 27
Rubinstein, Helena 129
Ruhlmann, Jacques-Emile 9–10, 146, 174, *176, 177*, 189
Ruskin pottery 22, 23
Ryan, Stephen 43, 122–9, 145

Saarinen, Eero 148, *150, 151*, 153, 158
Saint James Club, Paris 177
Saint-Laurent, Yves 66, *174*
Saladino, John 120
salvage 34, *34, 35*, 37–8, *39*, 76, 92
Samuel, Henri 65, 66
Sandberg, Ulf 148
Sandell, Thomas 148–53
Sander, August 187
Sander, Jil 113
Scott, Robert J. *186, 187*
Sené *54, 55*
Sherman, Cindy 97
shops 53, 133, 157, 174, 182
Silvestrin, Claudi 100, 168
Soame, Sir John 76
Soulages, Pierre 97
Stefanidis, John 27–8, 145
Stowe 44
Swedish Museum of Architecture, Stockholm 148

Takada, Kenzo 133
Terry, Emilio 62, 66
theatres 166
Thompson, Jim *72, 73*, 82

Thorsman, Ingegerd *148, 149*, 153
Topkapi Palace Museum, Turkey 20
Tranan 150
Triplet, Bruno 146
trompe l'oeil 43, *44, 45*
Tuttle, Ed 9, 130–7

van Velde, Bram 174
Vecchia Scuola 100–7
Ventosa, Jean Vidal *62, 63*
Versailles 53, 65
Victoria & Albert Museum, London *44*
Villa Taylor, Marrakesh 62
Voysey, Charles 158

Warhol, Andy 62
Wasserturm, Cologne 177
Waymouth, Victoria 145
Winchester School of Art 145
Wright, Frank Lloyd 10, 43, 133, 168, 189

Yamamoto, Yuhji 157

Zarzycki, Andrzej 28
Zecha, Adrian 133
Ziegler rugs 16, *134, 135*, 137
Zoffany 125
wine labels 80
Withnail and I (film) 44
wood stains/dyes 70
Woolf, Leonard 34
Woolf, Virginia 32, 34, 85, 111

Yeats, W B 24

Selected bibliography

Andrée Putman, by Sophie Tasma-Anargyros (Laurence King, 1997)

Classic Meets Contemporary, by Fleur Rossdale (Collins & Brown, 1998)

Design of the Twentieth Century, by Charlotte & Peter Fiell (Taschen, 1999)

East Meets West, by Kelly Hoppen (Conran Octopus, 1997)

A History of Interior Design, by John Pile (Laurence King, 2000)

Influential Interiors, by Suzanne Trocmé (Mitchell Beazley, 1999)

Jacques Garcia: Decorating in the French Style, by Franck Ferrand (Flammarion, 1999)

Modern, by Jonathan Glancey (Mitchell Beazley, 1999)

Addresses

ALIDAD
Studio 4, The William Blake House
Bridge Lane, London SW11 3AD
Telephone: +44 (0) 20 7924 3033
Fax: +44 (0) 20 7924 3088

CHARLES BATESON
18 King's Road, St Margaret's
Twickenham TW1 2QS
Telephone: +44 (0) 20 8892 3141
Fax: +44 (0) 20 8891 6483

ANTHONY COLLETT
Collett-Zarzycki, Fernhead Studios
2b Fernhead Road, London W9 3ET
Telephone: +44 (0) 20 8969 6967
Fax: +44 (0) 20 8960 6480

CHRISTIAN DE FALBE
Studio 2, The Glasshouse
49a Goldhawk Road, London W12 8QP
Telephone: +44 (0) 20 8743 3210
Fax: +44 (0) 20 8743 3210

JACQUES GARCIA DECORATION
212 Rue de Rivoli, 75001, Paris
Telephone: +33 (0) 1 42 97 48 70
Fax: +33 (0) 1 42 97 48 10

JACQUES GRANGE
118 Rue du Faubourg-St-Honoré
75008, Paris
Telephone: + 33 (0) 1 47 42 47 34
Fax: + 33 (0) 1 42 66 24 17

ASHLEY AND ALLEGRA HICKS
2/27 Chelsea Harbour Design Centre
London SW10 0XE
Telephone: +44 (0) 20 7351 9696
Fax: +44 (0) 20 7795 1429

KELLY HOPPEN
2 Munden Street, London W14 0RH
Telephone: +44 (0) 20 7471 3350
Fax: +44 (0) 20 7471 3351

ANNE MARIA JAGDFELD
amj design, Friedrichstrasse 71
D-10117, Berlin
Telephone: +49 (0) 30 2094 6303
Fax: +49 (0) 30 2094 6280

FRÉDÉRIC MÉCHICHE
4 Rue de Thorigny, 75003, Paris
Telephone: +33 (0) 1 42 78 78 28
Fax: +33 (0) 1 42 78 23 30

JOHN MINSHAW
119 George Street, London W1H 7H
Telephone: +44 (0) 20 7258 0627
Fax: +44 (0) 20 7258 0628

MIMMI O'CONNELL
122 Ebury Street, London SW1W 9QQ
Telephone: +44 (0) 20 7589 4836
Fax: +44 (0) 20 7823 9828

PETER PRELLER
Hansastrasse 13, 20149, Hamburg
Telephone: +49 (0) 40 410 32 26
Fax: +49 (0) 40 44 76 58

ANDRÉE PUTMAN
83 Avenue Denfert-Rochereau
75014, Paris
Telephone: +33 (0) 1 55 42 88 55
Fax: +33 (0) 1 55 42 88 50

JONATHAN REED
Reed Creative Services
151a Sydney Street, London SW3 6NT
Telephone: +44 (0) 20 7565 0066
Fax: +44 (0) 20 7565 0067

MICHAEL REEVES
91a Pelham Street, London SW7 2NJ
Telephone: +44 (0) 20 7225 2501
Fax: +44 (0) 20 7225 3060

NICO RENSCH
Architeam, Campfield House
Powdermill Lane, Battle
East Sussex TN33 0SY
Telephone: +44 (0) 411 412 898
Fax: +44 (0) 1424 777 181

STEPHEN RYAN
7 Clarendon Cross, London W1
Telephone: +44 (0) 20 7243 0864
Fax: +44 (0) 20 7243 3151

THOMAS SANDELL
Riddargatan 17 DII, Se–114 57
Stockholm, Sweden
Telephone: +46 (0) 8 506 217 00
Fax: +46 (0) 78 506 217 07

ED TUTTLE
Design Realization
Telephone: +33 (0) 1 42 22 65 77
Fax: +33 (0) 1 45 49 18 49

Acknowledgements

Dominic Bradbury and Mark Luscombe-Whyte would like to express their gratitude to all of the designers who have agreed to feature in this book and to thank them for their hospitality. We would also like to thank the following for their assistance and support: Zoe Antoniou and all at Pavilion, Erik M. Anderson at Interior Plus, Martin Waller at Andrew Martin, Thomas Niederste-Werbeck at Architektur & Wohnen, Joachim v. Schönberg at Hahne & Schönberg, Richard Blight and Design Hotels.
Special thanks to Faith and Florence Bradbury and to the intrepid Marie Valensi.